LIFE

THE AMERICAN JOURNEY OF
BARACK OBAMA

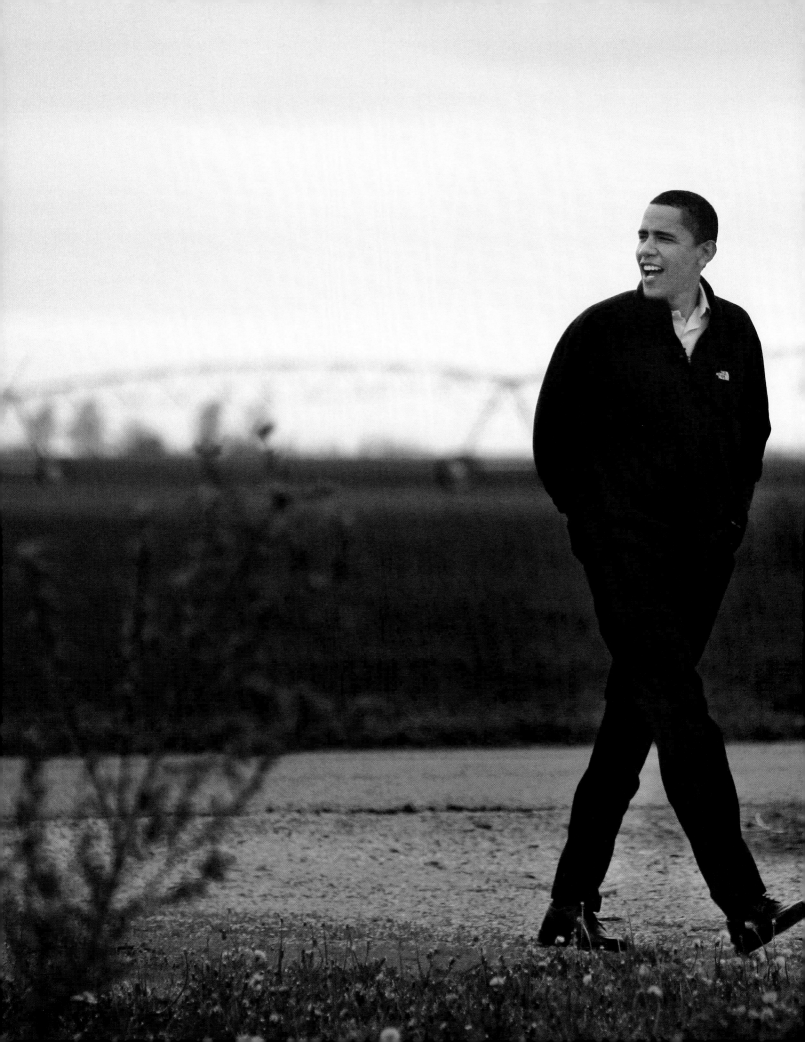

THE AMERICAN JOURNEY OF
BARACK OBAMA

THE EDITORS OF LIFE

LITTLE, BROWN AND COMPANY
NEW YORK BOSTON LONDON

LIFE Books

EDITOR Robert Sullivan
DIRECTOR OF PHOTOGRAPHY Barbara Baker Burrows
CREATIVE DIRECTOR Mimi Park
DEPUTY PICTURE EDITOR Christina Lieberman
WRITER-REPORTERS Hildegard Anderson (Chief),
Danny Freedman (Senior Writer), Marilyn Fu
COPY Barbara Gogan (Chief), Amélie Cherlin,
Heather L. Hughes, Parlan McGaw
PHOTO ASSISTANT Forrester Hambrecht
CONSULTING PICTURE EDITORS Sarah Burrows,
Mimi Murphy (Rome), Tala Skari (Paris)

PRESIDENT Andrew Blau
BUSINESS MANAGER Roger Adler
BUSINESS DEVELOPMENT MANAGER Jeff Burak

PUBLISHED BY LITTLE, BROWN AND COMPANY,
A DIVISION OF HACHETTE BOOK GROUP, INC.
The Little, Brown name and logo are trademarks of Hachette Book Group, Inc.

HACHETTE BOOK GROUP, INC.
CHAIRMAN AND CEO David Young

LITTLE, BROWN AND COMPANY
EXECUTIVE VICE PRESIDENT AND PUBLISHER Michael Pietsch
VICE PRESIDENT, EDITOR-IN-CHIEF Geoff Shandler
EXECUTIVE EDITOR Michael Sand

TIME INC. HOME ENTERTAINMENT
PUBLISHER Richard Fraiman
GENERAL MANAGER Steven Sandonato
EXECUTIVE DIRECTOR, MARKETING SERVICES Carol Pittard
DIRECTOR, RETAIL & SPECIAL SALES Tom Mifsud
DIRECTOR, NEW PRODUCT DEVELOPMENT Peter Harper
ASSISTANT DIRECTOR, BRAND MARKETING Laura Adam
SENIOR MARKETING MANAGER Joy Butts
ASSOCIATE COUNSEL Helen Wan
BRAND MANAGER Shelley Rescober

EDITORIAL OPERATIONS Richard K. Prue, David Sloan (Directors),
Richard Shaffer (Group Manager), Brian Fellows, Raphael Joa,
Angel Mass, Stanley E. Moyse, Claudio Muller, Albert Rufino (Managers),
Soheila Asayesh, Keith Aurelio, Charlotte Coco, Osmar Escalona,
Kevin Hart, Norma Jones, Mert Kerimoglu, Rosalie Khan, Marco Lau,
Po Fung Ng, Rudi Papiri, Robert Pizaro, Barry Pribula, Carina A. Rosario,
Vaune Trachtman, Paul Tupay, Lionel Vargas, David Weiner

SPECIAL THANKS Andi Vaida

Little, Brown and Company
Hachette Book Group
237 Park Avenue, New York, NY 10017
Visit our Web site at www.HachetteBookGroup.com

First Edition: October 2008

ISBN 978-0-316-04560-5
Library of Congress Control Number 2008933525

10 9 8 7

Printed in the United States of America

HALF TITLE PAGE: *Young Barack as a batter in Honolulu, in 1963*
POLARIS

TITLE PAGE: *On the campaign trail in Kempton, Indiana, in May 2008*
EMMANUEL DUNAND/GETTY

THIS PAGE: *At the U.S. Capitol Building in Washington, D.C.,
in June 2005*
DAVID BURNETT/CONTACT

CONTENTS

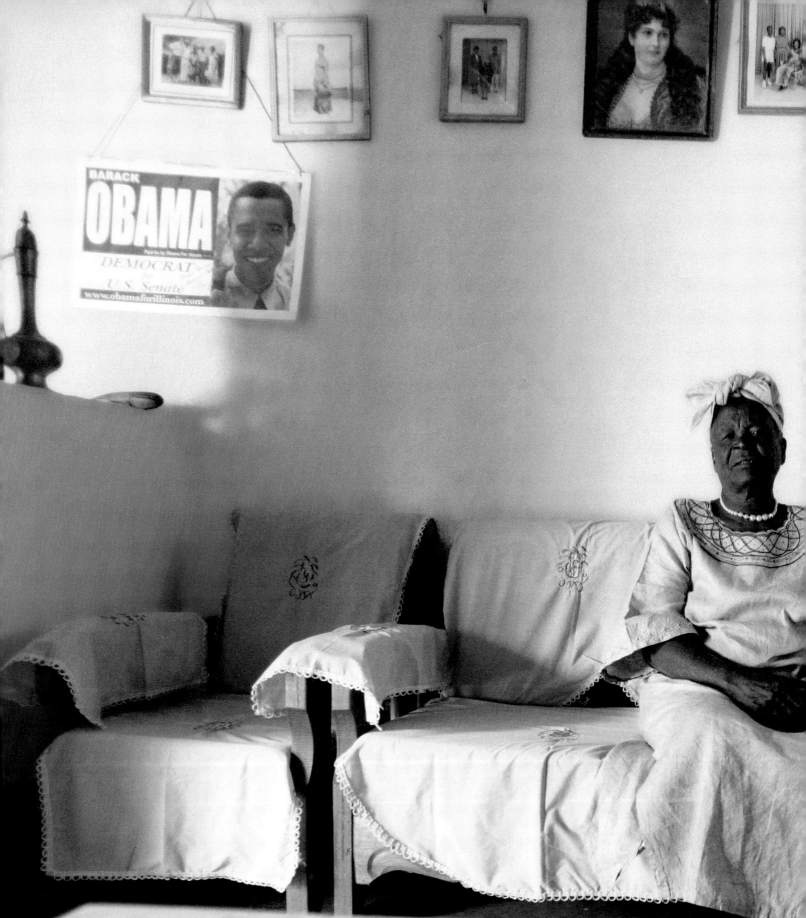

THE HERITAGE

Among the things that distinguish Obama on the American political land-scape is that his father was African. Here, his step-grandmother, Sarah, who was principally responsible for raising Obama's dad, sits in her home in Kenya amidst family mementos.

MOMENTS IN A JOURNEY

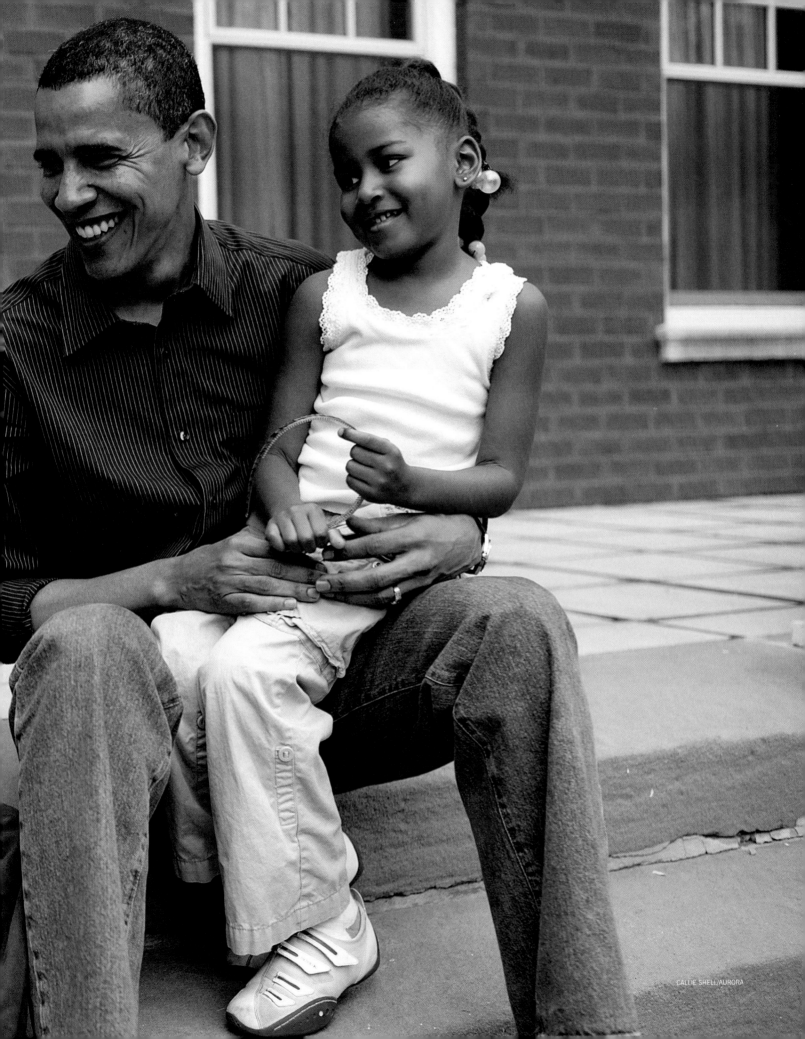

In the fall of 2004, the Democrats' new supernova won election to the United States Senate. Two years later, in October 2006, he is at an event at the John F. Kennedy Presidential Library in Boston, and he is only a few months away from announcing his presidential bid.

THE AUDACIOUS ATTEMPT

Having served little more than two years in Washington, Obama leaps into the fray for the presidency. His campaign appearances are passionate affairs—like this one, in St. Paul, Minnesota, on the night in June 2008 when he has finally captured enough delegates to secure the nomination.

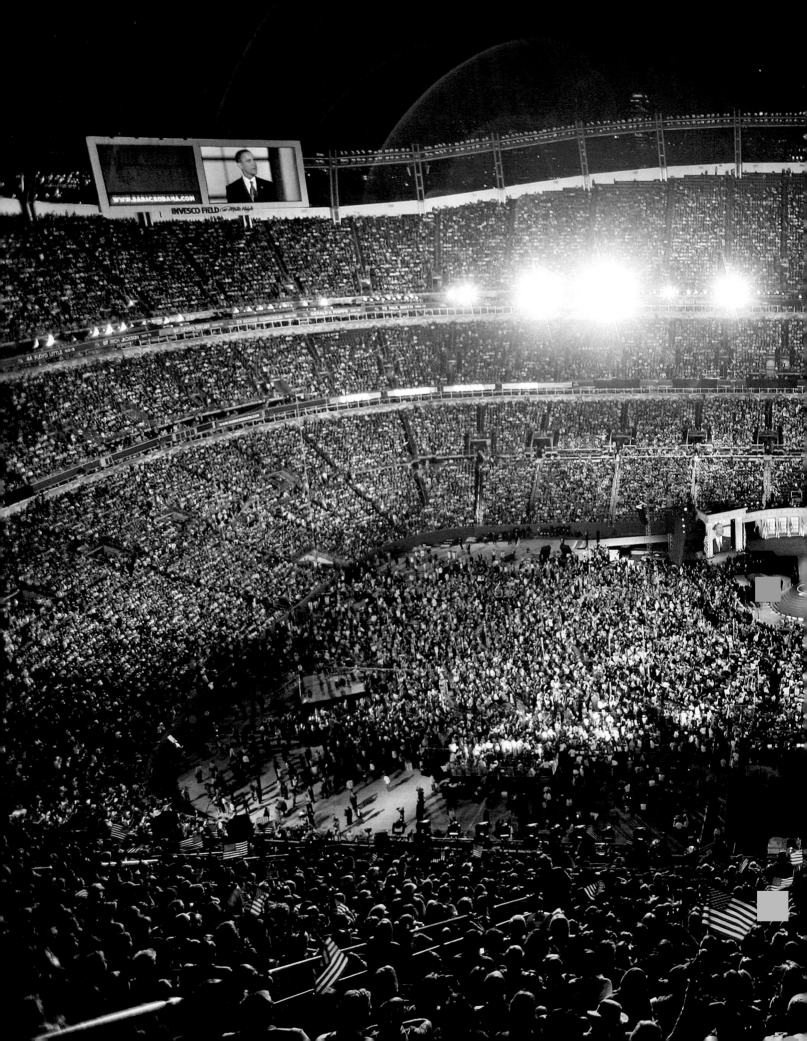

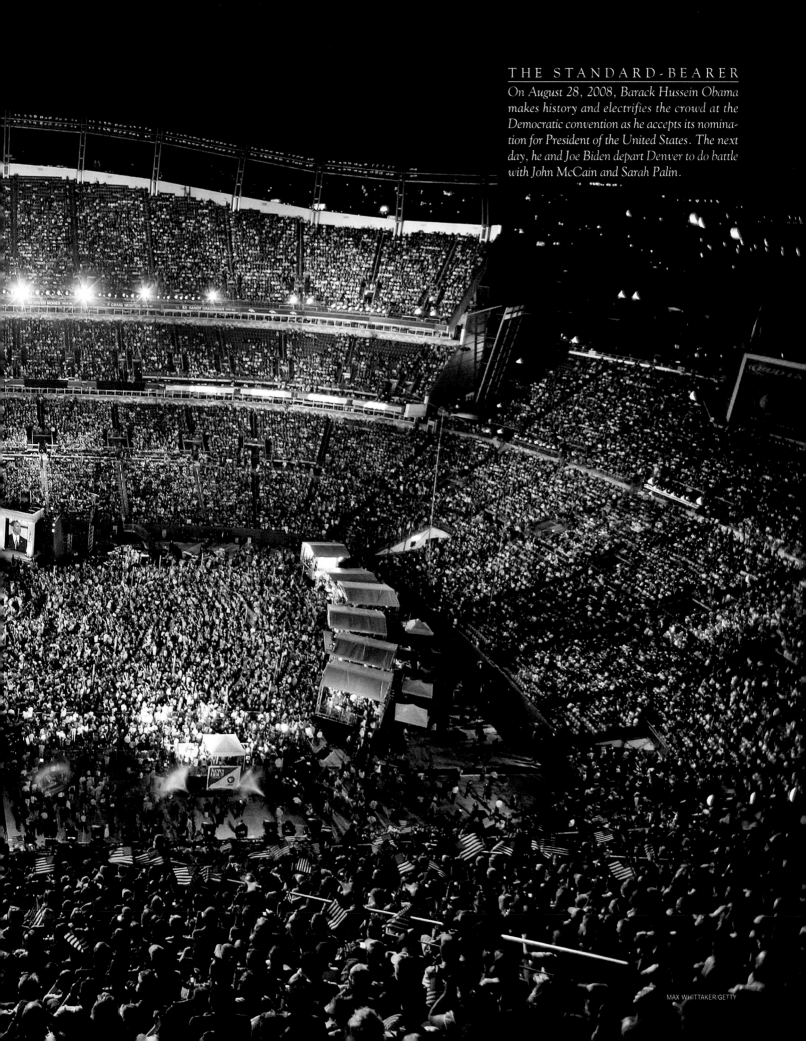

THE STANDARD-BEARER

On August 28, 2008, Barack Hussein Obama makes history and electrifies the crowd at the Democratic convention as he accepts its nomination for President of the United States. The next day, he and Joe Biden depart Denver to do battle with John McCain and Sarah Palin.

INTRODUCTION

SOME LIVES ARE, no matter an observer's political, philosophical or cultural orientation, so inarguably and objectively fascinating that to gaze upon them—to see the twists and turns, the lucky breaks and the hard knocks— is a riveting pleasure. Barack Obama's is one of those unlikely, almost preposterous, lives. His story is, no matter which side of the political aisle you are on, a thriller. And it is a story that (again, regardless of the reader's political leanings) you should know at this point in time—and in the days and years ahead.

As the title of our book implies, this is a journey that, to use the old phrase, could only have been made in America. An underlying premise of our nation has been the Melting Pot, and this concept, having everything to do with democracy and freedom of opportunity, has made us who we are. Nevertheless, we have progressed two centuries and longer with an unbroken string of white, male leaders (if we are referencing the ultimate post, the presidency). The events of 2008 said many things but what they said most clearly was: The times they are a- (finally) changin'. Ours was a country ready, willing and able to elect a woman or minority candidate. This election, no matter the ultimate outcome, was a watershed.

Which is not to say that, with Obama, race was not an issue. It has always been an issue, for him as well as for those who would either have problems with or applaud his multiculturalism. In the early chapters of *The American Journey of Barack Obama*, we have tried to untangle and explain the complicated heritages— the twisty paternal African side, and the more straightforward maternal part that is often put forth as the "Kansas" component of Obama, but that is, as we shall see, much more about Hawaii, certainly as pertains to the man himself if not his forebears. Obama has been formed by Hawaii, then the halls of academia, then the streets of Chicago's South Side, then the chambers of state and federal legislatures. He has been formed by his mother and her parents. Obama does not necessarily become easy to understand in this book, but he becomes easier.

You will hear from partisan voices in these pages; goodness, on the pages immediately following you'll hear from Ted Kennedy, who famously threw in with Obama when the Democratic nomination was very much up for grabs. And you will hear from the unaligned: the historian Richard Norton Smith, the writers Gay Talese and Bob Greene, the journalists Nancy Gibbs and David M. Shribman, and several others. Each will parse an aspect of Obama, who is beyond doubt a man of many aspects. You will hear from Obama himself. He is already on the record in two memoirs, the first of which was particularly candid and compelling, and in countless interviews since entering public life. How Obama regards his own narrative is made clear in the chapters that follow.

Throughout these chapters there are, as this is LIFE, the pictures, telling their own revealing and vibrant story. We have been very fortunate to obtain some intimate images of young Barack that have never before been seen by the public, and several behind-the-scenes pictures of the adult Obama that will also be new to the reader. No part of his life, in America and abroad, goes unexamined, and the pictures have been selected with an eye toward getting our readers (to use the phrase) up close and personal.

Here, then, is Barack Obama—so far.

His has been an extraordinary American journey. Everyone agrees on this.

There will be future chapters. Everyone agrees on this, too.

Where and when people disagree, they are nonetheless better off for knowing the man. —THE EDITORS

FOREWORD

BY SENATOR EDWARD M. KENNEDY

AFTER TOO MANY LONG YEARS OF DIVISION AND DIVISIVENESS in our politics and our government, Americans hunger for change. I believe we've found at last a leader of remarkable vision and ability who can unite us to bring about that change, and his name is Barack Obama.

I've had the privilege of working with Barack Obama for the past several years in the United States Senate. I was impressed from the beginning with his special insights into the hopes and needs of average Americans. We worked closely on key issues such as jobs, education, healthcare, immigration and civil rights, and on each of these issues, I witnessed his ability to bring people together to achieve genuine progress.

But it was not until the primary election campaign that I saw the full range of Barack Obama's abilities. I had not planned to endorse any candidate in the primaries. I knew them all personally and respected them. Whenever I was asked whom I supported, I responded that I was looking for a candidate who could inspire the people, lift our vision and renew our belief that America's best days are still ahead.

The first days of 2008 brought not just the stunning results of the Iowa caucuses but an inspiring victory speech by Barack Obama. It was then that I realized that he had the extraordinary gifts of leadership and character needed to meet and master the challenges facing us at home and abroad.

I described the Barack Obama I had come to know and admire when I endorsed him on January 28. I explained that he refuses to be trapped in the patterns of the past. He is a leader who sees the world clearly without being cynical. He is a fighter who cares passionately about the causes he believes in, without demonizing those who hold a different view.

He is tough-minded, but he also has an uncommon capacity to appeal to "the better angels of our nature."

I marveled at his grit and his grace as he traveled the country, attracted record turnouts of people of all ages, and got them "fired up" and "ready to go." I've seen him connect with men and women from every walk of life and with members of Congress on both sides of the aisle. With every person he meets, every crowd he invigorates, he generates new hope that this generation of Americans can come together to meet our own rendezvous with destiny.

I remember another such time. In the 1960s, when I first came to the Senate at the age of 30, we had a new President who inspired the nation, especially the young, to seek a New Frontier. Those inspired young people marched for civil rights and sat in at lunch counters. They protested the war in Vietnam and served honorably in that war, even when they opposed it. They realized that when they asked what they could do for their country, they could change the world.

They went on to enlist in the cause of equality for women. They joined the Peace Corps, and put an American on the moon. They led the first Earth Day and issued a clarion call

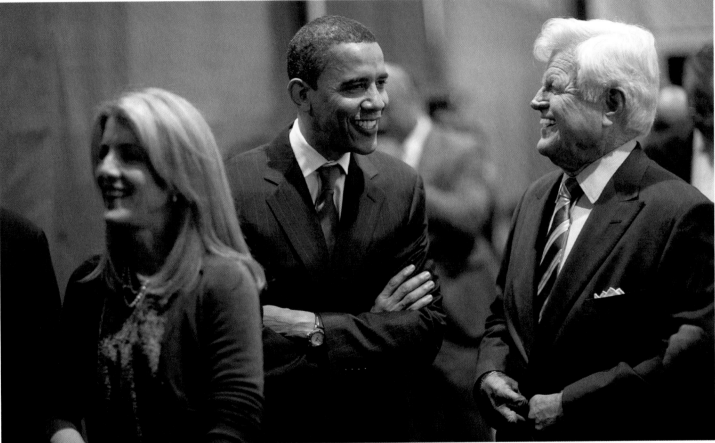

On January 28, 2008, at American University in Washington, D.C., Obama is endorsed for President by Caroline Kennedy and her uncle Ted.

to protect the environment. They showed the world the true character of America at its best.

Now is another such time. I sense the same kind of yearning today, and the same kind of hunger and dedication to move America forward. I see it not just in our young people but in all our people.

As I write this, I do not know whether Barack Obama will become our nation's forty-fourth President, but I hope very much that he will. What I do know is that he has already changed our nation. In Barack Obama, we see not just the audacity, but the reality of new hope for the stronger, better and fairer America that is yet to be.

THE FAMILY TREE

IN THE HISTORY OF THE MELTING POT that is the United States, there have surely been more complicated lineages than this one that descends to Barack Obama Jr. and his children. But among our nation's leaders, few have so exotically personified the notion that an American can come from anywhere, from any background or combination of backgrounds. The Obama family tree is not a slender birch, easy to follow from trunk to uppermost branch. It is a gnarly and complicated plant, more akin to the volatile Whomping Willow of the *Harry Potter* saga.

Even in its distilled version on the adjacent page, it describes a remarkable story the equal of Harry's. What is not in the grid is the nifty nitty-gritty and the fascinating footnotes.

On the African side of the family, the heritage is Kenyan. There are many, many relations, as Obama's father, paternal grandfather and paternal great-grandfather each had several wives and many children. Of particular significance to Obama is his grandfather's third wife, Sarah, whom the politician calls his grandmother. This is because, after his biological grandmother, Akuma, left her family when her children were young, Sarah became the moving force in the life of Obama's father, Barack senior. Of passing interest is that the grandfather in question, Hussein Onyango Obama, fought for the colonial overlord, Great Britain, in World War I. Also: The first person in the Obama family to leave Africa and live in another country was Obama's own father, Barack senior. So Obama's people never lived under slavery in the United States—or anywhere else.

The American saga leading to the birth of Stanley Ann Dunham, Obama's mother, on November 29, 1942, is a pip indeed. Hers is an old family in the country's history, though some of the peripheral—and most colorful—claimed links remain, even in this age of sophisticated genealogical science, to be authoritatively confirmed. Yes, Obama is, in fact, distantly related to George W. Bush's vice president, Dick Cheney—and probably to Bush himself, if we venture back to the 1600s—something that has made for great sport among late-night comics. Whether he is also kin to Wild Bill Hickok, as he implied at a campaign stop in Springfield, Missouri—"[He] had his first duel in the town square here. And the family legend is that he is a distant cousin of mine"—still requires a rubber stamp.

But Obama is eligible for membership in the Sons of the American Revolution, and when he wrote in his memoir *Dreams from My Father*, "One of my great-great-grandfathers, Christopher Columbus Clark, had been a decorated Union soldier, his wife's mother was rumored to have been a second cousin of Jefferson Davis, president of the Confederacy," he was technically incorrect only in that Clark was his great-great-*great*-grandfather. As the allusion to Davis might imply: Yes, several of Obama's maternal ancestors were slave owners. If some see this as an irony, Barack Obama does not. "That's no surprise," he says. "That's part of our tortured, tangled history."

In the current generation—not the very freshest one, but the one involving Barack and his siblings as opposed to their kids—affairs are only scarcely less interesting. Stanley Ann Dunham was Barack Obama Sr.'s second wife, and with him conceived Barack junior, the subject of our book. Ann and Obama Sr. divorced, and Ann married Lolo Soetoro; they had a daughter, Maya, with whom Barack junior is close and of whom we will learn more later. Then Ann died—of ovarian cancer at the tragically young age of 52—in 1995.

Earlier, Barack Hussein Obama Sr. had left three wives—plus seven sons and a daughter—when he died in 1982, at the age of 46, in a car crash in Nairobi. His son in America, Barack, has come to know his African half sister, Auma, very well; and Malik Abongo (Roy) Obama was Barack's best man at his and Michelle's wedding in Chicago in 1992. But some of his African half siblings, such as George, who was born of a woman not married to his father, are known to Obama only slightly. In the late summer of 2008, a story emerged that George was living on less than a dollar a month in a shack outside Nairobi, and was reluctant to speak of his relationship to the U.S. presidential hopeful, lest he embarrass him.

Maya once recalled fondly a special day, particularly so for her half brother, Barack: "I remember his wedding. And there were everything from the very fair Kansas complexion, you know, the Scots-Irish thing, to the blue-black Kenyan. And we looked like the rainbow tribe—and me in between, I'm Indonesian.

"The united colors . . .

"Never a dull moment, right?"

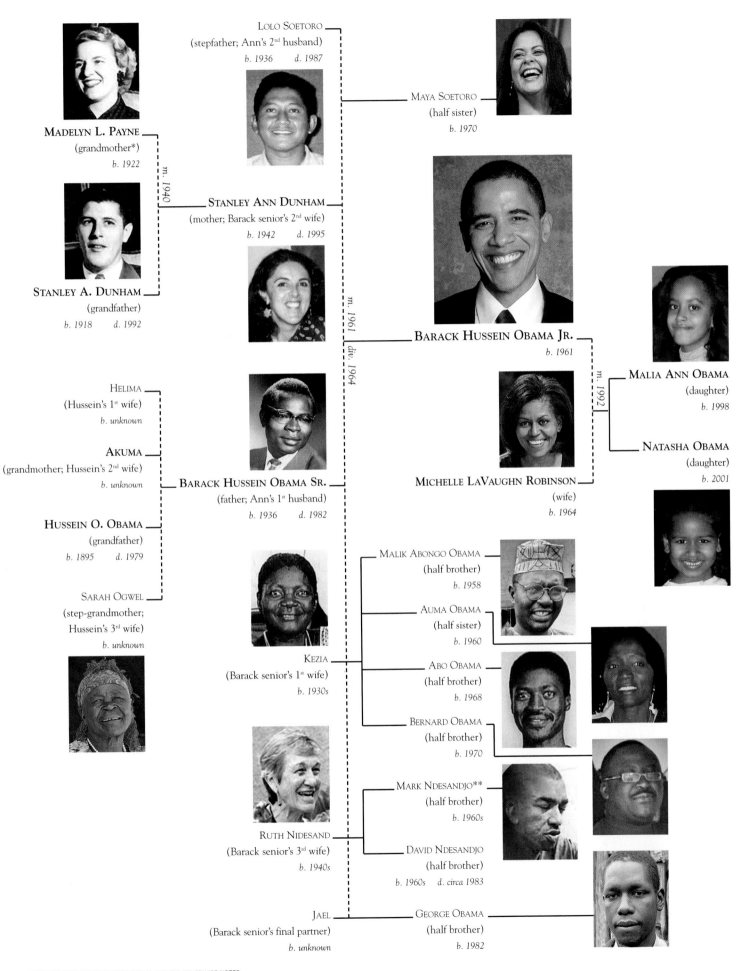

LOLO SOETORO

(stepfather; Ann's 2nd husband)

b. 1936 d. 1987

MAYA SOETORO

(half sister)

b. 1970

MADELYN L. PAYNE

(grandmother*)

b. 1922

m. 1940

STANLEY ANN DUNHAM

(mother; Barack senior's 2nd wife)

b. 1942 d. 1995

STANLEY A. DUNHAM

(grandfather)

b. 1918 d. 1992

BARACK HUSSEIN OBAMA JR.

b. 1961

m. 1961

div. 1964

MALIA ANN OBAMA

(daughter)

b. 1998

m. 1992

HELIMA

(Hussein's 1st wife)

b. unknown

AKUMA

(grandmother; Hussein's 2nd wife)

b. unknown

HUSSEIN O. OBAMA

(grandfather)

b. 1895 d. 1979

BARACK HUSSEIN OBAMA SR.

(father; Ann's 1st husband)

b. 1936 d. 1982

MICHELLE LAVAUGHN ROBINSON

(wife)

b. 1964

NATASHA OBAMA

(daughter)

b. 2001

SARAH OGWEL

(step-grandmother;

Hussein's 3rd wife)

b. unknown

MALIK ABONGO OBAMA

(half brother)

b. 1958

AUMA OBAMA

(half sister)

b. 1960

KEZIA

(Barack senior's 1st wife)

b. 1930s

ABO OBAMA

(half brother)

b. 1968

BERNARD OBAMA

(half brother)

b. 1970

MARK NDESANDJO**

(half brother)

b. 1960s

RUTH NIDESAND

(Barack senior's 3rd wife)

b. 1940s

DAVID NDESANDJO

(half brother)

b. 1960s d. circa 1983

JAEL

(Barack senior's final partner)

b. unknown

GEORGE OBAMA

(half brother)

b. 1982

*ALL RELATIONSHIPS ARE TO BARACK OBAMA, UNLESS OTHERWISE NOTED.
**THE TWO SONS OF BARACK OBAMA SR. AND RUTH NIDESAND CHOSE THE LAST NAME OF THEIR STEPFATHER, NDESANDJO.

ROOTS

AMERICANS, FAMOUSLY, COME
FROM EVERYWHERE.
BARACK OBAMA'S PEOPLE
HAVE COME FROM VASTLY
DIFFERENT PLACES, BUT
WHAT HAS SET HIM APART AS
A PUBLIC FIGURE—WHAT
HAS, FOR SOME, DEFINED
HIM—IS THAT HIS
FATHER CAME FROM AFRICA.

In 2006, Senator Obama makes an emotional trip to his late father's homeland in western Kenya, where he, a success story in another land, has become revered.

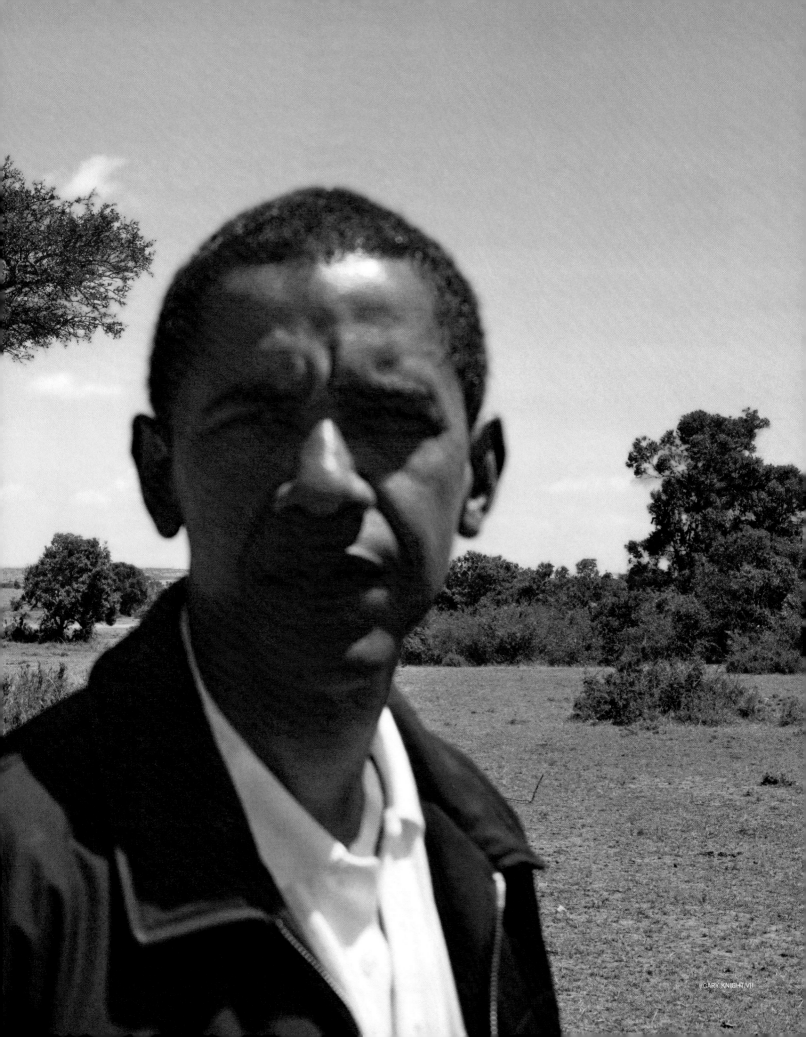

NOTHING CAN BE PREDICTED for any of us, of course. But consider: Barack Hussein Obama Jr. was born in Honolulu on August 4, 1961, to the son of a Kenyan farmer and the Kansas-born daughter of a furniture salesman. From that start in a state far from the mainland, he has risen to the heights of fame and achievement. There is much that, from today's vantage point, looks unlikely, in fact altogether remarkable, about this.

His father—with whom he shares his first name, meaning "blessed"—was from the village of Nyang'oma Kogelo, near Lake Victoria, where, as a boy, he looked after his own father's goats and attended school in a shack. He was bright and gregarious, and possessed quite a mischievous streak. As a teenager, he gained a chance to move on to secondary school, but his pranks—stealing chickens as an alternative to eating the school's food, sneaking girls into the dorm—eventually got him expelled.

Pushed into the workforce, he landed in Nairobi, the Kenyan capital, where he became involved in his country's independence movement (perhaps a precursor of his son's political inclinations?). He had met a woman named Kezia, with whom he would have two children before Barack junior's arrival, and two more much later. While working, the young Kenyan met as well a pair of American teachers who discerned in him a considerable potential. They helped him get a diploma through a correspondence course, after which he mailed a slew of letters to U.S. colleges asking for aid. Eventually, he heard back from the University of Hawaii with an offer of a scholarship. In 1959, at age 23, he arrived in Honolulu to study economics, leaving behind with his parents a pregnant wife and an infant child.

It was at the University of Hawaii, in Russian class, that he met the intense yet bashful 18-year-old Stanley Ann Dunham (she, like Barack, had been given the name of her father, who had been hoping for a son; from college on, she would be known as Ann). Hers was an old American family, dating to the Revolution and even earlier. In the recent generation, her father had worked on oil rigs during the Depression and had enlisted in the military the day after Pearl Harbor was attacked. He had served under General George Patton in the Second World War while her mother had helped build bombers back home in Kansas.

Ann and her family had arrived in Hawaii the same year as Barack Obama Sr., 1959, which was the same year, as it happens, that the islands joined the nation as the fiftieth state. Ann's life theretofore had been spent hopscotching the country on the left side of the Mississippi—Kansas, California, Texas, Washington—and now her father was lured much farther west by the promise of a business opportunity.

Though Ann's parents were liberal-leaning and were taken with her African friend's intellect, poise and endearing British accent, they were initially hesitant about a marriage. Obama's father in Kenya was outright opposed to the union, at least in part because he felt his son was neglecting the wife

On August 27, 2006, Obama visits an AIDS prevention project in northern Kenya.

and two children he already had back home. Polygamy was a part of the local culture, but there was concern among the Obamas as to whether a white woman from America could accept this life.

The details of Ann and Barack's 1961 marriage imply that it was made in haste or otherwise intentionally below-the-radar. "There's no record of a real wedding, a cake, a ring, a giving away of the bride," Barack Obama Jr. writes in his 1995 memoir, *Dreams from My Father*. "No families were in attendance; it's not even clear that people back in Kansas were fully informed. Just a small civil ceremony, a justice of the peace."

BUT IN THE RACIAL AND CULTURAL POTPOURRI that was Hawaii, Obama writes further, a mixed marriage was scarcely the sort of thing that turned heads. For a young Obama, it certainly made little difference at the time: "That my father looked nothing like the people around me—that he was black as pitch, my mother white as milk—barely registered in my mind."

Ann's parents were, in the aftermath of the marriage, sanguine about embracing her new husband. While living in Texas, they had confronted racism bluntly on several occasions, including when a mob of children taunted and jeered Ann as she lay in the front yard, reading with a young black girl. Ann's mother later told her grandson: "Your grandfather and I just figured we should treat people decently, Bar. That's all."

The marriage did not last long. Obama Sr., who graduated from the University of Hawaii in just three years and earned a spot in Phi Beta Kappa, was offered two opportunities: a comprehensive scholarship to continue his studies at The New School in New York City—which would have allowed him to bring his family with him—and a tuition-only scholarship to Harvard. The allure of Ivy was too great and so, in 1962, when Barack Obama Jr. was only a year old, his father left the family.

Though Ann eventually filed for divorce, both she and her son would continue to correspond with Barack senior in letters. But little Barack would see his dad just once more before a car accident ended Barack Obama Sr.'s life in 1982. During the

years ahead, Barack junior would become increasingly conscious of the identity chasm caused by his father's absence—haunted by the lack of a model for what kind of man he should, or should not, be. He would focus exhaustively on trying to fill this perceived void.

Much later, mostly through reconnecting with family members and having taken his first trip to Kenya, Obama would be able to piece together a glimpse of his father's life subsequent to his leaving Ann. Obama Sr. had returned to Kenya after Harvard and had prospered, working for a U.S. oil company and, later, as a government economist. His marriage to another white woman, Ruth, whom he'd met while at Harvard, produced two more children. And there were more offspring—three more boys—two of them with Kezia, the first wife, and one later with another woman.

He was said to have been a stubbornly principled man with a giving nature—both to a fault, leading to a government blacklisting and an empty wallet. He drank heavily and his temper worsened, which left him estranged from Ruth and all his children. Obama, the son, learned painfully of an earlier car accident in Kenya, which might have occurred after his father had been drinking and which resulted in the death of another man. That crash, possibly just one of several, had led to a yearlong hospitalization.

And of course, Obama learned of the final crash and the death at age 46. Barack Obama Sr. is buried today in the village where he grew up in Kenya's Siaya District.

When Obama met many of his relations during his inquiries into his African roots, he impressed them with his resemblance in manner to the late Obama Sr. "Barack was a lot like my father," his half sister Auma, Kezia's daughter, told the London newspaper *The Guardian*. "His hand movements, his gestures, how he talks, how he sits. He's got a certain quietness about him and he sits and he concentrates like my father. He can be in a room full of people and he withdraws on his own. And we've all got the Obama hands—the fingers and everything. So it was amazing to watch that, because I was meeting him for the first time but it felt like I knew him."

Two years after her husband had left the family to pursue

Barack senior and Ann: In Hawaii, an old family from Kansas and a tangled clan from Kenya come together.

his education at Harvard, Ann met another man at the University of Hawaii: a short, cool-mannered Indonesian named Lolo Soetoro. After two years of courtship, he proposed. Barack would spend the final few years of the 1960s with his mother and stepfather in Indonesia, where he took to the language and environment, and relished this new unbridled adventure, as any boy might.

Outside their house on the outskirts of Jakarta, Lolo had secured an ape named Tata, and the backyard teemed with chickens, ducks and other birds, a dog and, behind a fence, a pair of baby crocodiles. His first night there, Barack Obama watched as a hen was slaughtered for dinner and then performed its brief, headless dance before dropping to the ground.

Years later, he wrote: "I could barely believe my good fortune."

During an early trip to Kenya, Obama poses with his step-grandmother, Sarah Ogwel Onyango Obama. "Granny," as Obama calls her, was principally responsible for the upbringing of his father, Barack Obama Sr.

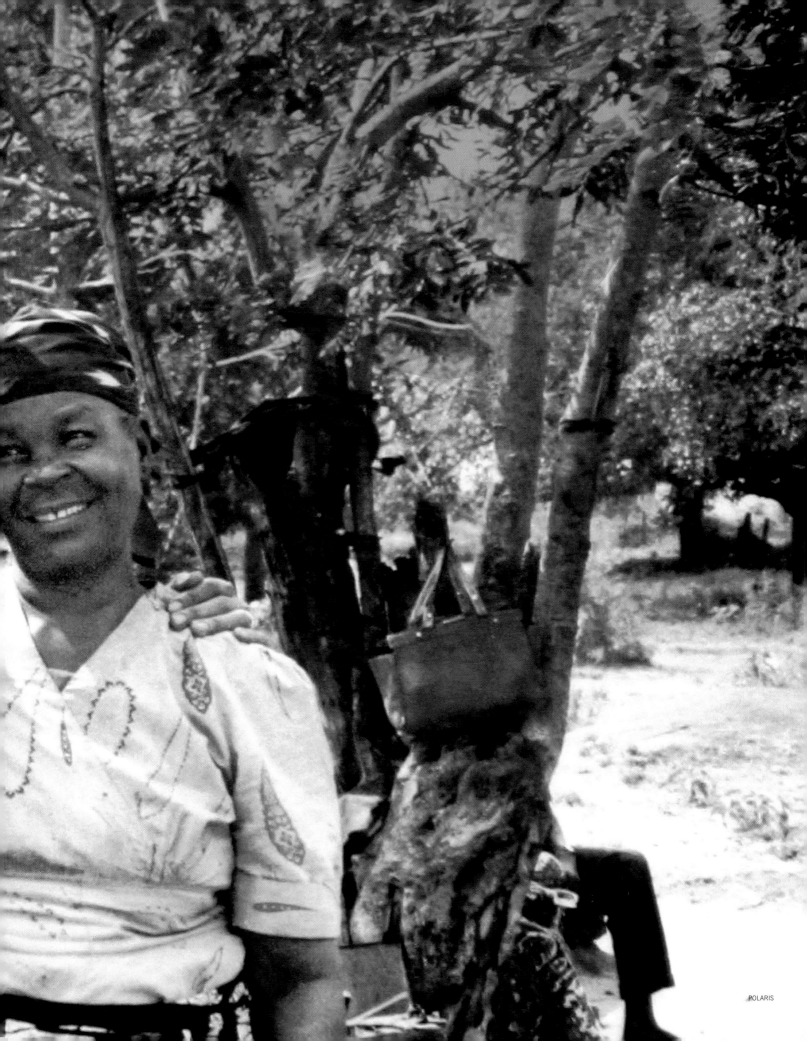

In 1987, Obama is included in a family portrait (below) during his first visit to Kenya. Standing, from left, are Barack's uncle, Said; Barack; his half brother Malik Abongo, also known as Roy; Malik's ex-girlfriend Amy; Barack's half brothers Abo and Bernard. Seated, from left, are Barack's half sister Auma; Kezia, Barack senior's first wife; Sarah, Barack senior's stepmother; and Aunt Jane. Right: On a subsequent trip, in 1992, Obama poses with Sarah outside her house.

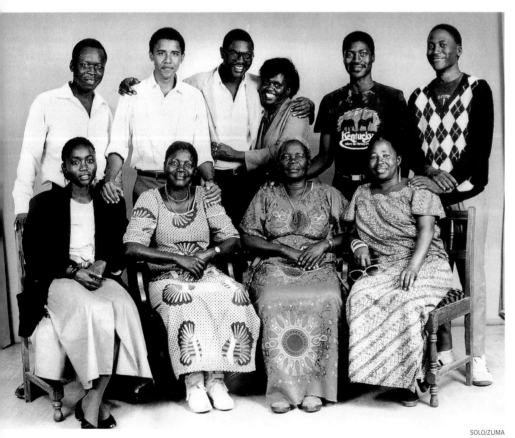

SOLO/ZUMA POLARIS

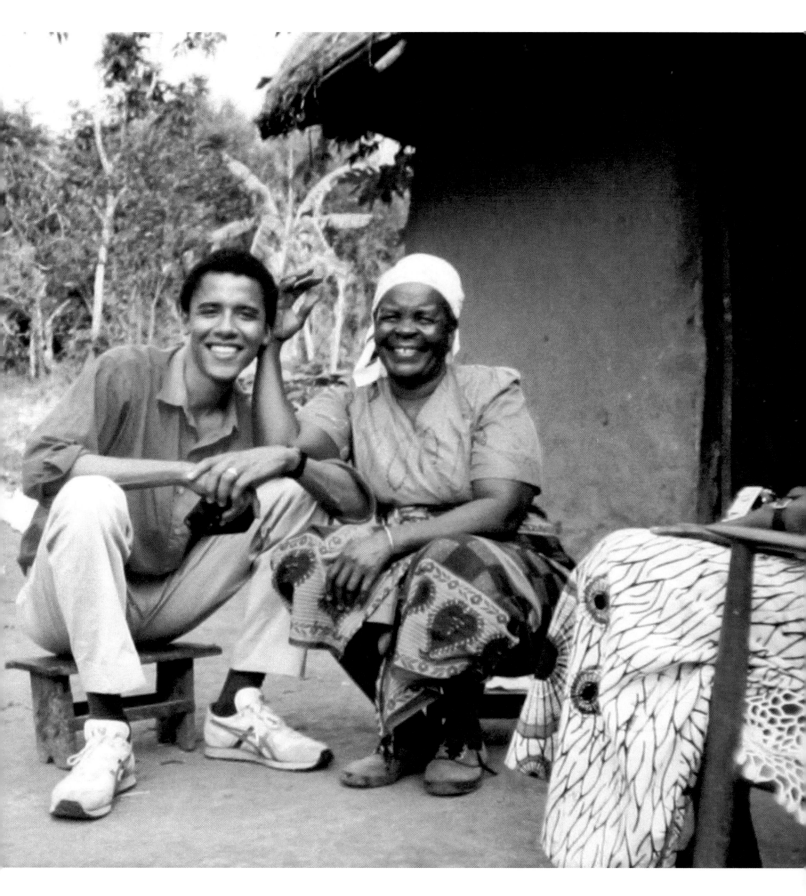

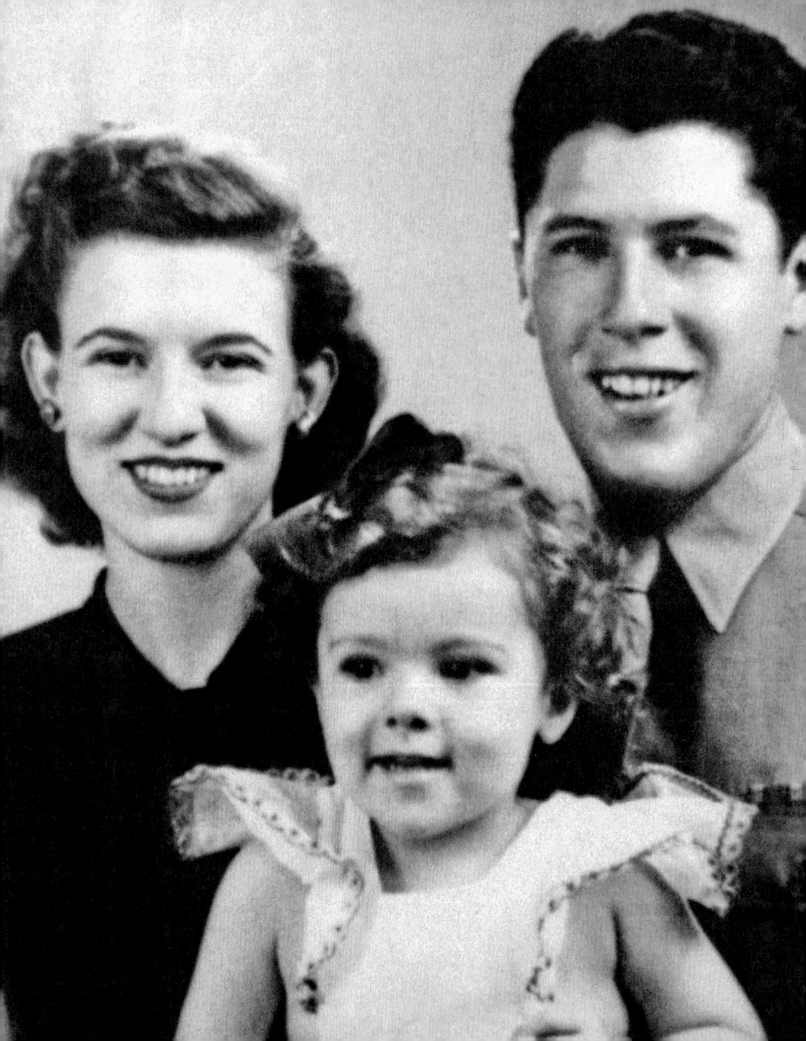

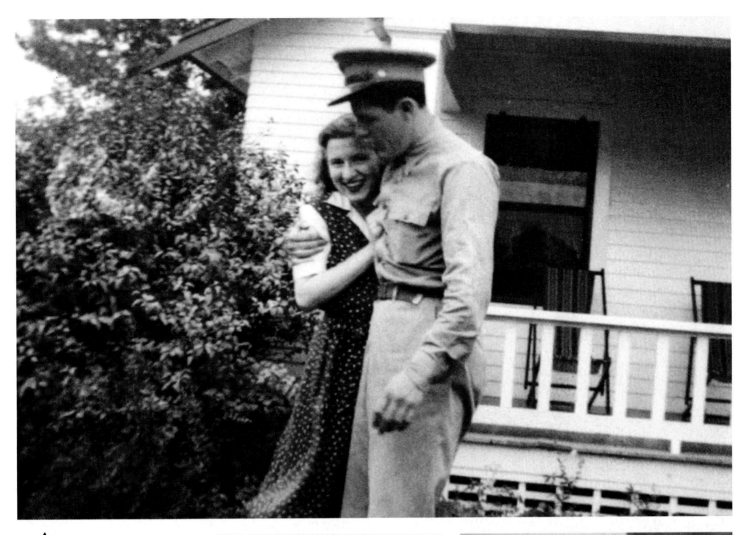

A family portrait of Madelyn, Stanley and Ann Dunham (opposite) taken in Kansas in the mid-1940s. Ann's father died in 1992 in Honolulu; he is buried in that city in Punchbowl National Cemetery. Ann, who is also seen in this yearbook photo from 1957 (right) and in a picture taken in Indonesia in the late 1970s (far right), died of ovarian cancer in 1995. Madelyn Dunham (seen again with her husband, above), Barack Obama Jr.'s maternal grandmother, lives today in Oahu, Hawaii. While the void left by an absent father perhaps underlies Obama's independence and fortitude, it was his mother and grandparents who shaped him.

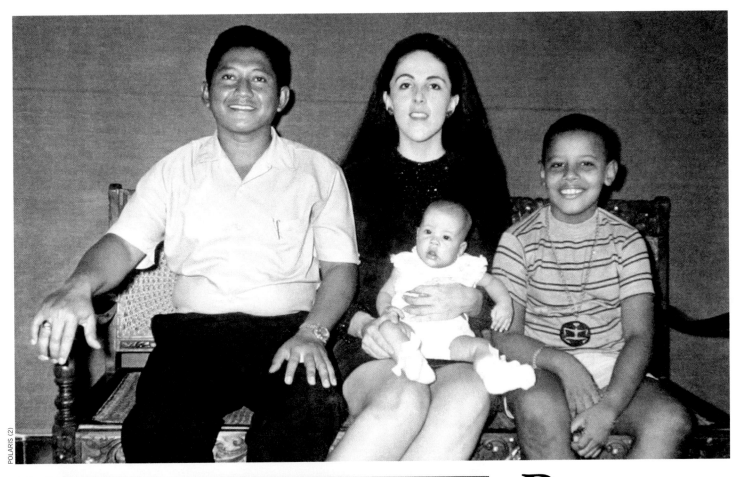

POLARIS (2)

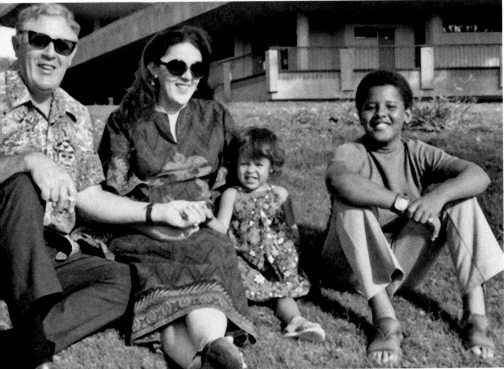

Barack Obama Sr. in Honolulu in 1962 (opposite). At this point, his American son was a year old. At about this time, after graduating from the University of Hawaii, Obama Sr. would leave the family and head for the East Coast. When Barack was 5 or 6, his mother married Lolo Soetoro, an Indonesian oil manager she met in Hawaii. In 1967, after Soetoro's student visa had been revoked because of political unrest in Indonesia, the family relocated to Jakarta, Indonesia, where the photograph above was taken in 1968. The baby is Barack's half sister, Maya Soetoro, with whom he is today very close. After four years in Indonesia, Ann sent Barack back to Hawaii to live with her parents. At left, in the early 1970s: Stanley Dunham; his daughter, Ann; and her children, Maya and Barack. "Gramps" would mentor Barry far longer than the boy's father or stepfather had.

BOYHOOD

ANYTHING MIGHT HAVE HAPPENED. A KID WHOSE FATHER HAD LEFT THE FAMILY BEFORE EXERTING ANY INFLUENCE, A KID SUDDENLY IN A FOREIGN LAND, A KID SENT BACK HOME TO LIVE WITH HIS GRANDPARENTS— ANYTHING MIGHT HAVE HAPPENED. BUT A SMART KID, AN INTROSPECTIVE KID, AN AMBITIOUS KID . . . STILL, ANYTHING MIGHT HAVE HAPPENED.

In this class photo, taken at his elementary school in Jakarta circa 1970, Barack is in the top row, dead center, in a white shirt.

L IFE IN INDONESIA WAS CERTAINLY exotic, even thrillingly strange for young Obama—how could it not have been?—but in those few years outside the U.S., Barack also would be exposed to a disturbingly raw humanity that existed in plain sight—floods and famine, suffering, poverty and even physical mutilation. Ultimately, Obama's mother would decide that this society did not offer the childhood—or the future—that she had in mind for her son. But for four of his formative years, Indonesia was home to Barack.

Lolo Soetoro had taken him under his wing as his own son, but Barack, it is made clear in his subsequent writings, was his mother's child. Ann, for her part, became determined to instill in the boy values that Obama describes as those of "secular humanism"—more philosophical, perhaps, and empathetic, less cut-and-dried, than principles that might be born of a struggle for day-to-day survival in Jakarta.

Which is not to say there weren't rules. From the start, Ann instituted a tough regimen on school days, waking Barack at 4 a.m. for tutorials in English before she left for work. And she impressed upon her son the lessons to be learned from a man she thought to be a good role model: his father. Though her former husband had grown up without means in difficult conditions, she said, he had, throughout his life, remained loyal to moral principles—he was an honest, hardworking soul. "You have me to thank for your eyebrows . . . your father has these little wispy eyebrows that don't amount to much," Obama writes, recalling his mother's words from long ago. "But your brains, your character, you got from him."

In truth, the picture of Barack senior that was presented to Barack junior by Ann was mythologized, and the absent father played little role in shaping his son, even through letters; it would be difficult to understate Ann's own influence in the boy's

development. Obama certainly realized this—if not at first, then eventually. In a preface to *Dreams from My Father,* he writes of his mother, who died very shortly after the book was published: "I know that she was the kindest, most generous spirit I have ever known, and that what is best in me I owe to her."

They were always close, mother and son, and remained so until her death; she proofread drafts of that soul-searching book even as her health was failing. Obama has said that if he had known she wasn't going to survive, the book might perhaps have been "less a meditation on the absent parent, more a celebration of the one who was the single constant in my life."

During the years in Indonesia, Ann began to introduce Barack to black culture and emphasized the values and heroes— heroes beyond his father—to be found there. She told of inequality and the struggle for civil rights in America. She quoted the words of Martin Luther King Jr. She brought black music into the home. "Every black man was Thurgood Marshall or Sidney Poitier; every black woman Fannie Lou Hamer or Lena Horne," Obama writes of his mother's teachings. "To be black was to be the beneficiary of a great inheritance, a special destiny, glorious burdens that only we were strong enough to bear."

Barack, still a boy, accepted this as the way things were, just as he accepted the portrait of his father as a great man. But at

the age of 9, he came across a magazine article about a man who had tried to chemically scrub the darkness from his skin. *Why would he? Why would anyone?* This was a harsh awakening. It created an open wound through which, as he learned more and more about prejudice and the reality of race relations in America, doubt, confusion and bitterness would enter and fester. His own biracial status was cause for years of identity confusion and loneliness.

Ann and Lolo had a daughter together, Maya, in 1970. Meanwhile Barack, with an assist from a business connection of Ann's father's, was admitted to an elite Hawaiian prep school, the Punahou School, and returned to the United States in 1971 to stay with his grandparents as he entered the fifth grade. Ann promised Barack as she sent him off that she would soon follow (and she did, with her daughter, just a little more than a year later when she separated from Soetoro).

The transition was not easy for the boy. His entry into a prep life was uncomfortable, marked by a sense of not belonging. He was one of only a few black children at Punahou; he was living without either parent for the first time; and he was adjusting to another cultural shift, this one from life in Jakarta back to life in Honolulu. And he was barely 10 years old.

THE CHRISTMAS SEASON OF 1971 BROUGHT A STRAINED, monthlong visit from both his father and mother that did little to answer any of Barack's budding questions about their relationship, about being black, about being himself. Obama remembers that his father was jovial at times during this reunion, but at other times excitable and stern. He had been in a car accident, and walked with the use of a cane; in ways physical as well as emotional, Barack senior was not the manifestation of a hero that his son had built up in his mind. The schoolboy had falsely bragged to his friends that, back in Africa, his father was a prince in a tribe "of warriors," even that the clan name, Obama, translated as "Burning Spear." Now, suddenly, this man was here in Hawaii, and invited to speak to Mrs. Hefty's class at Punahou. Barack was filled with dread, but the school visit went well enough, as his father gave an

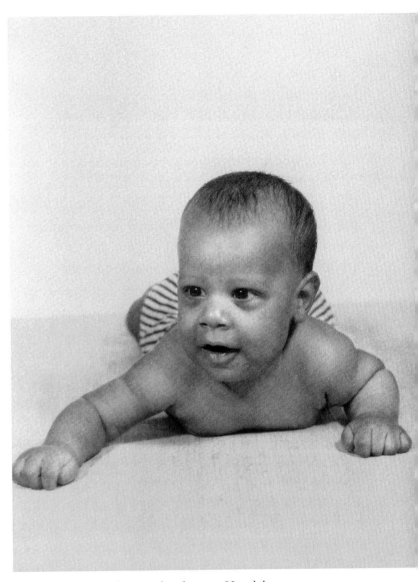

Baby Barack at home in Honolulu

engaging talk about Kenya and Kenyans. "Your dad is pretty cool," a classmate told Barry, as Obama was then called.

Father and son attended a jazz concert that month, and father presented son with a basketball for Christmas. Nevertheless, as the days passed, tension mounted in the household. Years later, Obama's mother would confide that his father, who had by then remarried and sired several more children in Kenya, had made a plea during his Hawaiian visit for the three of them—Ann, Barack junior and Maya—to join him in Africa. Ann declined. Barack would correspond with his father after that, but would never see him again.

"[W]hen I reach back into my memory for the words of my father, the small interactions or conversations we might have had, they seem irretrievably lost," Obama writes, while acknowledging that perhaps, in fact, there is little to recall. "I often felt mute before him, and he never pushed me to speak."

After Ann returned to the States with Maya in the early 1970s, she enrolled again at the University of Hawaii in pursuit of a graduate degree in anthropology. Barack moved from his grandparents' apartment and lived with her for the next few years. With their reunion, Ann resumed imparting her values to her son. Ann Dunham was, to use the clichéd phrase, a child of the '60s in that she believed strongly in the (some would say utopian) ideals of fairness and freedom. Barack remembers receiving regular refreshers on "tolerance, equality, standing up for the disadvantaged." He hardly rebelled against these notions; indeed, they resonated with him.

When Ann decided to head back to Indonesia for fieldwork that she needed to obtain her Ph.D., Barack, now a teenager, chose to stay with his grandparents. He was settling down in Hawaii and, as he told his mom, was not anxious to have to start all over again someplace else. Another, perhaps principal but unspoken factor is that he was now engaged in his search for self and felt that being on his own would allow him to ponder more deeply the question of who he was and who he wanted to be. "I was trying to raise myself to be a black man in America," Obama writes, "and beyond the given of my appearance, no one around me seemed to know exactly what that meant." So he was going to find that out for himself, by himself.

He spent his years in high school and the first half of college in a private struggle as he seesawed across a racial fault line—groping for a definition of blackness from close friends, pop stars and the movies, teammates on the basketball court, and the writings of icons such as Malcolm X. Often he saw a potential lifeline, only to have it fray under scrutiny.

Much has been made, as Obama has risen to prominence, of his nuanced, sometimes hard-to-pin-down views on race. Well, they were nuanced early on.

Beyond this deep-think stuff, Barry was a teen; life wasn't all brooding and pondering. The senator from Illinois reminisced to *Harper's* magazine in 2006 that, as a boy, he "was such a terror that my teachers didn't know what to do with me." The testimony from back in Honolulu indicates that this was an exaggeration—politicians have after all been known to embellish their curricula vitae—but Obama was without doubt a spirited kid.

He had a diverse gaggle of friends, he played basketball on the school team—earning the moniker "Barry O'Bomber" for his jump shot—and he was a member of the school's literary journal in his senior year. "He had lots of friends," Maya recalled to *Time* magazine just after Obama was elected to the U.S. Senate. She said her half brother was, in this adolescent period, already "charismatic" and "had powers."

In *Dreams from My Father*, Obama freely admits there were instances of angry, rebellion-fueled behavior: getting into fights, speeding "down a highway with gin clouding my head." He would find himself talking "about *white folks* this or *white folks* that," he writes. But then: "I would suddenly remember my mother's smile, and the words that I spoke would seem awkward and false." It was all very confusing, on an almost daily basis. Consider: The loving grandmother who helped raise him and provided balance to his life was disturbed on one occasion by a persistent panhandler who was black. Much later, in his notable March 2008 campaign speech on race, Obama recalled this incident and that his grandmother would, at times, utter "racial or ethnic stereotypes that made me cringe." What was he to draw from this, in his own home?

The basketball court, apathy, achievement, friendships, some booze, some drugs—marijuana, "maybe a little blow when you could afford it"—were all present in the turmoil that was the young Barry Obama.

Anything might still happen with this kid.

The young boy was known to family and friends as Barry.

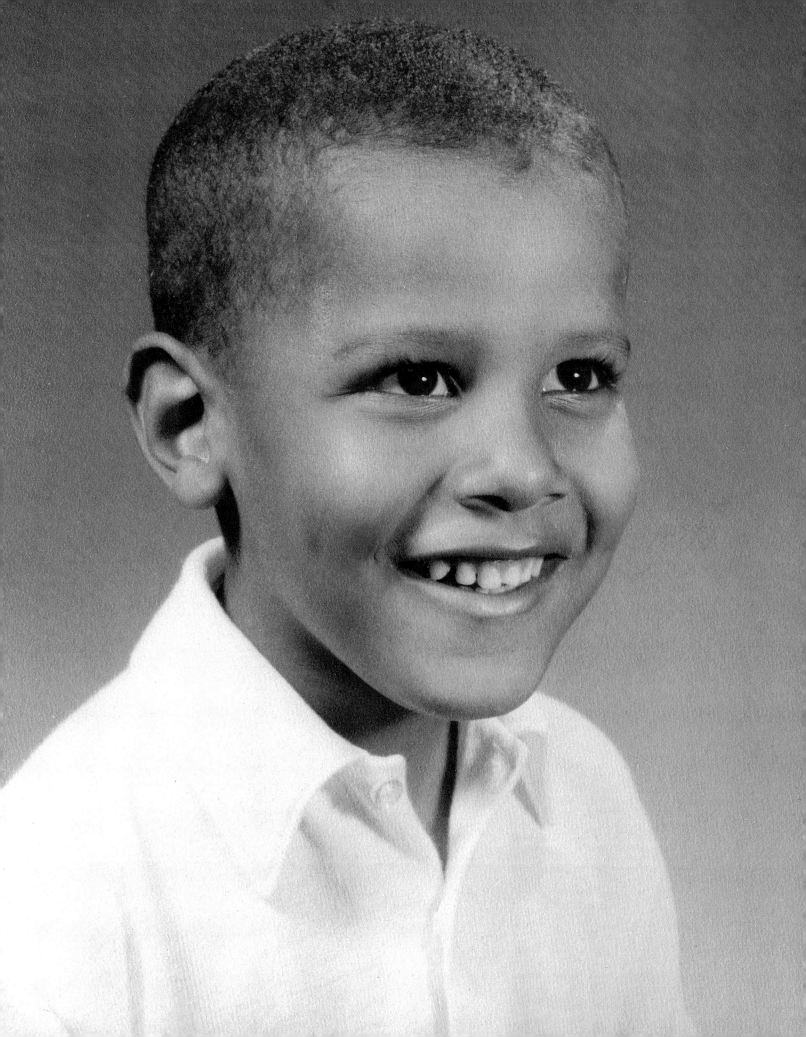

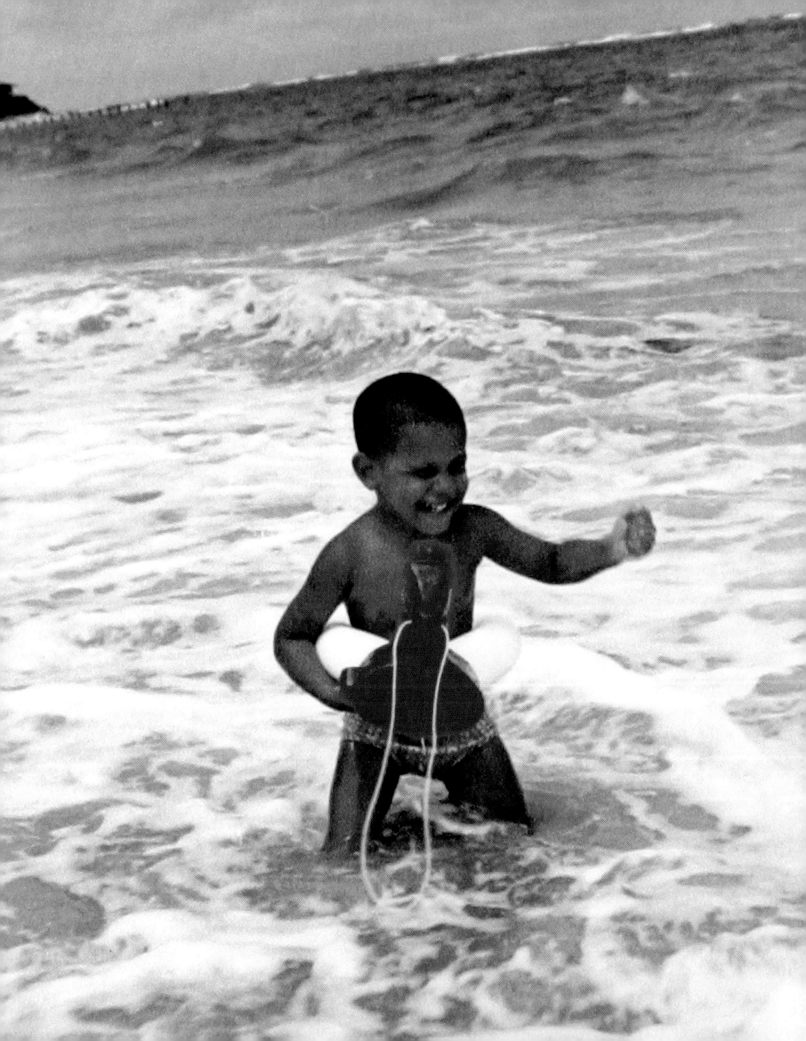

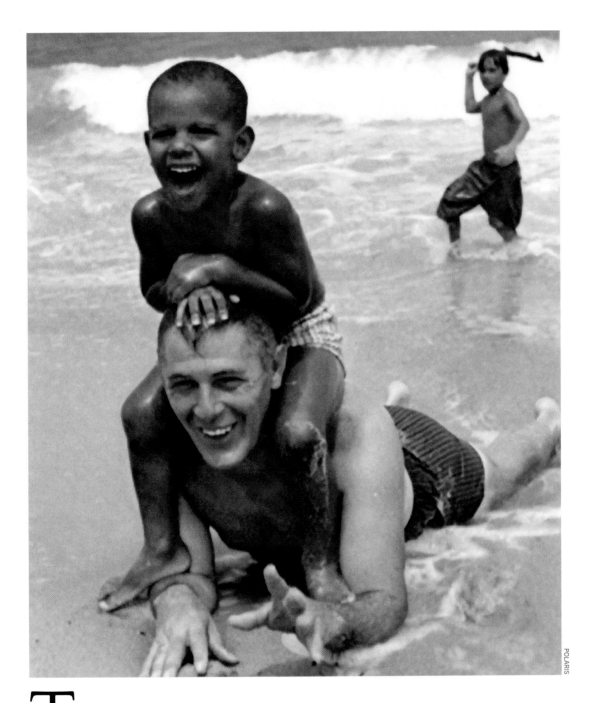

POLARIS

Two scenes from 1963 in the Hawaiian surf, the one on this page with "Gramps"—Ann's father, Stanley Armour Dunham. It is hard to overstate the role Stanley and particularly his wife, Madelyn, played in their grandson's development. Their two-bedroom apartment on the tenth floor of a very ordinary Honolulu building was a safe harbor for a boy whipsawed in his formative years between places and cultures. When Barry was 10, it was his grandfather who went to his own boss, a Punahou School alum, to help arrange for the boy's acceptance into the fifth grade there. Gramps, who dabbled in poetry and liked jazz music, fed his grandson's creative side, while his wife, a bank vice president, sought to keep the boy directed. Today, Obama's grandmother Madelyn still resides on Oahu, as does his half sister Maya. In August 2008, when the minister Rick Warren asked Obama to name people who inspired and influenced him day-to-day, the first two he mentioned were his wife and grandmother.

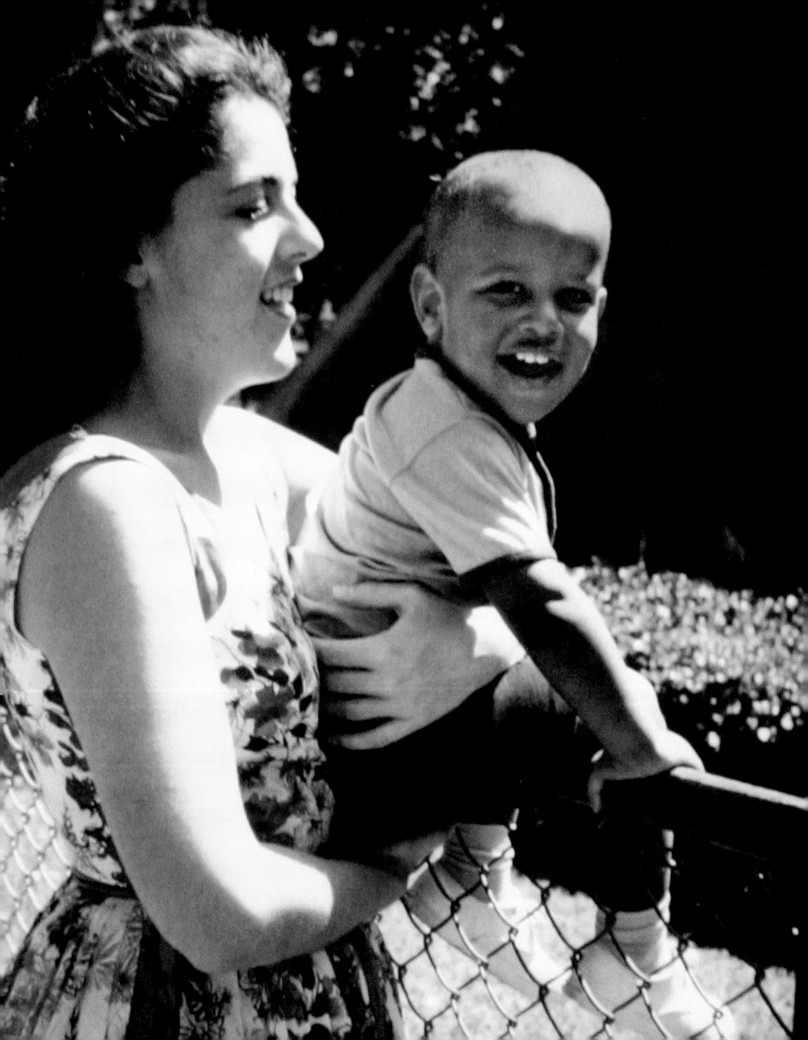

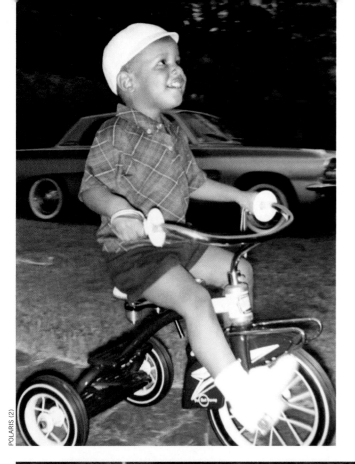

O pposite: Barry, barely 2 years old, is hoisted by his mother in Honolulu in 1963. From the start, Ann Dunham emphasized education with her son, and also emphasized that his native land was America. During the four years he was raised in Indonesia, correspondence courses from the U.S. were arranged by Ann to complement the education he was receiving in his Jakarta school. She would personally supervise his English lessons for three hours each morning before reporting to work at the American embassy. On this page are two more pictures taken in Hawaii, one before and one after Barry's time in Indonesia. Left: He takes a spin on his tricycle. Below: During a sometimes warm, sometimes tense Christmas-season visit to the United States in 1971, Barack Obama Sr. is reunited with his son. He appealed to his ex-wife, Ann, to return with him to Kenya. Although her marriage to Lolo Soetoro had soured, she understandably refused. She knew that her ex-husband had already remarried, and that there were more children; she foresaw an impossible situation.

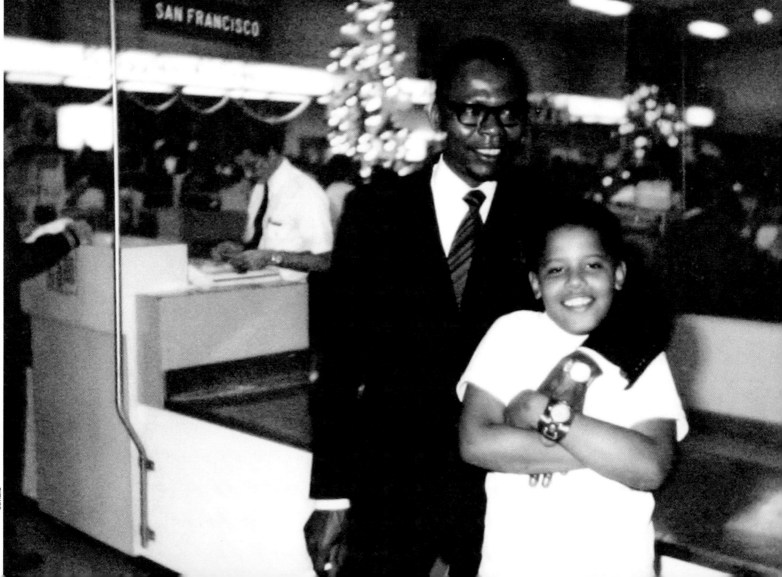

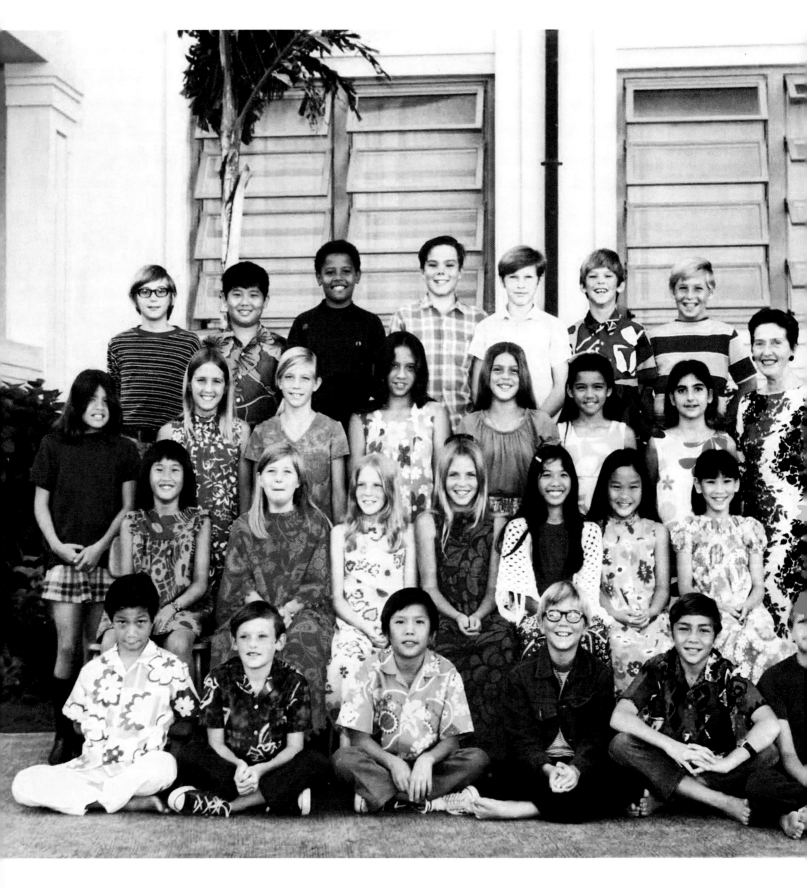

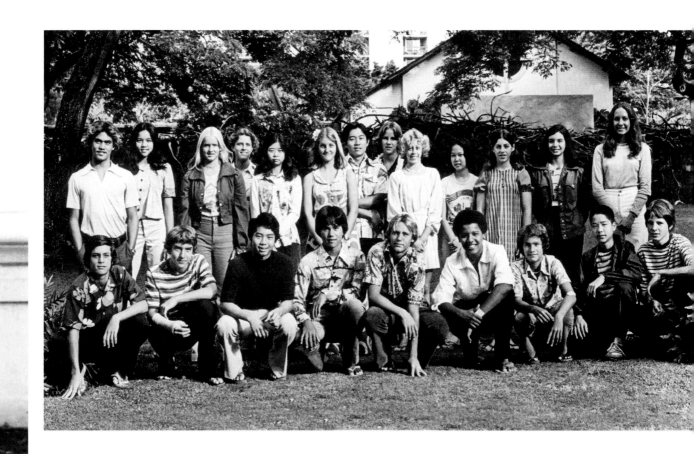

In two class pictures from the Punahou School, Barry Obama is top row, third from the left in fifth grade (left), and front row, fourth from the right in ninth grade (above). As can clearly be seen, as the son of an African man, he was an exotic. On his first day at the elite school in 1971, a little girl asked if she could touch his hair, and a boy asked if his father back in Kenya was, by chance, a cannibal.

NOW THE SCENE SHIFTS. LIKE HIS
FATHER ONCE DID, OBAMA TRAVELS
EAST IN SEARCH OF HIGHER
EDUCATION. HE FINDS IT AT SOME OF
THE WORLD'S MOST RESPECTED
UNIVERSITIES. HIS PERSONAL OUTLOOK
SHIFTS, TOO, AS HE LEAVES BEHIND
ASPECTS OF HIS ADOLESCENCE THAT
MIGHT HAVE HELD HIM BACK AND
BEGINS TO APPLY HIMSELF IN EARNEST.
AS A CONSEQUENCE, THERE IS A THIRD
SHIFT: THIS ONE IN HIS TRAJECTORY.

A YOUNG MAN ON THE RISE

In 1990, Obama, who has long wondered where he belongs, is happy and confident that he belongs at Harvard.

I N THIS NEXT PHASE OF HIS LIFE, Barack Obama Jr. comes to understand what he is pretty good at, what he is very good at and, perhaps, what he is destined for. At the very least, he comes to the realization that he is destined for a meaningful life.

As with many young people, a certain amount of his capacity for self-awareness was developed not in the classroom but on the playground. Barry Obama was not a Hawaiian skateboarder or surfer dude—he knew that—and he was a less than fair football player. But he could "play hoop," as he and his friends called it, and he played it then (and continues to today, on a regular basis) "with a consuming passion that would always exceed my limited talent." He was good enough to make Punahou's varsity, and bold enough to enter pickup games on the courts over at the University of Hawaii (where he also went, according to Maya, to "meet university ladies"). In the pickup games in particular, where the players acted however they chose, he was always making mental notes: of the coach who referred to the opposition as "a bunch of niggers," of the strutting and boasting. He was, he later recalled, "living out a caricature of black male adolescence"—but he loved being on the court.

Game over, he would head home for a pleasant family dinner with his grandparents, shuttling every evening "back and forth between my black and white worlds."

Obama left that day-by-day schizophrenia behind upon his graduation from Punahou, landing at Occidental College in Los Angeles, where he got some perspective. Occidental is situated in a plush suburban oasis near Pasadena; it's a bit of Southern Californian paradise. He saw black kids from inner L.A. who had escaped to Occidental and were busily grabbing their chance and buckling down. "I hadn't grown up in Compton, or Watts," he later wrote. "I had nothing to escape from except my own inner doubt." He still, in his early days at Occidental, tried to join this or that black clique, usually without success as he was forcing the issue: trying to be blacker than he felt, trying to prove his credibility and his worth. Then he finally came to a moment of clarity, even epiphany: He was black *and* white. He later felt that it was a lack of imagination and courage that "had made me think that I had to choose" between the two halves.

A yearbook picture from Obama's senior year, 1979, at the Punahou School.

POLARIS

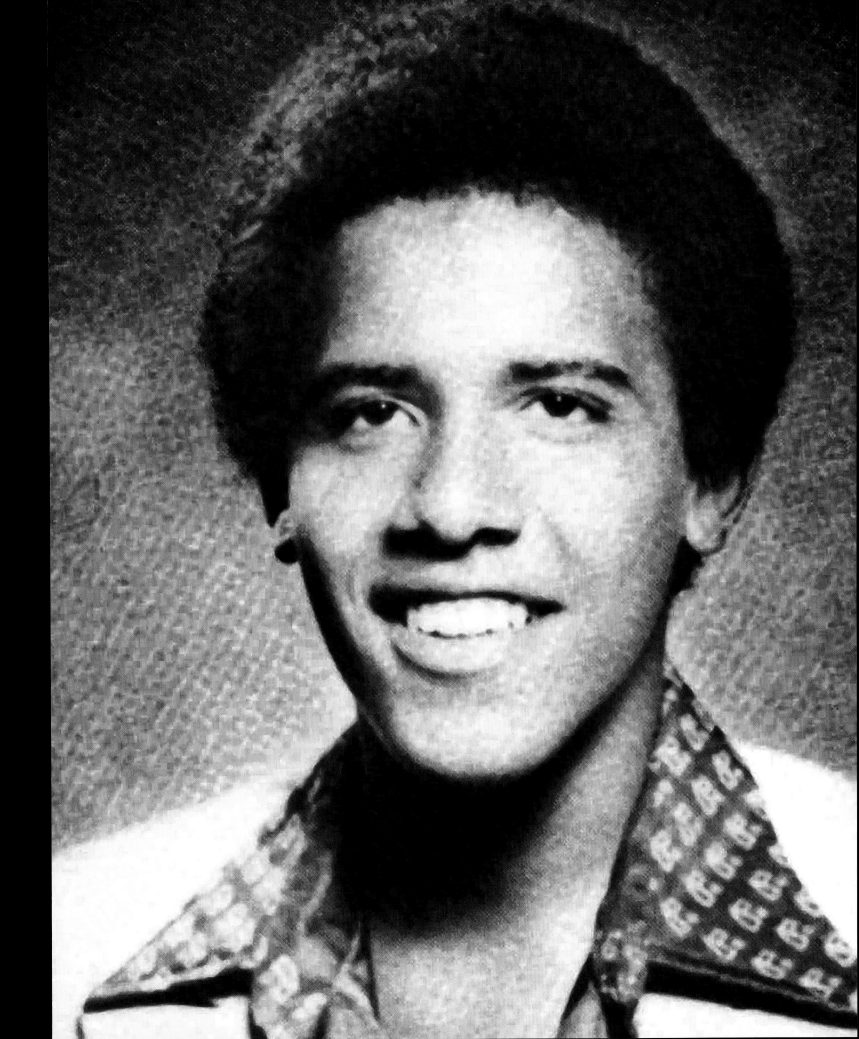

AFTER SPENDING TWO YEARS AT OCCIDENTAL, Obama transferred to Columbia University in New York City—"in the heart of a true city," in a place with minority neighborhoods, "a place where I could put down stakes and test my commitments." But more than a communion with the streets, what he found was a communion with the stacks in the library. At Columbia he pushed away from the drugs and fell into his course work. Obama also further developed a burgeoning social conscience that had been sparked at Occidental when, at one point, he took the stage at a school rally to speak out against apartheid in South Africa. Now, as he finished college, his stated goal was to become a community organizer—this despite not having the foggiest notion how such a job gets done. He was hungry to bring about change, a hunger fueled by romantic notions of the civil rights movement and a desire to be a part of something bigger than himself. He sent out letters to a passel of civil rights organizations, and heard back from none.

Therefore, after graduating in 1983, he took a job with Business International Corporation and, with his keen intelligence and drive, soon found himself making good money. He admits today that he was swayed by the allure of a big career in business, but says that it was two separate phone calls he received from his African kinfolk around that time that got him thinking again about his path. The first call from an aunt reported the death of his father, and the second, from his half sister Auma, let him know of the death of his half brother David, in a motorcycle accident.

Obama stayed put at Business International for a few more months, then abruptly quit and sent out more letters looking for community work.

It was in 1983 that Chicago's first-ever African American mayor, Harold Washington, was carried into office by an energized and empowered black electorate, an electorate burning with pride and hope. Corrosive, deep-rooted problems with violence, unemployment and barriers to quality education and city services were still a part of daily life—but that was going to change. So Harold Washington promised.

The offer to Obama in 1985 was $10,000 a year to assist laid-off workers on the South Side and generally elicit grievances in the black community and get them addressed. Obama grabbed the opportunity, and poured himself into his work—walking the beat, learning the basics of organizing: elucidating people's needs, finding the common goals among them and convincing individuals and groups to link together; learning effective ways of getting the issues heard; and navigating channels of political power and bureaucracy to bring solutions.

Though he met defeat several times in the trial-and-error process, he also scored some victories. He received publicity—and, eventually, action—for housing-project residents who were concerned about asbestos exposure. He led a successful drive to get the city to open a municipal worker-training center. He grew in the job: "What I'd lost in youthful enthusiasm I made up for in experience." It is clear now that, as he progressed, he began to formulate certain of the social-action policies of his presidential bid. Some of his speeches across the land in 2007 and '08 closely echoed talks he had given in Chicago way back when.

IN THE FALL OF 1988, AT AGE 27 and after three years spent stirring community activists in Chicago, Obama entered Harvard Law School. At the end of his first year there, he won a coveted spot (through grades and a written competition) among the 80 editors of the influential, student-run *Harvard Law Review*. During his second year, on something of a whim, he entered the fray for the *Law Review*'s presidency, which is sometimes jokingly referred to as the second-hardest-to-win electoral post in the country. Obama figured that the credential, which often is a springboard to clerkships in the U.S. Supreme Court or well-paid positions at private firms, would do little for a lawyer planning to go back to serving

community interests. But, well, what the heck: He'd give it a whirl.

Obama was a few years older than his peers, and his maturity and evenhandedness were apparent. He had gained a reputation among the political factions at the *Law Review* as a dispassionate listener, a trait that afforded both sides in an argument a modicum of comfort. They felt that their points at least might be heard and mediated, and that Obama wouldn't leave the fingerprints of his own viewpoint on the final conclusion.

On a Sunday in February 1990, the editors deliberated in private for 17 hours—while the candidates for president cooked them meals—to winnow the field of 19. When the number was finally narrowed to two, the conservative contingent decided to side with Obama. "Whatever his politics, we felt he would give us a fair shake," a former *Law Review* editor recalled to *The New York Times* in 2007. Obama became the first black president in the journal's more than a century of publishing.

As a slight foreshadowing of the clamor that would ensue nearly two decades later during Obama's bid for the U.S. presidency, this historic election attracted national media coverage. The press duly noted Obama's intriguing background, his slender frame and "boyish smile," and his confident air tempered by a gracious manner. In interviews, Obama was careful to acknowledge that he stood on the shoulders of many who had worked—and were continuing to work—to chip away racial barriers. "From experience I know that for every one of me there are a hundred, or thousand, black and minority students who are just as smart and just as talented and never get the opportunity," he told the Associated Press at the time.

That might be considered false modesty, but something else that he told the *Los Angeles Times* back then reflects a theory

Barry O'Bomber's hallmark jump shot,
on display during his senior year at the Punahou School in 1979.

that, it is now clear, he was going to investigate in his career: "One of the luxuries of going to Harvard Law School is it means you can take risks in your life. You can try to do things to improve society and still land on your feet. That's what a Harvard education should buy—enough confidence and security to pursue your dreams and give something back."

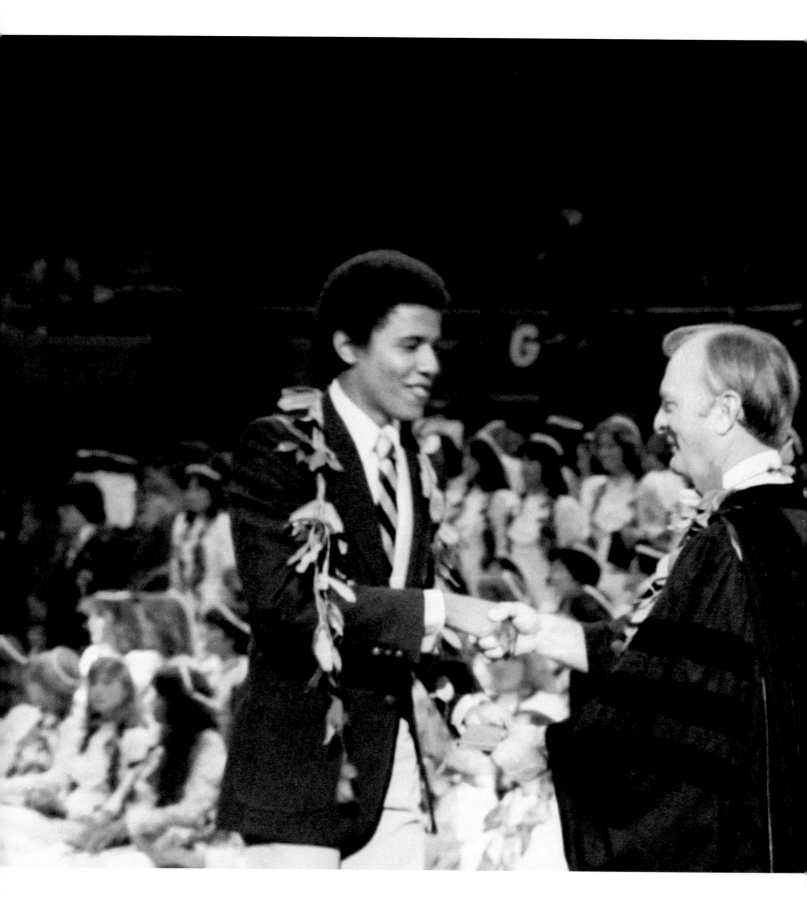

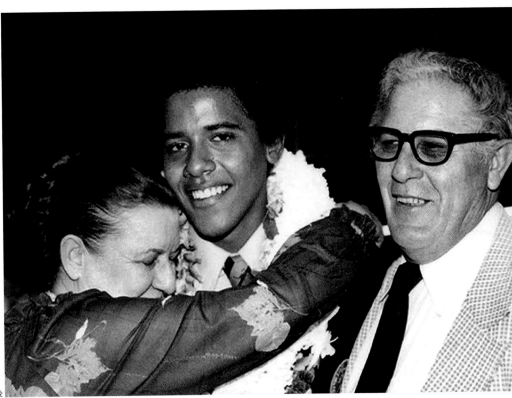

On these pages are joyous pictures from Barry's prep school graduation in 1979: receiving his diploma (left), and being congratulated by Madelyn and Stanley Dunham. Considering how large and tangled Obama's family tree is, it is nevertheless easy to see the crucial nuclear family: the maternal grandparents, seen here; Ann, the mother; and Maya, the half sister. In the notes accompanying his Punahou yearbook photo, the first two people Barry thanks are "Tut" and "Gramps." Tut, which Obama pronounces "toot," is his grandmother's nickname; it derives from tutu, which means "grandparent" in Hawaiian. Obama well knows, as he is poised to leave the nest in Honolulu and venture to the mainland—thence to the wider world—just how important Tut and Gramps have been to him.

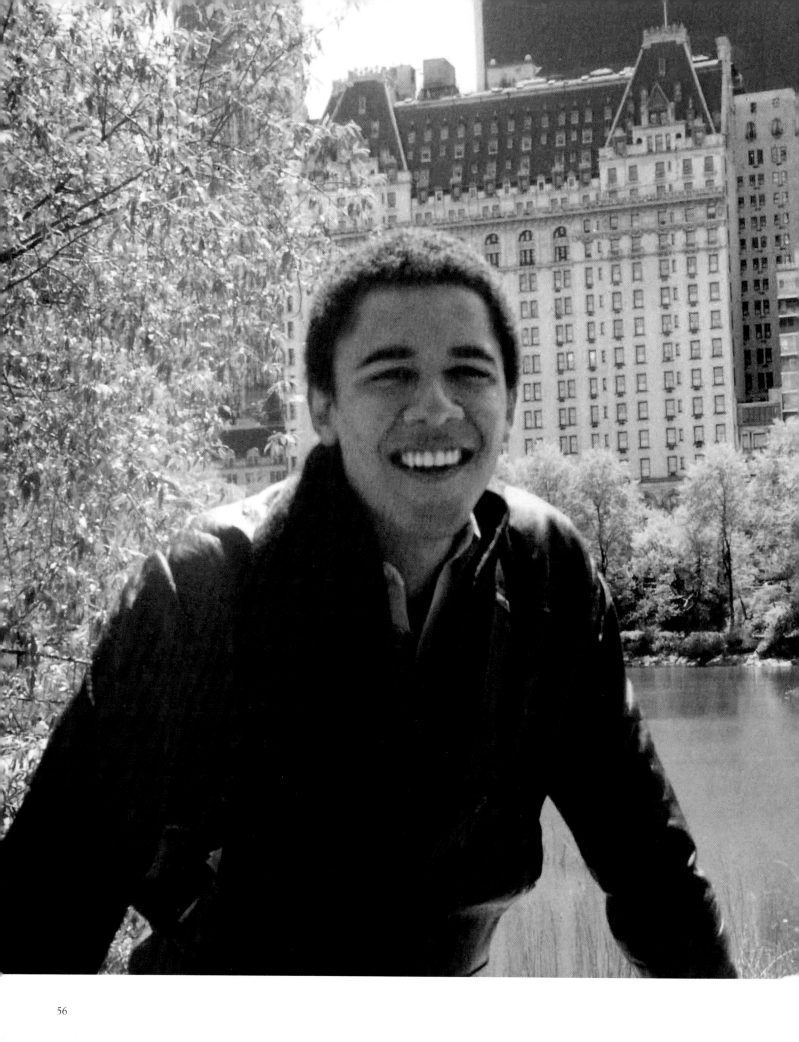

Obama went to New York expecting to be moved by the experience of the big city, but in fact his time at Columbia was spent being inspired by books and learning—if not for the first time, certainly more intensely than before. Left: He poses in 1983 on a bridge in Central Park, with the Plaza hotel in the background. Below: Maya and Barack in Java in 1987; they were there for an anthropological dig. In that same year, Obama made his first trip to Kenya to trace his father's story, and what was revealed to him was disturbing. He learned then and subsequently that political problems with the ruling party had cost his father his job, and that poverty and acute alcoholism had followed.

POLARIS

57

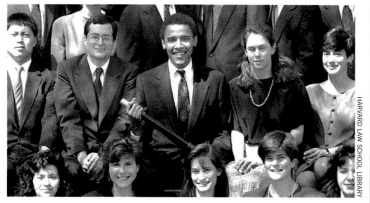

Upon his election as the first-ever black president of the Harvard Law Review in 1990, Obama experienced an early round of photo ops, which included both of these pictures. All the buzz hardly went unnoticed by fellow students, who joked about a biographical movie starring Blair Underwood as Obama. In his job helming the Law Review, a voluntary position taking up as many as 60 hours a week, Obama oversaw his fellow editors and made final decisions on the journal's content, which was generated by students, judges and legal scholars. He led, he mediated and he faced some criticism (at one point, for not naming more blacks to high positions at the Law Review). All of this was good training for . . . something.

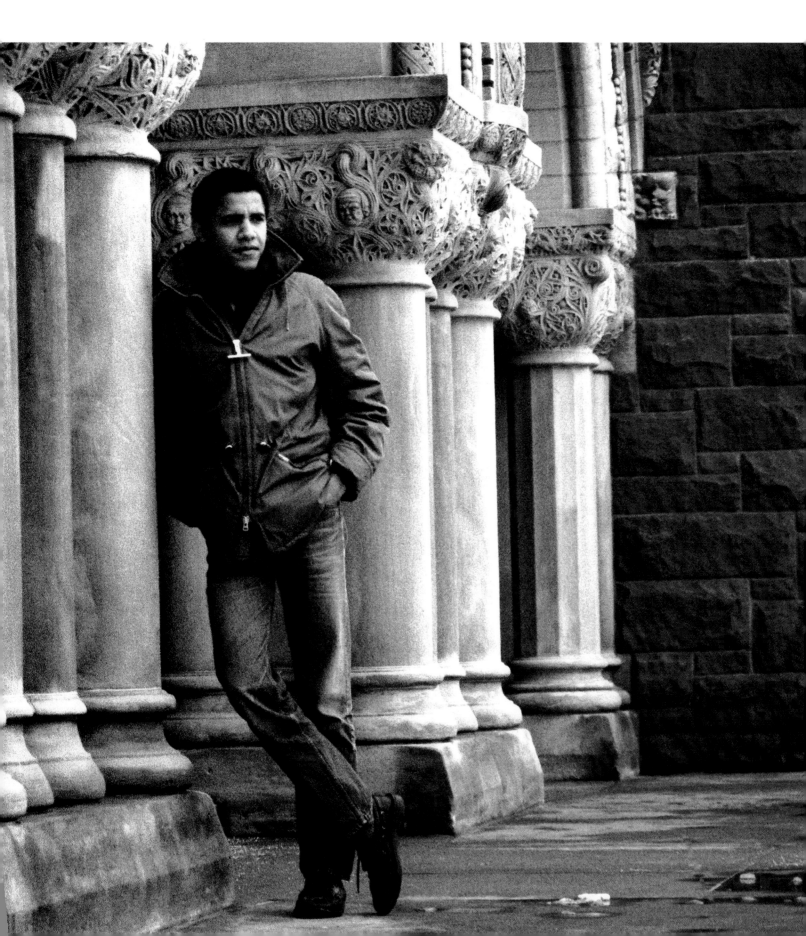

In 1995, during his campaign for state senate, Obama goes door-to-door, courting, in this case, the too-young-to-vote vote. As it happened, some of these lads would cast their first vote for a U.S. President in 2008.

MARC POKEMPNER

CHICAGO

AFTER HARVARD, HE KNEW WHAT IT WAS LIKE TO RUN FOR OFFICE. HE KNEW WHAT IT WAS LIKE TO WIN. FROM THE MOMENT HE TOUCHED DOWN IN ILLINOIS AFTER GRADUATING, HE KNEW POLITICS AND ELECTIVE OFFICES WERE IN HIS FUTURE. FROM THE VERY MOMENT HE TOUCHED DOWN—IF NOT SOONER.

Shortly before Obama graduated magna cum laude from Harvard Law School in 1991, Chicago attorney Judson Miner called the *Law Review* to offer him a job. The person who answered the phone—not Obama—told him, as Miner recounted to the Associated Press, "You can leave your name and take a number. You're No. 647."

Indeed, associating with Obama—bringing Obama aboard—would have been a coup for just about any law firm, jurist or corporate entity. As it eventuated, the Harvard grad, who had spent a law school summer interning in the Windy City, where his love of the place only deepened with experience, did return to Chicago after finishing his education. In 1991, he ran a drive that registered 150,000 black voters, which aided the campaign of Democrat Carol Moseley Braun; in 1992, Moseley Braun became the first black woman elected to the U.S. Senate.

He also began teaching constitutional law at the University of Chicago Law School, where he would continue to lecture until 2004. He is remembered as a sharp, engaging, energetic professor who liked to mix it up with students—but also as a professor who was in no way professorial. He wasn't interested in any kind of tenure track; as good a writer as he was (he was already under contract for the book that would become, in 1995, *Dreams from My Father*), he published no legal papers or treatises. It's too much to say that he acted as if he was passing through—he did put considerable energy into his work at the school—but he surely felt academia was not his vocation.

It turned out to be good that Judson Miner had made that phone call to the *Law Review,* because after finishing the voter registration drive, Obama signed on at the small civil rights firm of Davis, Miner, Barnhill & Galland. For Obama, the job presented an entree into not just law but also politics. He had by then expressed his political aspirations, and Miner would prove an important bridge to working outside the city's political machine. Miner had served as corporation counsel under Harold Washington, whose rise to power in 1983, juiced by the black community and white liberal voters, had been seen as a renegade affair by Chicago's old-school power elite. Miner's firm and Miner in particular were known for challenging the political power structure.

During his first years there, Obama spent much of his time working diligently behind the scenes, conducting research and writing briefs and other legal documents. Representative of the early cases that he assisted on was one in which the firm charged, successfully, that the state had failed to implement a law that would make it easier for poor people and minorities to register to vote. Another suit alleged that the city's ward boundaries discriminated against minorities. The firm won that case, too.

Obama settled down in the Hyde Park neighborhood, a liberal stronghold on the South Side not far from where he had first engaged in activism after graduating from Columbia. On one of his very first days in Chicago back in 1985, he had wandered into "Smitty's Barbershop," a classic of its kind on

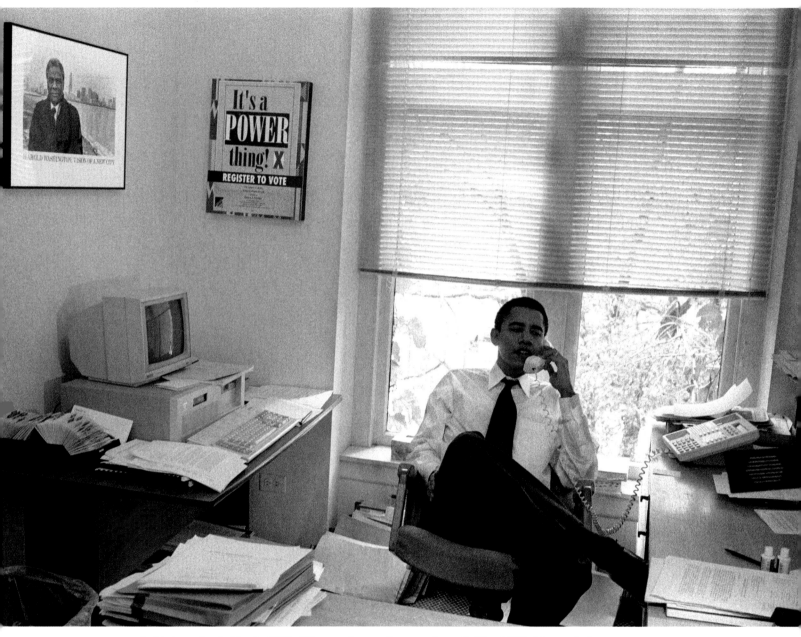

In his law school office in 1995, Obama takes a call as, on the wall, Harold Washington looks on.

the South Side. "Smitty" told him that day, "Come back a little sooner next time—your hair was looking awful raggedy when you walked in." Obama quickly became a regular at "Smitty's" and now, back in town and living in Hyde Park, he could be a regular again. (The quotation marks are explained on page 72.)

As had become his habit ever since leaving Hawaii, he got to work quickly. Through Miner and the firm, he made

connections with influential community leaders and activists. He joined the boards of charities that funded community groups. He was in motion; he was in play. He wasn't running for anything yet, but he was running.

On the personal side, "Smitty's" came back into his life, and so did some other institutions and people he had already met in Chicago.

Back in the mid-'80s, Obama had led something of a loner's

existence on the South Side. On weekends, he would often while away the time in his apartment reading. Although he had finally found, at least to some degree, the sense of camaraderie and community that he had been seeking for so long, he didn't require company—he didn't need the crowd—all the time.

But near the end of that first experience with the city, he had extended his roots deeper into a singular part of the black community by finding religion at a local church. Early one Sunday, Obama attended services at Trinity United Church of Christ on the South Side, after having reached out to the church's pastor, the Reverend Jeremiah A. Wright Jr., about working together on community issues.

He had, to this point, felt little desire to be involved in a particular religion. His father had initially identified himself as a Muslim, but spent much of his adult life as an atheist. Among his half siblings on the African side, some were Muslims, some nothing at all. His maternal grandparents were a nonpracticing Baptist and a Methodist. His mother embraced the core values of Christianity, but felt that, according to her son, "organized religion too often dressed up closed-mindedness in the garb of piety, [and] cruelty and oppression in the cloak of righteousness." Viewed through her anthropologist's prism, religion was just one "expression of human culture." She considered a familiarity with major religions required knowledge, but that was pretty much the extent of it for Ann.

Obama had inherited his mother's skepticism. As a child in Indonesia, attending a Catholic school and then a largely Muslim school, he was caught peeking during prayer ("Nothing happened. No angels descended," he writes in *Dreams from My Father*) and subsequently got in trouble for making faces during Koranic studies. His mother chided him to be respectful, but no big deal was made of the incidents. In Chicago in the 1980s, while he didn't doubt the convictions of others, he was himself wary of an instant salvation, and unable to "distinguish between faith and mere folly, between faith and simple endurance."

On this particular morning, however, Obama was moved to tears by Reverend Wright's sermon, overcome by a sense of religion's capacity to lift the individuals in the pews and allow them to transcend the pain of day-to-day life. Obama would borrow the title of that homily, *The Audacity of Hope*, for his second book.

He eventually would find faith and be baptized at Reverend Wright's church. It came about "as a choice and not an epiphany," he writes, a choice that began with him sensing that having faith did not necessarily mean he would have to shed his doubts. "The questions I had did not magically disappear," he writes.

His acceptance of religion—of faith—linked him, on multiple levels, not only to a common tradition but to a community in Chicago that was working, on the ground, for change.

So by returning to Chicago, he returned to not only his barbershop but to his church.

And then, of course, there was Michelle.

After his first year at Harvard had ended in 1989, Obama had won a summer associate position at the Chicago law firm Sidley Austin. There, he fell for his mentor, Michelle Robinson, a smart, ambitious South Side native. She was three years younger than Obama, but had settled in the firm's intellectual property group upon her graduation the previous year from, yes, Harvard Law School.

So much in common; so much to talk about.

Well, maybe.

Obama tried several times to score a date, but Michelle demurred. She even tried to set him up with her friends. She was actively attempting to give him away.

"Eventually I wore her down," the successful suitor writes in *The Audacity of Hope*, which, when you think about it, could have been the title for this particular passion play. Michelle relented, first, to Obama's offer of an ice cream cone. And then to a kiss.

The two certainly did seem to complement each other. Obama compared visiting Michelle's family to "dropping in on the set of *Leave It to Beaver*." Her father was a city employee, her mother a homemaker, her brother a basketball star. It was

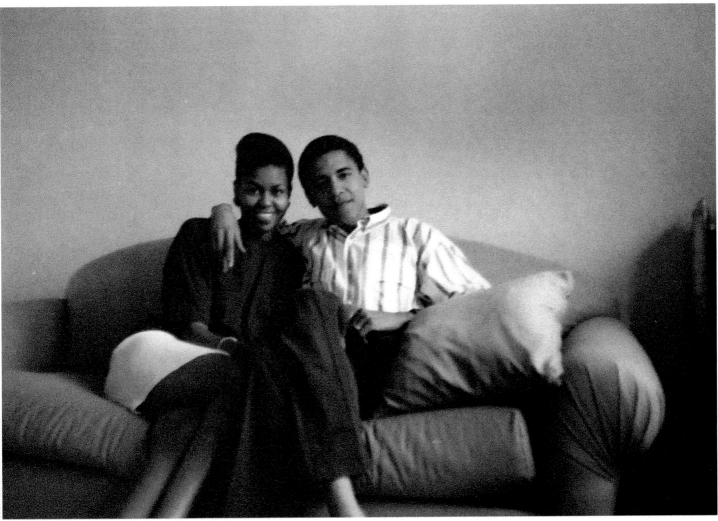

COURTESY OBAMA FOR AMERICA

The courting couple relax on the couch in the early 1990s.

all so normal and unexotic and . . . American. The almost unfathomable stability served to level out Obama's life-less-planned, and vice versa for Michelle.

Two years after Obama's first efforts at courtship, he and Michelle were married in the fall of 1992 at Trinity United. Reverend Wright presided, and he would subsequently baptize their two daughters, Malia, born on the Fourth of July in 1998, and Sasha, born three years later in June of 2001.

Obama's mother and half sisters Maya and Auma made it to Chicago for the wedding, and of course all of Michelle's family was there. The bride would tell a reporter for *The New Yorker* much later on: "Our families get along great. . . . [W]e're both Midwesterners. Underneath it all, he's very Kansas,

because of his grandparents and his mom."

"Very Kansas": a phrase theretofore never applied to Barack Hussein Obama Jr.

BY THE MID-'90s he was certainly looking *very Chicago*, and in 1995, at age 34, he saw his political opening. State Senator Alice L. Palmer, a Democrat, had decided to enter a special election to fill a vacant seat in the U.S. House of Representatives. When she assured him that she didn't intend to run for reelection to her state senate seat as a backup, Obama entered the race. But Palmer lost her congressional bid, and her supporters asked Obama to back down. He stood his ground,

creating friction among some Democrats. Palmer quickly set out to gather enough voter signatures to get on the ballot.

Once they were filed, Obama's campaign put up legal challenges against some of the signatures—not just those for Palmer, but for three other Democratic rivals as well. His audacious, hopeful move knocked all four candidates off the ballot in the primary, and Obama went on to win that race, and then the 1996 general election.

The decision to stifle Palmer's reentry by using legal challenges was a tough one, Obama has indicated. He told the *Chicago Tribune* in 2007 that parts of that campaign were "very awkward." Asked by the *Tribune* whether voters in the primary were well served by having just one candidate, Obama smiled and replied: "I think they ended up with a very good state senator." The newspaper didn't disagree and hardly seemed critical, saying the tactics showed Obama to be a quick study in the "bare-knuckle arts" of Chicago politics.

Obama arrived in Springfield, the state capital, with some ready-made enemies thanks to his confrontation with Palmer. On top of that, as a newbie he was subjected to a certain amount of hazing and was expected to keep a low profile. Despite the static, he made some allies in high places and showed a propensity for finding compromises to get bills passed—among them, a campaign finance reform bill that banned most gifts from lobbyists and the personal use of campaign money by legislators.

But he got restless, a condition he describes as "chronic" (and critics say implies unreliability). He jumped at the opportunity to run for Congress in 2000. This proved a disastrous mistake, one that, even midway through the campaign, he was well aware of. In the aftermath, he was left feeling rejected by the community.

His opponent was incumbent U.S. Representative Bobby L. Rush, a former Black Panther who had lost a Chicago mayoral race the previous year. Thinking that Rush's defeat signaled a deficit of support, Obama challenged him for the congressional seat. "It was a race in which everything that could go wrong did go wrong," Obama writes in *The Audacity of Hope*. Obama commissioned a poll shortly after launching his campaign that showed his opponent's name recognition and approval ratings were sky-high, but his own lingered in or near the single digits. During the race, Rush's adult son was shot and killed, and later Rush's father died, certainly bringing the candidate due sympathy. Then, while Obama was on a Christmas trip with his family to visit his grandmother in Hawaii, his daughter Malia, 18 months old, became sick and was unable to fly, delaying his return home. Obama missed a vote on gun control legislation that just narrowly failed. Add to all this his Ivy League pedigree and work as a law lecturer at the University of Chicago, which gave him the sheen of an elitist outsider, and Obama was in trouble.

"I arrived at my victory party to discover that the race had already been called," he writes in *The Audacity of Hope*. Rush had clobbered Obama, his closest competitor in the primary, by a 2-to-1 margin.

The race, looked upon in hindsight, is not without interesting footnotes. Obama had performed admirably in fundraising, hinting at his potential in that realm. And although he lost much of the black vote to Rush, he did well among some white liberals.

Crushed by the defeat and having spent the money he'd raised and then some, Obama returned, in a decidedly desultory way, to the state senate. The excitement of debates and of greeting supporters was now replaced by the realities of "begging for money," mercilessly long hours and the "clipped phone conversations with a wife who had stuck by me so far but was pretty fed up with raising our children alone and was beginning to question my priorities." It's stunning to think now, considering what has happened since, but Barack Obama started to wonder whether it was time to hang up his gray suit.

He decided it was not, and proceeded to do what a good legislator does: his job. In the state senate, he redoubled his efforts and over the next few years—especially after the Democrats regained control of the chamber in 2002—shepherded some important bills, including one mandating that interrogations in all capital cases be videotaped, another expanding access to healthcare and a third to monitor racial profiling at police traffic stops.

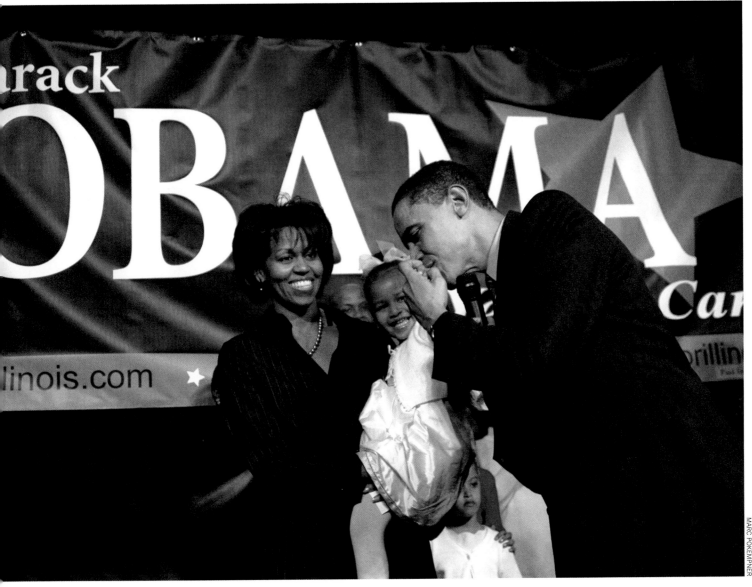

The Obamas celebrate Dad's U.S. Senate primary victory in 2004.

IN OCTOBER OF 2002, Obama was invited to give a speech at a local antiwar rally, little more than a week before lawmakers in Washington would vote to authorize the use of force in Iraq. He took the opportunity to set himself apart as an early detractor. There could be no predicting at that point in time, when much of the country and the Congress was supporting President Bush, just how fateful that decision would become.

The rush to military action, he said, amounted to a "war based not on reason but on passion, not on principle but on politics." He went on: "I am not opposed to all wars. I'm opposed to dumb wars."

After having had trouble connecting verbally with voters in his 2000 congressional bid (his penchant for detailing the minutiae of policy was bloodless in the extreme), this speech showed some of the oratorical acrobatics—the well-placed swells, the ministerial cadence and elegant turn of phrase—that would become Obama hallmarks and help fuel his meteoric rise. In an irony, his declaration of antiwar was closer to

67

his amateur attack on apartheid while a student at Occidental College than it was to his recent performances as a "professional politician." And, to boot, it would put him, politically speaking, on the right side of the argument—once the Democratic Party turned against the war.

Around this time, Obama began weighing another political leap: this time, to the U.S. Senate. His pitch to Michelle, who had never warmed to the idea of a life revolving around politics, was, as he writes in *The Audacity of Hope:* This was the one last-ditch effort "to test out my ideas before I settled into a calmer, more stable, and better-paying existence." If that sounds a little like Ralph Kramden pleading with his wife in an old *Honeymooners* episode—"This is the big one, Alice!"— so be it. In any event, it worked.

There was plenty of competition for the seat being relinquished by U.S. Senator Peter G. Fitzgerald. Among the seven Democratic hopefuls were the state comptroller as well as a multimillionaire, Blair Hull, who said he was prepared to spend up to $40 million of his own cash.

For Obama, this race would turn out to be the obverse of the 2000 contest: Everything went right. He didn't reach the head of the Democratic pack until the final weeks of the primary season, when, out of the blue, Hull was whacked by allegations of abuse by an ex-wife. Obama's camp launched a late media blitz, and when the smoke had cleared he was in possession of more than 50 percent of the vote. Another electoral postscript worth noting: His support had come from blacks and whites alike, from inside and outside the city.

He caught another big break in the general election when his Republican opponent, Jack Ryan, bowed out of the race in late June, just four months ahead of the vote. This time, the downfall was brought about by newly unsealed divorce records containing allegations by his ex-wife regarding trips to sex clubs. An entirely unpredictable profusion of peccadilloes seemed to be paving Obama's highway to Washington; his opponents were exploding like so many Spinal Tap drummers. Obama was blissfully unopposed for six weeks while Republicans scurried for a replacement candidate. Finally, the conservative Alan Keyes agreed to uproot himself from Maryland to fill the gap. Even many Republicans found him impossibly alienating.

That general election is not remembered as much of a race, aside from its bizarreness, but it should be said: It was a historic race. This marked the first time in U.S. history that two African Americans dueled as major-party nominees for a seat in the Senate. Obama ended up trouncing Keyes by the widest margin for a Senate race in Illinois history, collecting 70 percent of the vote to Keyes's 27 percent. A postmortem in the *Chicago Tribune* said that the landslide relegated Keyes to the same class of "losers" as the 1962 Mets, Wile E. Coyote and the *Titanic,* and that assessment seems just about right.

The victory meant that Obama, once seated, would be the Senate's sole African American member, and just the third ever to be sent to that chamber by popular election. But before that substantial bit of excitement on inauguration day, there would be another.

IN THE MIDST OF THE RACE, Obama, his reputation spiraling upward like a brilliant shot from a Roman candle, was asked to be the keynote speaker at midsummer's Democratic convention. John Kerry would be the star of the show, surely, but Barack Obama would have his moment to shine.

Backstage in the moments before he was to take the stage, Obama began to feel in his gut just how big of a deal this was. His wife was comforting, in her fashion. "Just don't screw it up, buddy," Michelle said.

He did not.

Obama's electrifying speech, a spirited call for unity that brought supporters to their feet, catapulted him into the national spotlight. One moment Obama was the semi-anonymous guy who was getting lucky out in Illinois with the great-vanishing-opponents phenomenon, and the next he was known to one and all. This was not just a political happening, it was a cultural one. At workplace watercoolers throughout the land, folks gathered the next morning to ask one another, "Did you see?"—just as they had on the morning after Michael Jackson moonwalked on the Motown 25th anniversary special.

"The pundits like to slice-and-dice our country into red

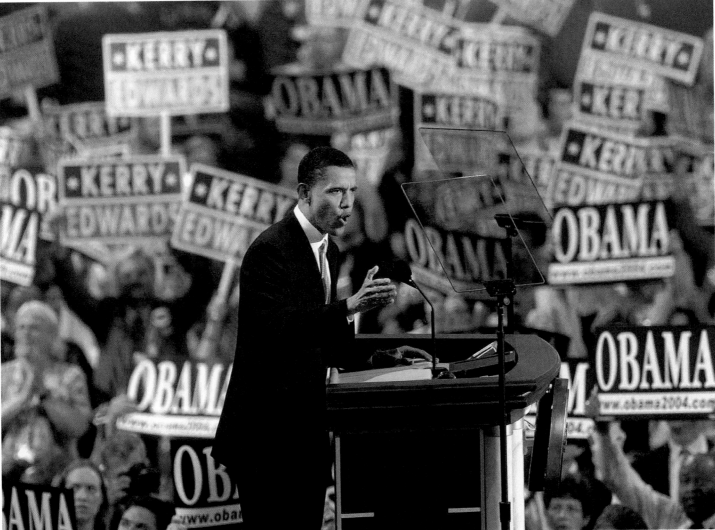

In Boston in 2004, at the Democratic convention, Obama arrives as a national figure.

GRETCHEN ERTL/PROVIDENCE JOURNAL

states and blue states; red states for Republicans, blue states for Democrats," Obama told his revival-meeting audience. "But I've got news for them, too." He paused; his voice rose. "We worship an 'awesome God' in the blue states, and we don't like federal agents poking around in our libraries in the red states. We coach Little League in the blue states and, yes, we've got some gay friends in the red states. There are patriots who opposed the war in Iraq and there are patriots who supported the war in Iraq. We are one people, all of us pledging allegiance to the stars and stripes, all of us defending the United States of America."

He linked the upcoming election to a shared, intrinsic,

nationalistic sense of hope, which included "the hope of a skinny kid with a funny name who believes that America has a place for him, too."

Obama was now a rock star. Between the speech and his leap to the U.S. Senate, his name began, instantly, to be mentioned in the context of the White House. But on his first day as a senator-elect, Obama demurred when asked about any presidential ambitions for 2008. "My understanding is that I will be ranked 99th in seniority," he said. "I am going to be spending the first several months of my career in the U.S. Senate looking for the washroom and trying to figure out how the phones work."

At the University of Chicago Law School in 1992, Obama is (of course) a charismatic teacher; he would continue to work there for more than a decade, even into 2004 after he had begun his run for the U.S. Senate. He did it for the students, and also for himself. "The great thing about teaching constitutional law is that all the tough questions land in your lap," he told a New Yorker reporter in '04. "Abortion, gay rights, affirmative action. And you need to be able to argue both sides. I have to be able to argue the other side as well as [Supreme Court Justice Antonin] Scalia does. I think that's good for one's politics." His summation: "Teaching keeps you sharp."

Why, *in the early part of this chapter about Obama's Chicago experience, did we put quotation marks when referencing "Smitty's Barbershop"? Because there is no "Smitty's." In his memoirs, Obama gave aliases to many places so that they would not become tourist stops for people wanting to trace his story. His fame has become such that many of these locations have been revealed anyway, and here we see Obama getting a trim in the Hyde Park Hair Salon, a.k.a. "Smitty's," which was owned not by a man named Smith but by Abdul Karim Shakir. Obama dropped in for a trim—no appointment necessary—on an almost weekly basis for 20 years. Muhammad Ali, Mayor Harold Washington and other luminaries were also regulars. The storefront barbershop, a pillar of community life for 80 years at the corner of East 53rd Street and South Harper Avenue, was forced to relocate in 2007 when the University of Chicago sold the building in which it was housed to a commercial developer.*

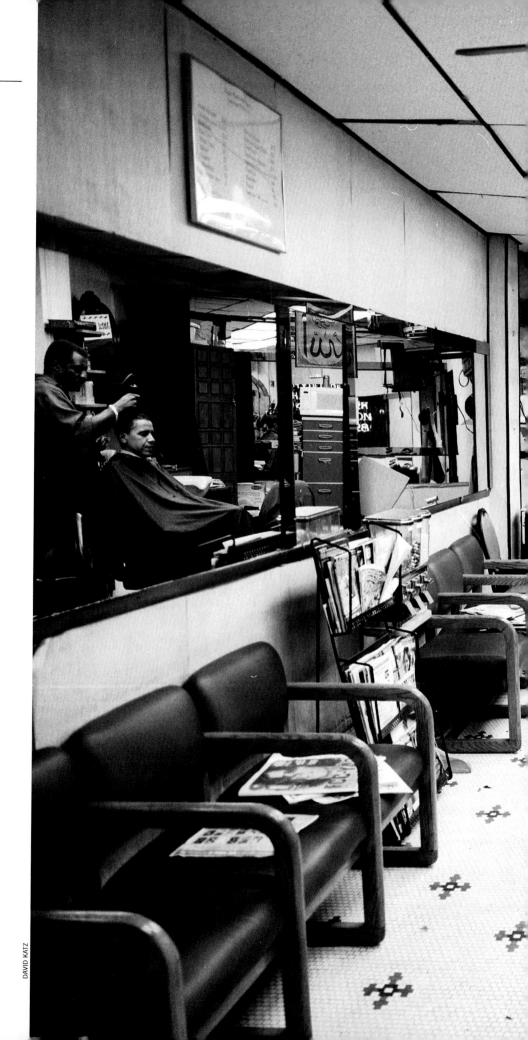

DAVID KATZ

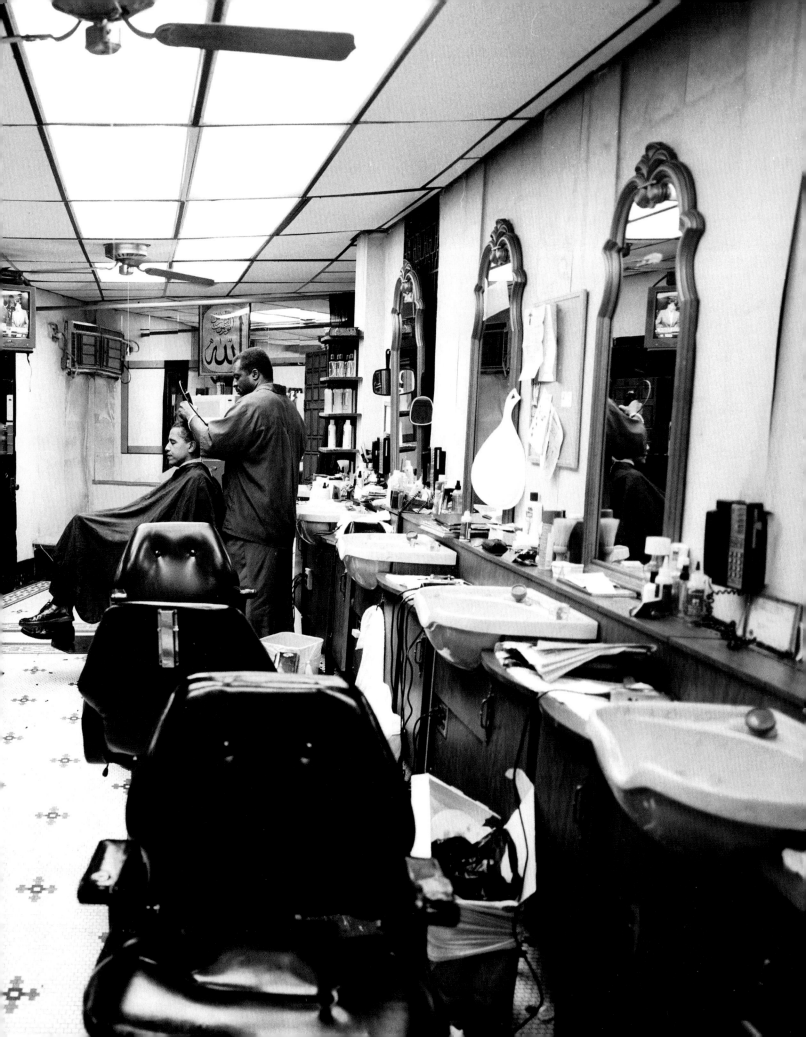

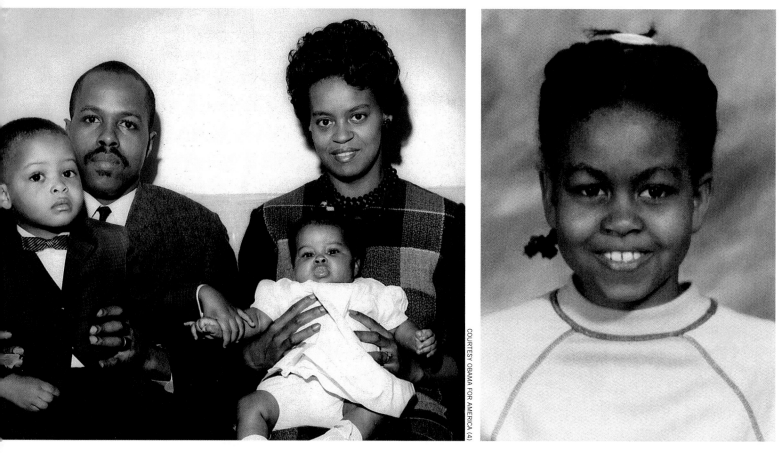

COURTESY OBAMA FOR AMERICA (4)

BARRY BRECHEISEN/GETTY

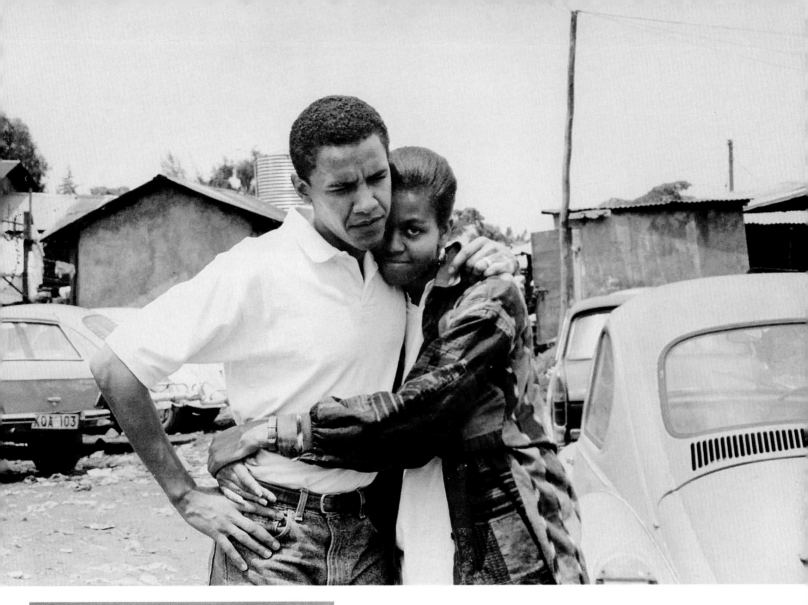

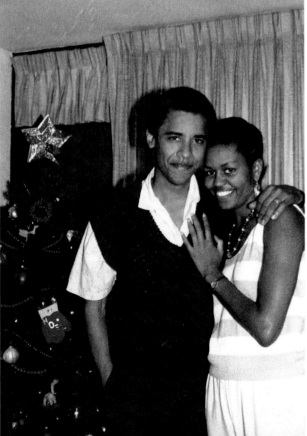

The little girl who would become the love of Barack Obama's life and the mother of their children was Michelle Robinson, who grew up in a family of four on Chicago's South Side. *Opposite, top left:* Baby Michelle in 1964 with her parents, Fraser and Marian, and her older brother, Craig. *Top right:* Michelle the schoolgirl. *Bottom:* The family home in a blue-collar, largely black neighborhood; her father was a precinct captain at the municipal water department and her mother a housewife. Life there was happy, day after day; Michelle contrasted it with her husband's upbringing for a *New Yorker* article in 2004: "He had this mixed-up, international childhood, while I was Chicago all the way. My grandmother lived five blocks away. Ozzie and Harriet, Barack says." When he remembers the allusion, Obama usually cites Leave It to Beaver. Michelle also told The New Yorker: "I was just a typical South Side little black girl." Well, she was anything but typical, exceedingly bright and vivacious. She followed her brother, a basketball star, to Princeton University in New Jersey. She graduated cum laude in 1985 and proceeded to Harvard Law School. When Michelle returned home, she went to work for a corporate law firm, where she met Obama when he arrived as a summer associate in 1989. *On this page:* The dating couple at Christmastime, 1989 (left), then, in 1992, the affianced couple during one of Barack's sojourns in Africa (above).

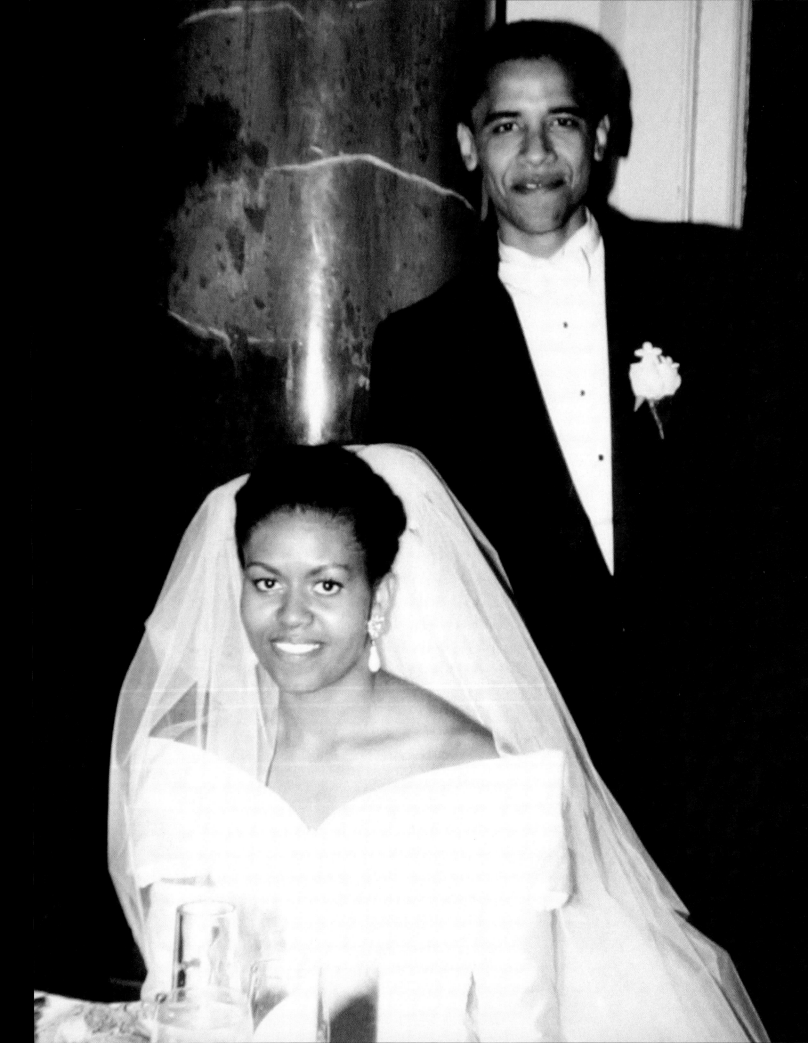

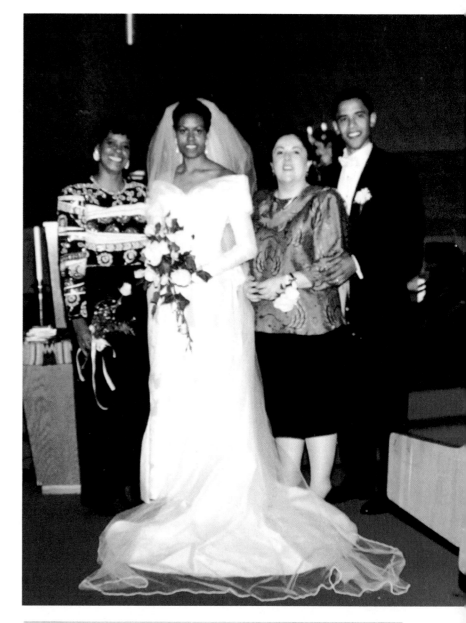

They were wed on October 18, 1992, in Chicago's Trinity United Church of Christ, where they were both congregants, Reverend Jeremiah A. Wright Jr. officiating. In the photograph at right, the happy couple pose with their proud mothers, Marian Robinson and Ann Dunham. Michelle certainly knew what she was getting into by the time she married Barack, but when he broached a political run for a state office not too long after they married, she was hesitant. She later recalled the incident: "I said, 'I married you because you're cute and you're smart, but this is the dumbest thing you could have ever asked me to do.'" Michelle was skeptical about subsequent campaigns waged by her husband as well. But by the time he announced his run for President, she was all in.

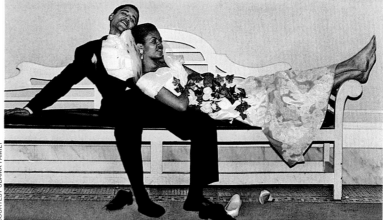

COURTESY OBAMA FAMILY

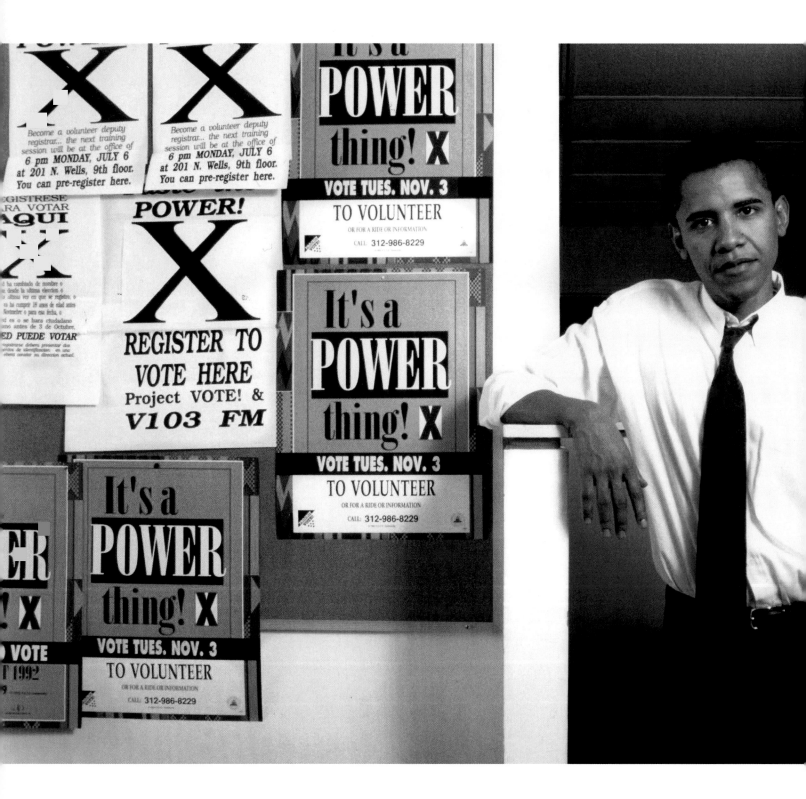

POLARIS

MARC POKEMPNER

Many in the South Side district where Obama had worked as an organizer during his first tour of Chicago remembered him when he returned to tell them, in 1995, that he was seeking their support in his run for state senate. Obama remembers the time in his second memoir, The Audacity of Hope: "I entered the race and proceeded to do what every first-time candidate does: I talked to anyone who would listen. I went to block club meetings and church socials, beauty shops and barbershops. If two guys were standing on a corner, I would cross the street to hand them campaign literature." Below: He gets two women to sign his nominating petition. Left: He strikes a pose during the earlier voter-registration campaign. On the following pages: Obama goes one-on-three on the South Side, flashing a smile and seeking support. All this effort, some of it more fun than the rest, paid off with a victory.

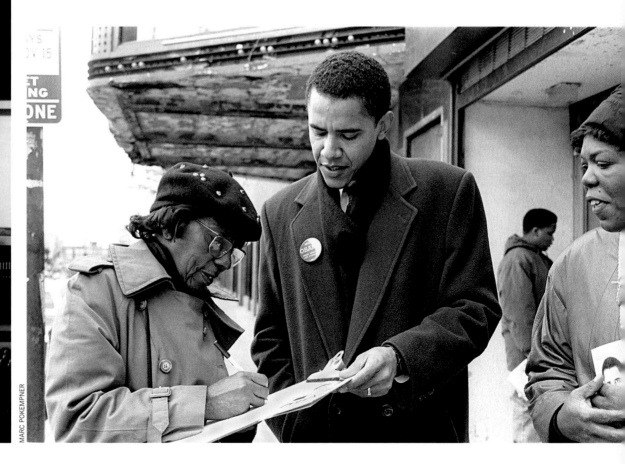

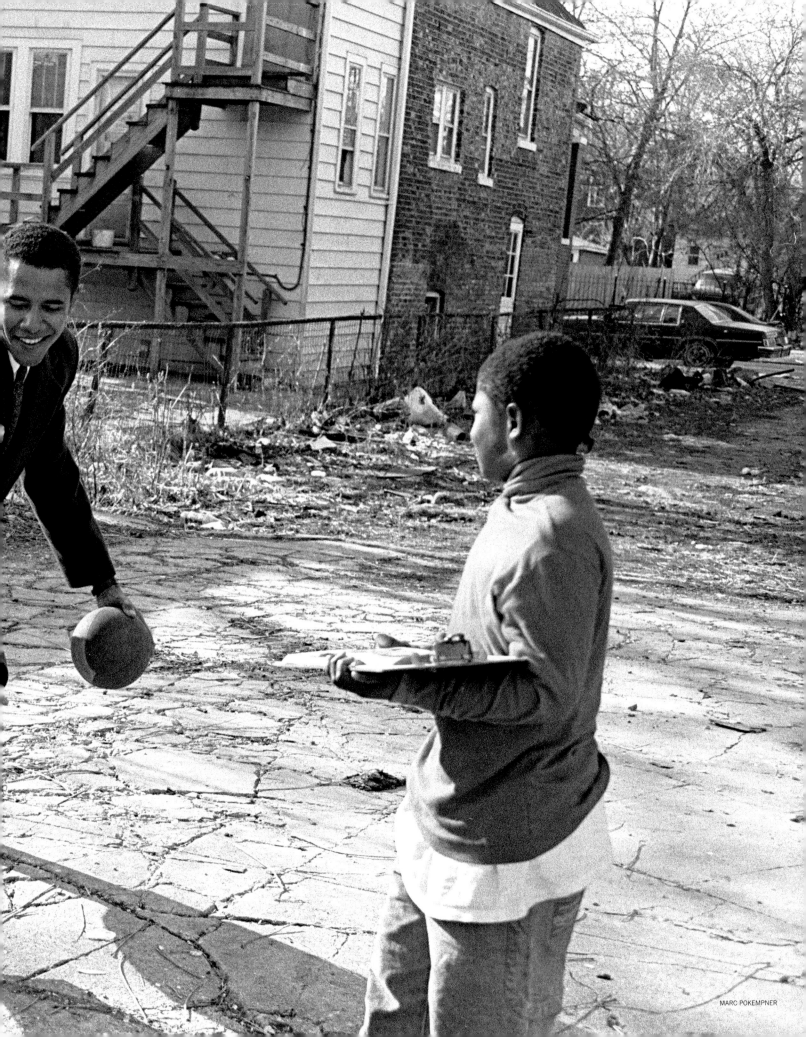

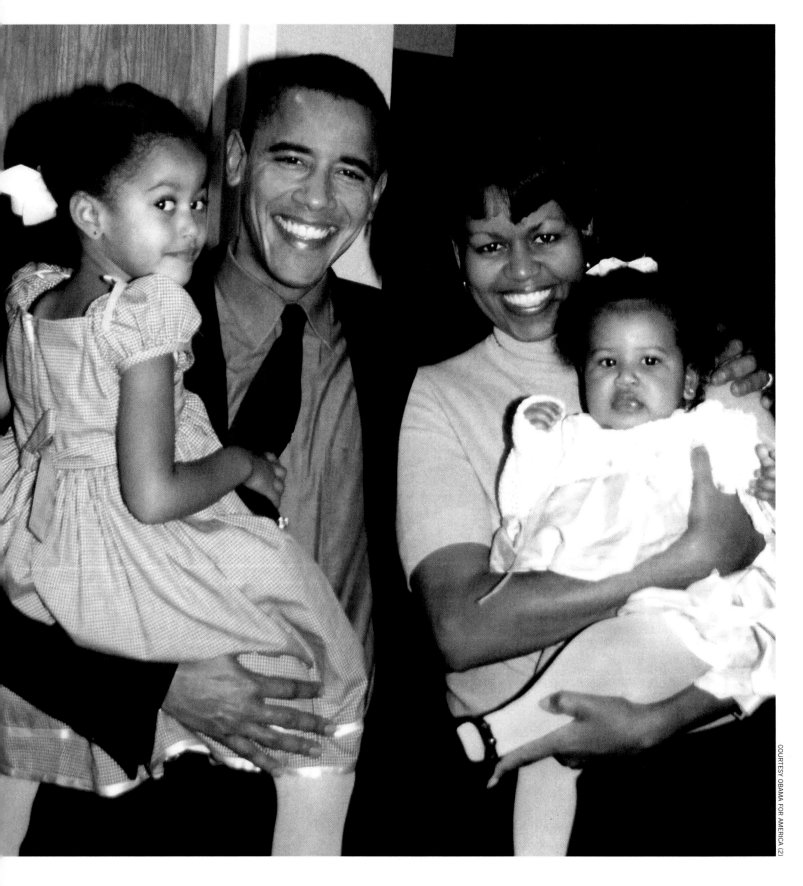

PETER BARRERAS/ZUMA

Family matters: On the day of their daughter Sasha's christening in 2002, Barack and Michelle pose with the baby and her older sister, Malia (opposite). The Obamas moved in 2005 from Hyde Park to this Georgian Revival mansion (left) in Chicago's Kenwood district. The purchase of the home and a vacant strip of land next door prompted controversy when it was alleged that Obama had been able to secure the vacant land for below-market value from a friend, an indicted—subsequently convicted—wheeler-dealer named Tony Rezko. Above: Half sister Maya (center) and her husband, Konrad Ng (right), with the Obamas at Niagara Falls in 2003.

E ntirely unforeseen on this afternoon in 2002, even by one as politically astute and ambitious as Obama, was how crucial this speech against the war in Iraq would be in the tough-as-nails, tight-as-a-drum battle for the 2008 Democratic Party's nomination for President. We will never know how many voters chose against Hillary Clinton because she had voted in the Senate to authorize the war, or for Barack Obama because of his opposition—but it was more than a few. A footnote: There is no profit, today, in guessing what was going through the mind of former presidential candidate Jesse Jackson (far left) as he watched Obama talk that day. Much later, during the 2008 contest, Jackson was caught on tape disparaging Obama in an unsavory manner.

MARC POKEMPNER

W e now know from their own testimony: Michelle and Barack are, at this moment in Boston on the evening of July 27, 2004, as nervous as cats. He is about to take the stage at the Democratic convention to deliver the keynote speech. She has urged him to . . . well—to not blow it. He'll do his best.

STEPHEN FERRY/REDUX (2)

Very soon after the tension-breaking playfulness seen on the previous pages, the anxiety sets back in as Obama waits in a makeshift holding room behind the podium (left) and, then, Michelle roots for him fretfully as he delivers the speech. These moments cannot be accurately parsed until much later: There is no way for her to know, at this moment, that her husband is announcing himself to the nation—indeed, to the world—as a future force. There is no way for him to know, as he exhorts the crowd (on the following pages), that his life has just turned, crucially and irretrievably. They'll wake up in the morning, realizing that something special happened that night, but they do not yet know what it means.

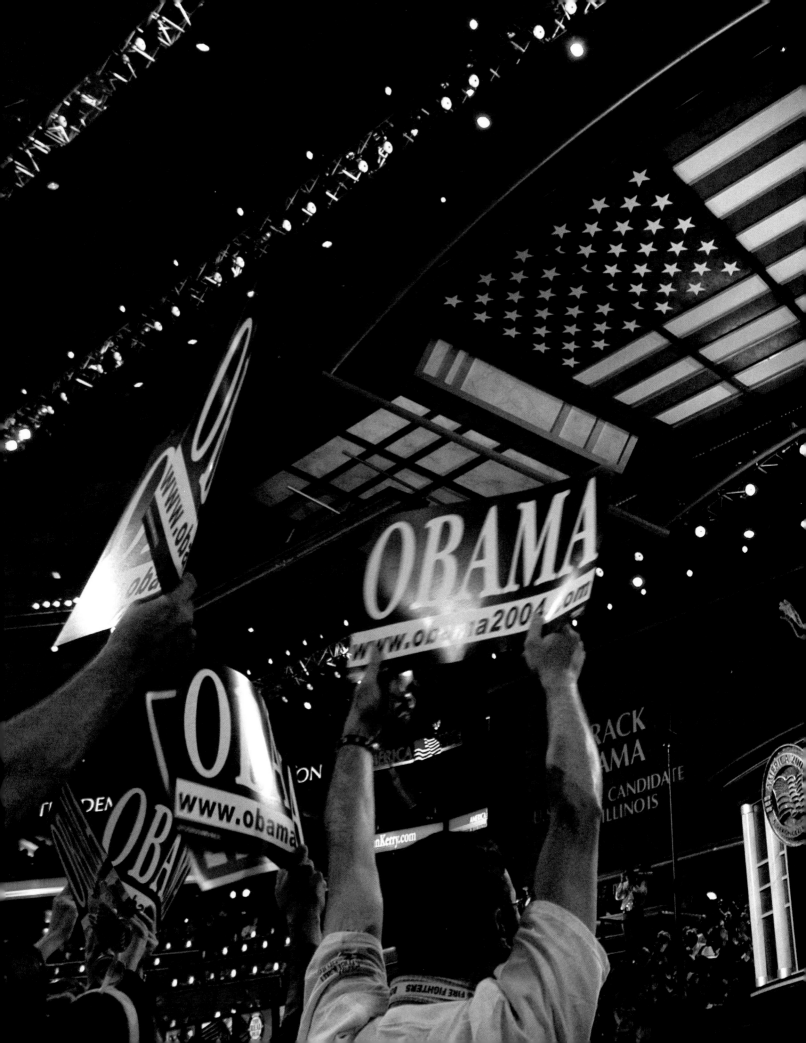

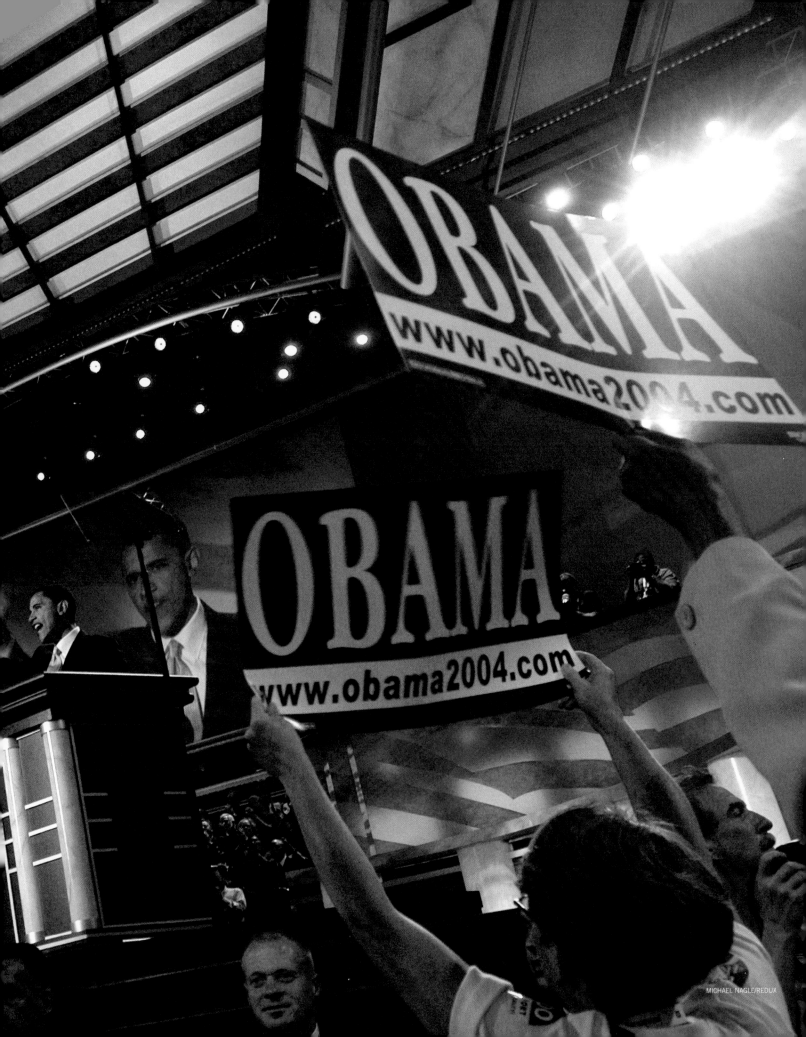

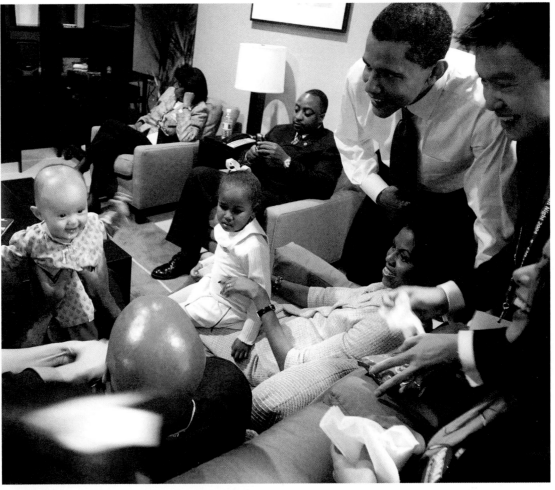

DAVID KATZ (3)

When Barack Obama announced his run for the U.S. Senate, it looked like a quixotic campaign. It turned out to be a cakewalk, as one opponent after another self-immolated. By the time of election night when he and Michelle, their daughters and friends gather in their room at the Hyatt Regency in Chicago (far left and above), the fat lady has already sung a loud aria and it is clear that Obama's will be a margin for the ages. It is tempting to speculate that the stoicism and concern Obama evinces as he rides the elevator en route to the celebration with daughter Malia and family caregiver Marlease Bushnell are exaggerated. But this is a serious man, and he takes special moments seriously. This is a special moment.

Three months earlier, in service to someone else's nomination—namely, that of Massachusetts Senator John Kerry as the Democratic candidate for President—Obama truly was worried backstage. Now, on November 2, 2004—a night when Kerry is losing narrowly to George W. Bush, but Obama is steamrolling Alan Keyes—he is at his ease in the hallways of the Hyatt, sharing a sweet moment with 6-year-old Malia, then reviewing his victory speech one last time. As the confetti falls (below), the Senate-bound Obamas exult. Dad has Malia wrapped up, while Mom hoists 3-year-old Sasha.

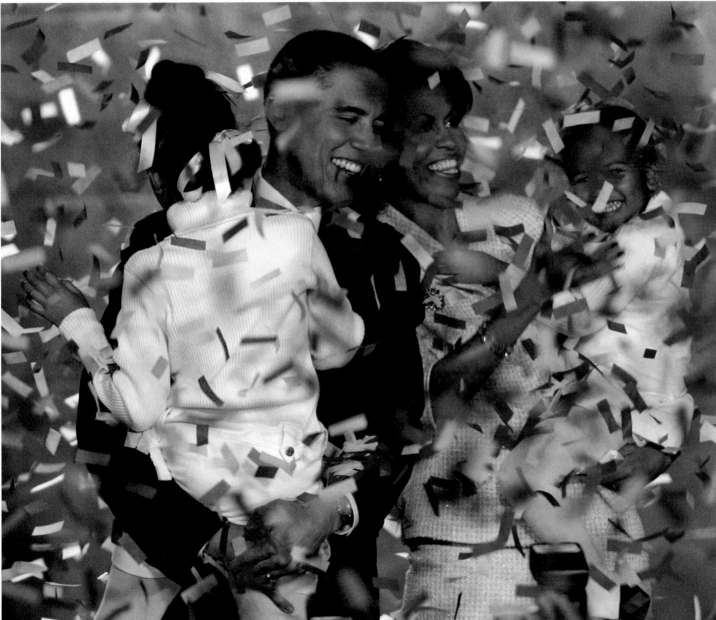

JOHN GRESS/CORBIS

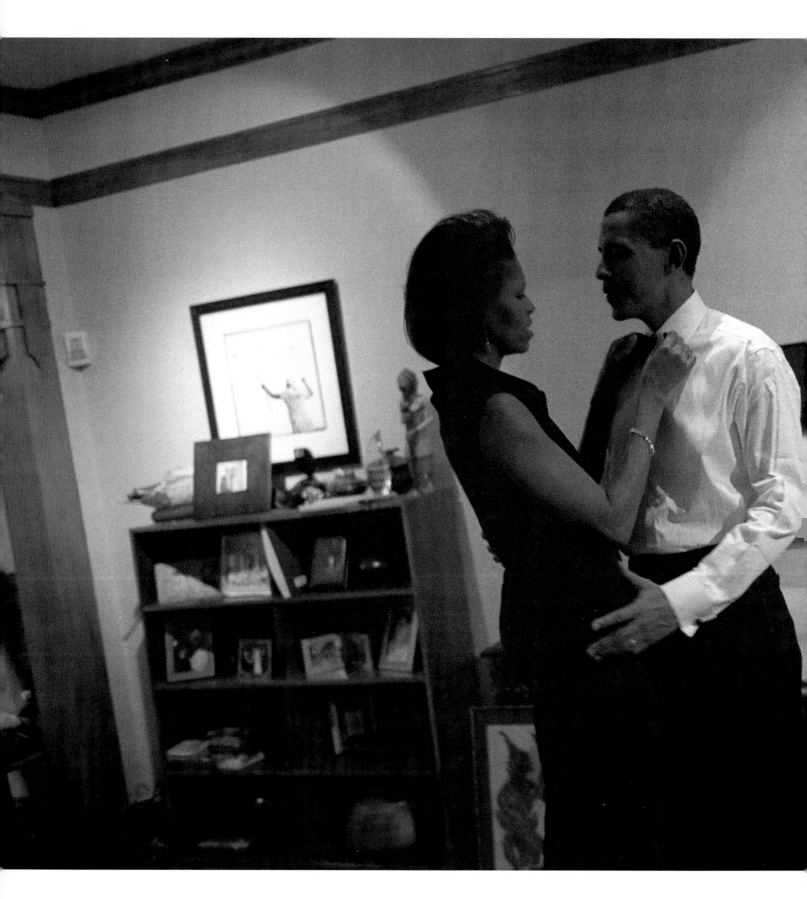

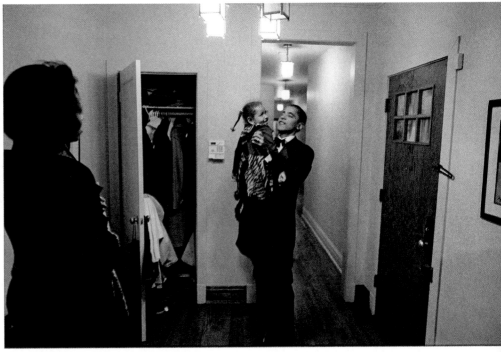

Having become Mr. Keynote Address, the senator-elect from Illinois prepares for a night on the town with his wife. Not an intimate night, mind you, but an appearance at the Economic Club of Chicago dinner where, yes, he will deliver the keynote. It is December 2004, and he is, as he awaits his inauguration, firmly in the spotlight and also on the cusp. Mr. Obama is going to Washington, and what he might do there, and for how long, is anyone's guess. On these pages, Michelle makes sure hubby is properly dolled up, then she and he tell Sasha to be good and to go to bed on time. On the following pages: At the dinner, Obama works the crowd. In shorter order than most would have predicted, he will be working much bigger crowds than this, in pursuit of much higher office.

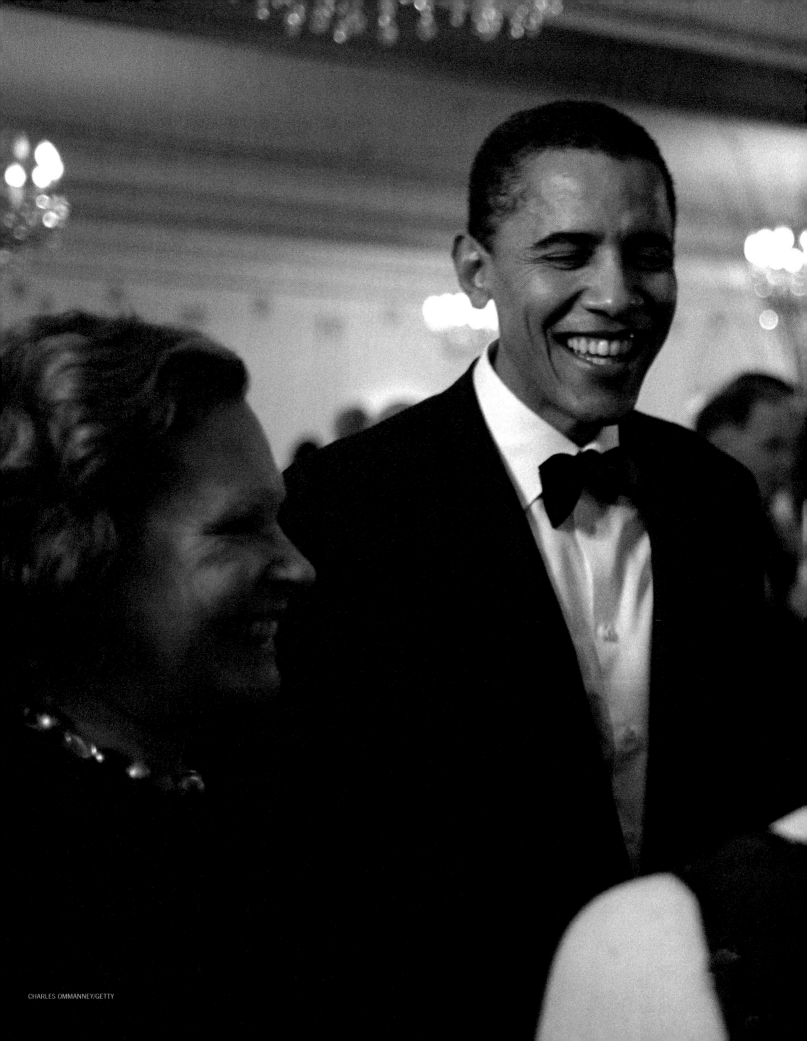

WASHINGTON

On the day of Dad's swearing-in as a senator, the Obamas have the Capitol in the background. Does he already have the White House in his sights?

HE TOOK HIS SEAT IN THE SENATE, BUT DID HE REALLY SIT DOWN? WITHIN A YEAR HE WASN'T ADAMANTLY DENYING THAT HE HAD HIS EYES ON THE WHITE HOUSE, AND WITHIN TWO IT WAS EVIDENT HE WAS RUNNING. WITHIN THREE HE WAS ENGAGED IN THE MOST RIVETING PRIMARY BATTLE EVER. WITHIN FOUR YEARS . . . THE OVAL OFFICE?

"I RECOGNIZE THERE IS A CERTAIN

presumptuousness—a certain audacity—to this announcement."

So admitted Barack Obama, whose middle name at that point in time could have been Audacity (for a number of reasons, not least his new best-selling book). He made the admission on a frigid February day in Springfield, Illinois. This was in 2007, and he had completed just two years and a month of his rookie six-year term as the state's junior senator. The announcement, to which a certain presumptuousness and, yes, a certain audacity certainly did attach, was that Obama, at age 45 and having won two out of three elective posts he'd already sought (not counting the Harvard thing), was running for President of the United States of America.

Everyone was bundled up in winter coats, hats and mittens that day, and the applause had a thump-thump quality. "I know I haven't spent a lot of time learning the ways of Washington," Obama continued. "But I've been there long enough to know that the ways of Washington must change."

Some said, "Really? Long enough?"

Some said, "You knew Washington was broken before you went."

And some said, "Right you are, Barack. Let's go!"

Springfield was not casually chosen as a launching pad; these things never are. The resonance of Springfield—of Abraham Lincoln—was missed by no one and, more important, was inarguably pertinent. This was not the first African American to announce for the presidency; Jesse Jackson, for one, had made more than one serious run for the office. But this was the first, thought many, with a real chance.

Obama wanted to hark back to the past in his speech that day, but also to touch upon the present and the future. He invoked the legacy of Lincoln more than once, and alluded to what he saw as several seismic changes in U.S. history—for independence, for unification, for space exploration, for civil rights. He called for a renewed effort to end military involvement in Iraq and to tackle challenges involving the economy, education, healthcare and the environment.

"Each and every time, a new generation has risen up and done what's needed to be done," he said, looking back. Then, looking forward, he continued: "Today we are called once more—and it is time for our generation to answer that call."

That was interesting, because it forced anyone who heard it to ask: What generation is this? Obama, 15 years younger than Bill Clinton, wasn't a boomer (although the philosophies he had inherited from his mother would have satisfied many left-leaning boomers). And he wasn't a youngster (although he certainly looked like the youngest thing on the American political landscape).

But like everything else about Obama, this was unique, and therefore okay. Not just white, not just black, not ultra-liberal, certainly not conservative, not of this generation or that one. He might not have been post-racial, as some were claiming (nothing in America yet has been post-racial, as the campaign served to confirm). But he was decidedly post-modern. There was no template available that could remotely accommodate Obama.

This, of course, was appealing in and of itself, especially in an age of general disaffection brought on not only by an

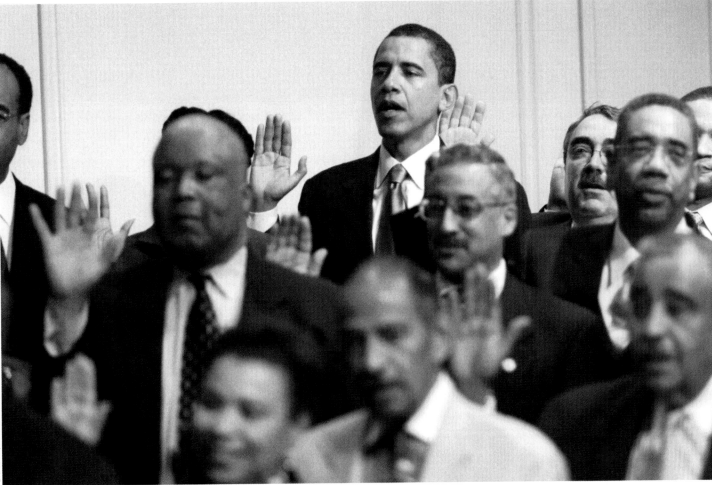

PETE SOUZA/CHICAGO TRIBUNE

On January 4, 2005, Obama joins his new colleagues in the Congressional Black Caucus for a ceremonial swearing-in.

increasingly unpopular war but also by a slumping economy. Yet Obama was, without argument, relatively untested and unproven—as a thinker, a doer and even as a campaigner. He was unconvincing as a winner. Two-for-three is great in baseball, not so great when climbing a political ladder. Many of the candidate's positives were intangible, while the negatives, principally having to do with his inexperience, could be quantified.

HE FACED OFF AGAINST A CROWD of seasoned Democrats, some with near ubiquitous name recognition and vast networks of political and fund-raising connections. Prominent among these was the favorite, former First Lady Hillary Rodham Clinton, who had spent eight years in the White House with her husband, Bill Clinton, and was serving her second term as a U.S. senator from New York. Appraisals from the left, right and center said that Clinton had been an energetic, effective, forceful legislator. There was also former Senator John Edwards, who had been the running mate of presidential candidate John Kerry in the 2004 election. On paper, Obama's résumé against these two was wanting (even though we now know that an Edwards presidential bid likely would have imploded disastrously upon revelation of his extramarital affair).

Elections, however, are seldom won on paper; they are won on the stump. Obama went to Iowa and went to New Hampshire, as was required. He ate a lot of corn and told a lot

of corny jokes, as was required. He drank beer when he probably didn't feel like having a beer, and he bowled when he probably should not have been bowling in public, opening his performance with two gutter balls and hanging up his shoes after scoring a 47 in seven frames. He kissed a lot of babies and, truth be told, more than a couple of local pols' posteriors. On regular occasion he inspired enthusiasm, and sometimes, especially among the young, he lit an inextinguishable fire.

THE PRIMARY SEASON FORMALLY KICKED OFF in Iowa on January 3, 2008, with an upset win for Obama, followed by a victory for Clinton in New Hampshire several days later. The race took off from there, eventually leaving just Obama and Clinton on a mad dash to rack up wins across the nation's states and territories over a grueling five months. It was only with the final contests that Obama surpassed the threshold of 2,118 delegates needed to secure the Democratic nomination. At the convention in August, he was anointed the first African American major-party standard-bearer.

A closer look at that historic primary competition, in which millions upon millions of dollars were spent and candidates who insisted they didn't want to get down and dirty kept switching between the high road and the low, reveals much about the tenaciousness and flexibility as well as the innate political skill of Obama. Against the Clintons—and he was certainly opposing both of them—he was dueling with the best of the best. That he came out on top, something no one had ever achieved against either of them, was remarkable.

Obama and Clinton reached people; the Democratic primaries set new records for voter turnout, and, as the debates' television ratings proved, gripped the electorate with the realization that it might make history by sending either a woman or an African American to the White House. The bickering between the candidates, which at times grew bitter, was not substantive. It was usually about a question of Obama's experience, and whether he was ready to deal with the intricacies of domestic and foreign policy; or the question of whether years in Washington bred wisdom as much as excess baggage; or the question of whether the inspiring words of a political newcomer amounted to a fresh perspective or simply naïveté; or the question of whether the Clintons were yesterday's news and it was time for them to go. These were hardly the issues that were going to solve the world's problems, but they roiled the Obama–Clinton face-off to such a degree, the observer felt like the answers meant life or death.

Obama had an advantage, one he would carry throughout the primaries and into the general election against John McCain. His youthful appeal and embrace of the Internet and its social-networking mediums allowed him to build an army of volunteers that mobilized on the Web and across the nation's cities, suburbs and plains to draw in ever more donors and voters. By the start of August 2008, Obama's campaign had posted more than a thousand videos on YouTube. Obama's MySpace page boasted 459,000 friends by late August 2008, a number comparable to that of the otherwise incomparable pop princess Miley Cyrus. Miley had 552,000 friends, but she wasn't running for President (a good thing for Obama).

WHETHER THE MEDIA, in thrall to the candidate's considerable charisma and romantic backstory, was treating Obama with kid gloves became its own issue. Clinton, who for years had been a punching bag for some critics and continued to be, shouted for fair play. McCain more mildly raised the point (the press was seen as his buddy, too) and *Saturday Night Live* had continuous sport with the controversy. Obamania, which swept the Net, many college campuses and much of the black community, was seen as a joyful cultural phenomenon or a plague—an insidious, hard-to-fight disease—depending on your point of view.

Many charges were thrown at Obama, and, initially, many slid off; he was seen as a Teflon candidate. If *Saturday Night Live* got it right, the late-night television comedians struggled to satirize the man: He was largely gaffe-free and, well, just not that funny. He was also—or at least his campaign was—pretty thin-skinned, instantly answering any criticisms, whether seriously or lightly made, with outrage.

Some things could not be dismissed, however—they needed to be dealt with. In March 2008, Obama gave a speech in Philadelphia (which became the content of his most popular YouTube video, summoned more than 4.7 million times) addressing a growing national agitation over footage that had surfaced showing Obama's former pastor, Reverend Wright. Wright had been making inflammatory remarks, among them, condemnations of the U.S. for its treatment of blacks, charges that Washington's foreign policy had brought on the September 11 attacks and suggestions that the government had invented HIV in order to spread it among minorities. Obama criticized Wright, who had retired earlier in the year, but did not throw him over. He made a direct, reasoned plea for a greater understanding of the underpinnings of racial tension on all sides, and for not letting wounds from the past taint the future. In one of the most substantive and nuanced political speeches in many a year, Obama said, "The fact is that the comments that have been made and the issues that have surfaced over the last few weeks reflect the complexities of race in this country that we've never really worked through—a part of our union that we have yet to perfect. And if we walk away now, if we simply retreat into our respective corners, we will never be able to come together and solve challenges like healthcare, or education, or the need to find good jobs for every American." He added later: "The profound mistake of Reverend Wright's sermons is not that he spoke about racism in our society. It's that he spoke as if our society was static, as if no progress has been made; as if this country—a country that has made it possible for one of his own members to run for the highest office in the land and build a coalition of white and black, Latino and Asian, rich and poor, young and old—is still irrevocably bound to a tragic past."

Obama also defended the character of and the community contributions made by Wright. He asked for the race debate to move to higher ground, and many commentators speculated that the address could be a watershed event.

If it's cold in Exeter, New Hampshire, five days before Christmas in 2007, the campaigner doesn't feel it.

BROOKS KRAFT/CORBIS

But Wright, for one, wasn't buying. He grew louder in his outrageousness, touring Washington and parading before TV cameras, invective pouring from him during contentious question-and-answer sessions with the press. In what was certainly a painful decision for him, Obama, in May, denounced Wright with emphasis, and formally quit the congregation of the Trinity United Church of Christ—where he and Michelle had wed, where their daughters had been christened.

OBAMA'S PASTOR BECAME AN ISSUE and, for some, so did his patriotism. How important it was for a candidate to wear an American flag pin in his lapel became a significant point when Obama, for a time, said he would not pander and sometimes went without one. The "question of who is—or is not—a patriot all too often poisons our political debates," Obama said. "I will never question the patriotism of others in this campaign. And I will not stand idly by when I hear others question mine." Obama's job is politics, though, and soon the pin was in place at all appearances. Once the race with McCain, an acknowledged war hero, was entered, it was clear this question of the depth of a candidate's love of country wasn't going away before November.

In the general election campaign, Obama worked to expand his appeal across voter groups; he said he would compete in every state, the red as well as the blue. Some liberals who had long felt that Obama was a fellow traveler accused him of waffling on positions and principles. Others viewed the perceived shifts, on issues from a timetable for ending the war to offshore drilling, as pragmatism and a willingness to compromise when compromise was called for. Still others said there were no shifts—that if people had been listening to Obama all along, they would have realized he wasn't a leftist, certainly not a true believer. This was just the latest in a lifelong string of such episodes: observers gazing upon the individual that is Barack Obama and not knowing quite what to make of him.

Obama's supporters eventually came to terms with a salient fact that could at times contrast with the candidate's idealism and lofty rhetoric: Their guy was a pol, and he was playing a pol's game. Not long after securing the Democratic nomination, Obama became the first major party candidate ever to opt out of the Watergate-era public financing system for the general election. He had earlier pledged to operate within the system's roughly $84 million spending limit if his opponent did the same, and McCain had indicated he would proceed within the rules. Obama now said the system, which was intended to free politicians from obligations to the special interests, was broken (and he had earlier pointed out that he had banned donations from federal lobbyists and political action committees). But what was

going on seemed clear. Obama had promised to operate within the system before he had proved himself a fund-raising phenom. Suddenly he was a candidate who could raise millions in a moment without even asking. Also, he had seen, four years earlier, how independently financed attacks such as those by the Swift Boat Veterans for Truth, which helped sink John Kerry's presidential bid, could come out of nowhere and cause havoc, no matter the truth or falsity of the accusations. If a stealth group such as that came at him in September or October, Obama wanted to be certain he had the war chest to fend it off, and the ability to tap into that chest.

Politics is not always pretty. Obama's legions took solace—even heart—in the fact that their man seemed to be in this thing to win.

IF, AGAINST CLINTON, Obama's chief vulnerability seemed to be his general lack of experience, against McCain it was not only that but also the notion that he was a foreign-policy neophyte. To address this, Obama embarked in July on a week-long tour to Iraq, Afghanistan, Jordan and Israel, then the European capitals of Berlin, Paris and London. It was a high-risk, high-reward tour; if he stumbled he looked like a bumpkin, but if he succeeded he looked like a world leader. It was generally felt he succeeded splendidly.

At each stop, Obama was greeted with open arms by international leaders, several of whom, particularly in Europe, were eager for a change-in-guard in Washington, and felt McCain looked too much like Bush. As for the man on the street, he seemed to adore Obama. With intended echoes of John F. Kennedy's more significant visit to cold war Berlin in 1963, Obama went to that city and drew a veritable flood of people, estimated at around 200,000, to the Victory Column near the historic Brandenburg Gate. Acknowledging that at times (like the present?) the U.S. and Europe had "drifted apart," Obama told the throng that the "burdens of global citizenship continue to bind us together." He said a renewed collaboration was necessary to meet the security threats and social challenges of the new century. "The walls between old allies on either

side of the Atlantic cannot stand," he said. "The walls between the countries with the most and those with the least cannot stand. The walls between races and tribes, natives and immigrants, Christian and Muslim and Jew cannot stand. These now are the walls we must tear down." It was the global version of his view of America as elucidated in his 2004 speech to the Democratic convention; Obama was announcing himself to the world in the same way he had, four years earlier, announced himself to his countrymen. The German audience was rapturous in its applause.

Obama said that the overseas trip was a chance to speak in-depth with leaders "whom I expect to be dealing with over the next eight to 10 years." At times, with him, it was hard to figure out what was hope and what was hubris. His opponent tried to make hay with these very questions: As Obama looked more and more like Elvis, McCain sought to make this—his popularity, as well as his confidence (or cockiness)—the issue. A quickly made TV spot featured photos of Britney Spears and Paris Hilton, followed by images of Obama before the crowd in Berlin, as a narrator said: "He's the biggest celebrity in the world. But is he ready to lead?" Another ad called Obama "the One," clearly referencing the messianic overtones of his speeches. Lest the point be missed, among the ad's visuals was a clip of Moses parting the waters in Cecil B. DeMille's *The Ten Commandments*. Although Hilton deftly satirized the first spot with her own, thanking the "old white-haired dude" for his endorsement, the issue did resonate in some corners. "There's nothing new about narcissism in politics," wrote the conservative columnist Charles Krauthammer. "Every senator looks in the mirror and sees a President. Nonetheless, has there ever been a presidential nominee with a

wider gap between his estimation of himself and the sum total of his lifetime achievements?" Krauthammer added: "His most memorable work is a biography of his favorite subject: himself."

But Obama had never disputed a measure of self-absorption. Becoming a senator, he wrote in *The Audacity of Hope*, required "a certain megalomania, a belief that of all the gifted people in your state, you are somehow uniquely qualified to speak on their behalf; a belief sufficiently strong that you are willing to

CALLIE SHELL/AURORA

He became known for many things during his quest for the White House, among them toting his own luggage.

endure the sometimes uplifting, occasionally harrowing, but always slightly ridiculous process we call campaigns."

The extension of that thought, when applied to a presidential candidate, is plain: He or she has a belief that of all the gifted people in the country, he or she is the one uniquely qualified to lead.

At the end of the day, that was the crucial point: Whether he was right or wrong, Barack Hussein Obama Jr. had that belief—a belief that any aspirant to the presidency must possess.

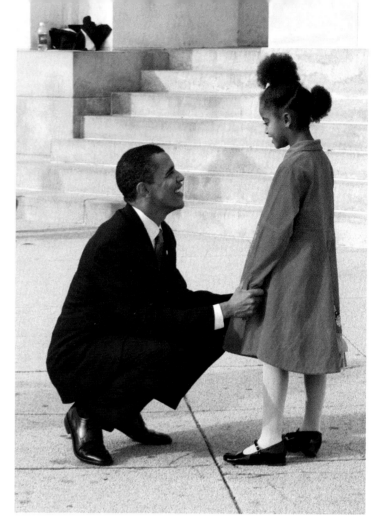

January weather can be nasty or lovely in the nation's capital city. On the day his daughters visit in 2005—the day Barack Obama and other congressional newbies arrive to take their oaths of office and pose for their photo ops—it is nice and warm. His girls enjoy the festivities in Washington, as do friends and other family members from not only Illinois but Hawaii and Kenya. Later in the year, it's another fine day as Senator Obama jogs to work (opposite). He is, hands down, the most closely watched freshman legislator in town.

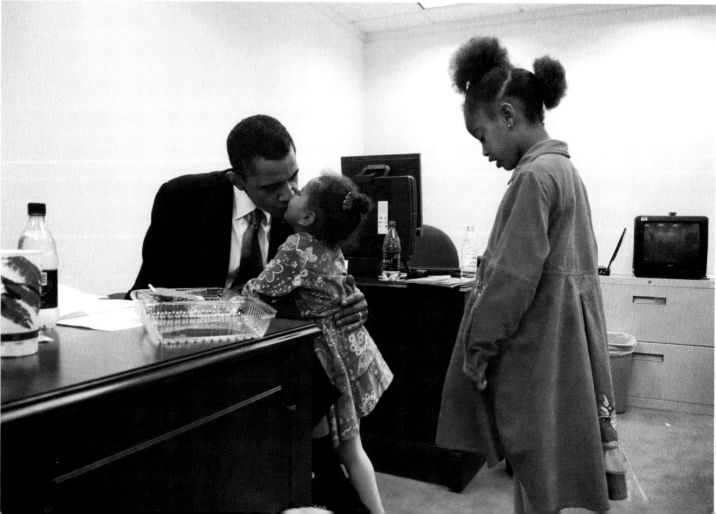

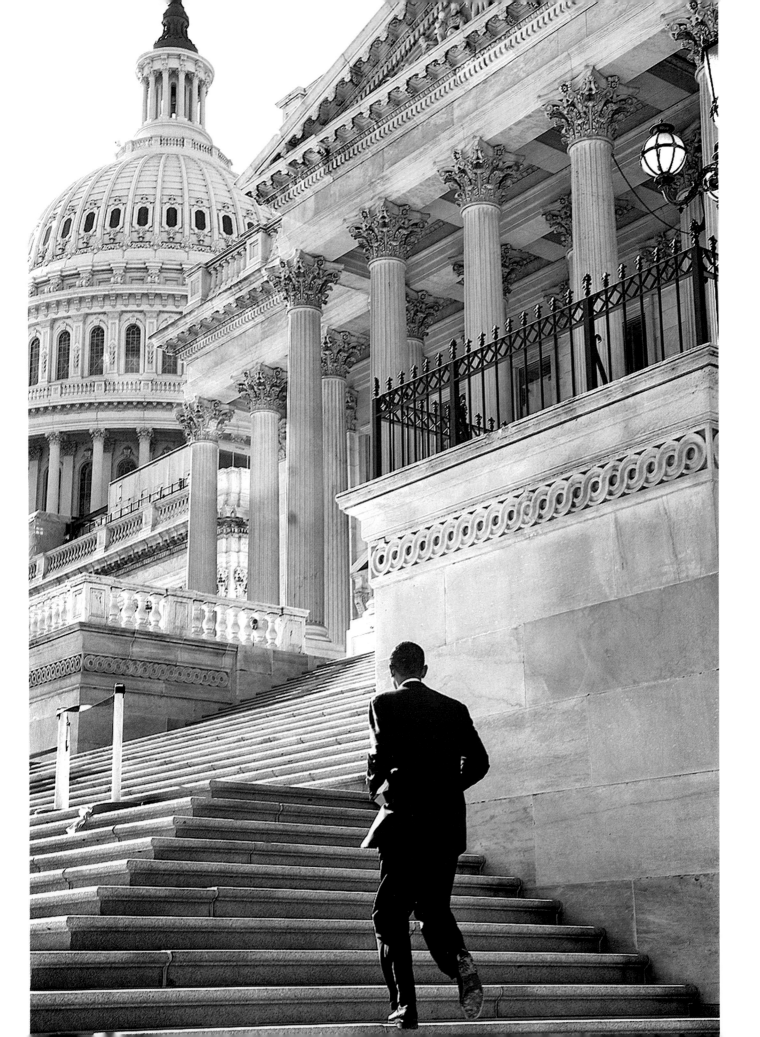

PETE SOUZA/CHICAGO TRIBUNE (2)

T*he largest anti-Obama issue during the presidential campaign would be his "lack of experience." This did not reference, of course, his rich life story, but rather his experience as a legislator, either in state government or, now, in federal. There was little that Obama could do in the short time before announcing his intentions that would prohibit this charge, but he did spend his first two years in Washington as an eager, engaged senator. The formalities included votes on the floor, meetings and a never-ending round of fetes. The informalities included pizza lunches with office interns (above) and on-the-go strategizing with colleagues such as Colorado Senator Ken Salazar (on the Senate subway, right).*

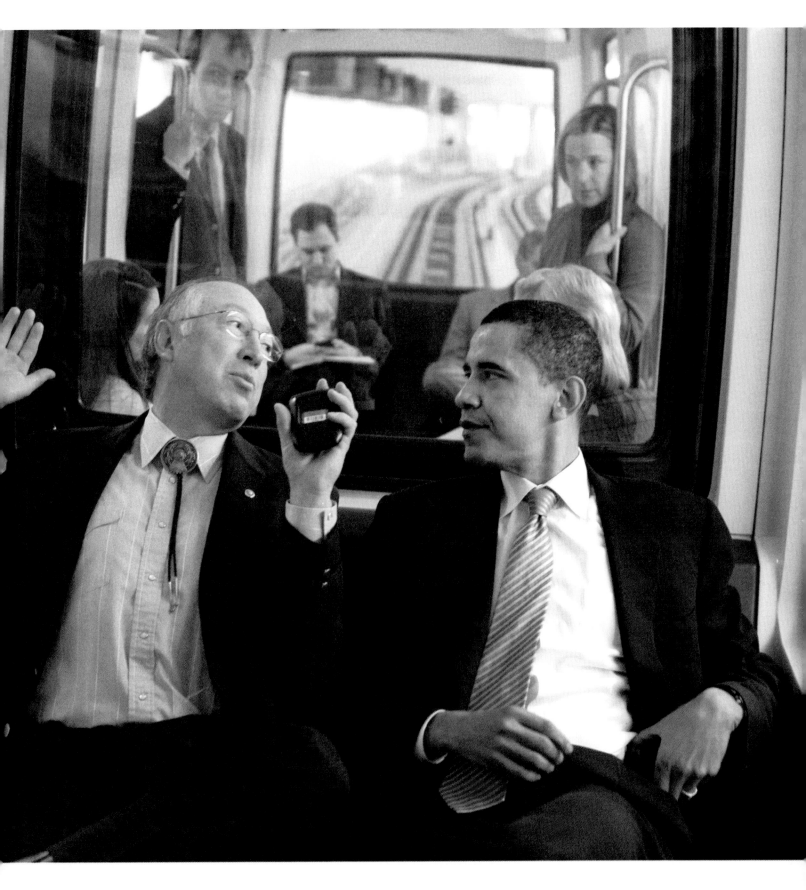

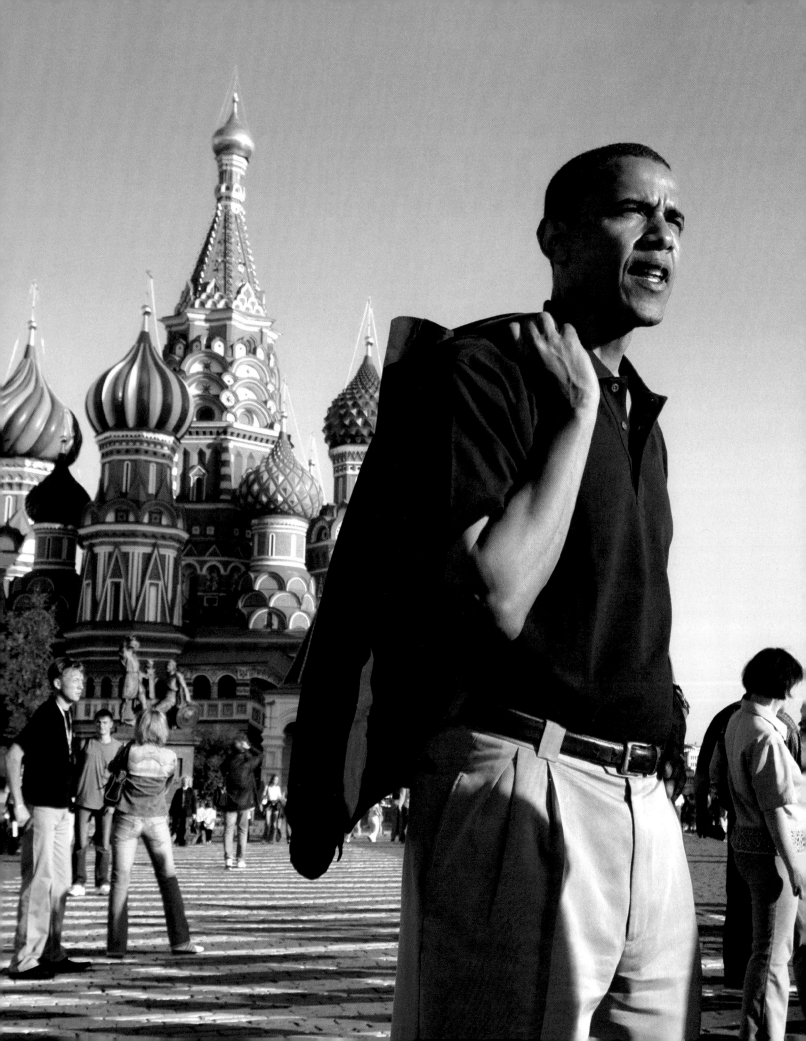

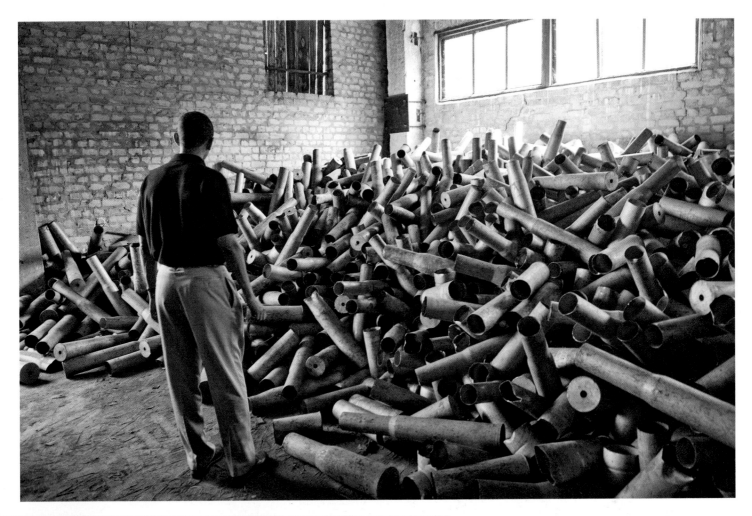

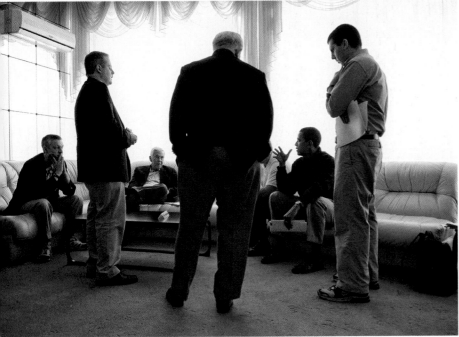

PETE SOUZA/CHICAGO TRIBUNE (3)

He was noticed immediately—and beyond America's shores, too. The influential British journal New Statesman included him on its list of 10 people "who could change the world." How or why he could do this was, as with many things involving Obama, unspecific, but it generally had to do with who he was: what he represented with his youth, energy and multi-cultural background. (Also, he looked oh-so-different from the sitting President, so that meant change.) Now a U.S. senator, Obama could promote and better educate himself as a world citizen. In August 2005, he is in the former Soviet Union, touring Red Square in Moscow (opposite), and, a few days later, viewing spent artillery shells at a weapons-destruction plant in Donetsk, Ukraine (above). Left: A staff confab on the road.

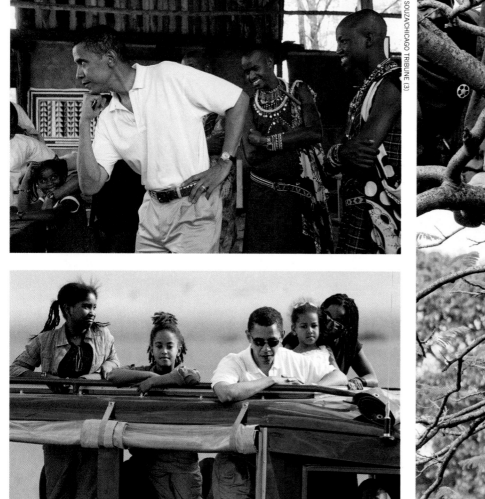

PETE SOUZA/CHICAGO TRIBUNE (3)

When Obama first traveled to his father's homeland in the 1980s in search of his roots, he did so as one more anonymous tourist. When he returned to Africa in August and September 2006, he was greeted as a conquering hero. This sojourn was attended by a trailing press corps and monitored by millions back in the States who were buzzing, as were the Africans, about Obama's presidential prospects. Safaris and photo opportunities were on the itinerary, as were visits to institutions where political points could be made. *Right:* On August 26, Kenyans gather outside a hospital in Kisumu for a glimpse of Obama, who, along with his wife, will take an HIV test at a mobile unit and then address the crowd, hoping to draw attention to the AIDS crisis and the need to be tested.

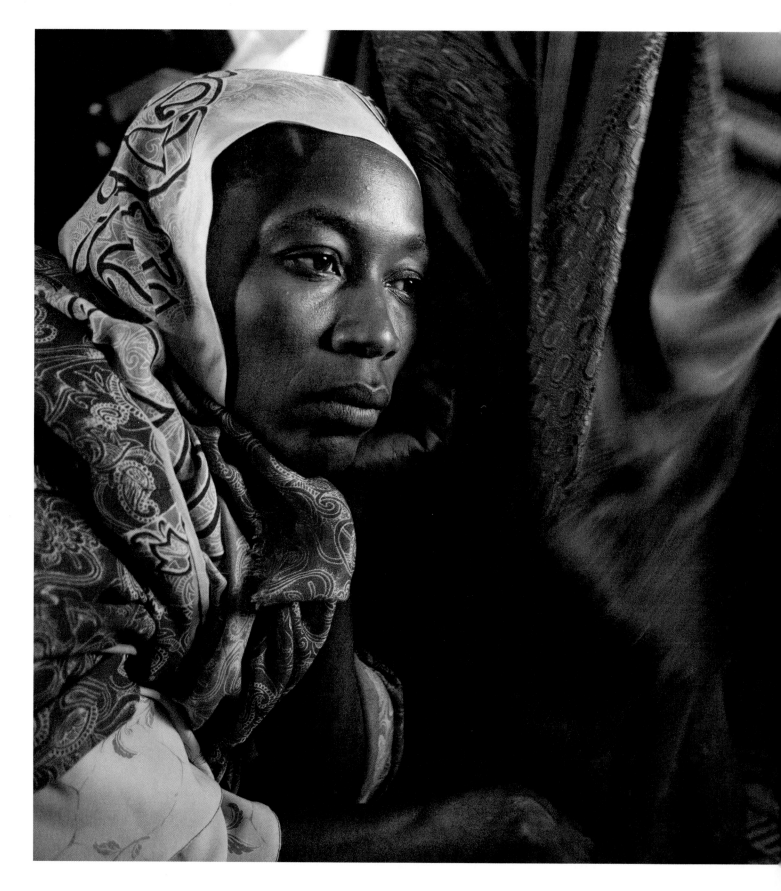

These photographs highlight three present and past issues in Africa. Top: Obama has blood drawn during his HIV test. Left: The senator listens to the stories of Sudanese refugees at the Milé Refugee Camp near Guereda, Chad. Above: During a visit to the jail on Robben Island, just off Cape Town, South Africa, Obama opens the cell that was home to Nelson Mandela for 18 of his 27 years of imprisonment. There were personal side trips during Obama's African tour, but every day had a political component. As a U.S. senator, Obama now had a hand in shaping public policy that might affect not only domestic issues but also global ones. And as everyone was now speculating, he might one day have a much bigger role in shaping such policy.

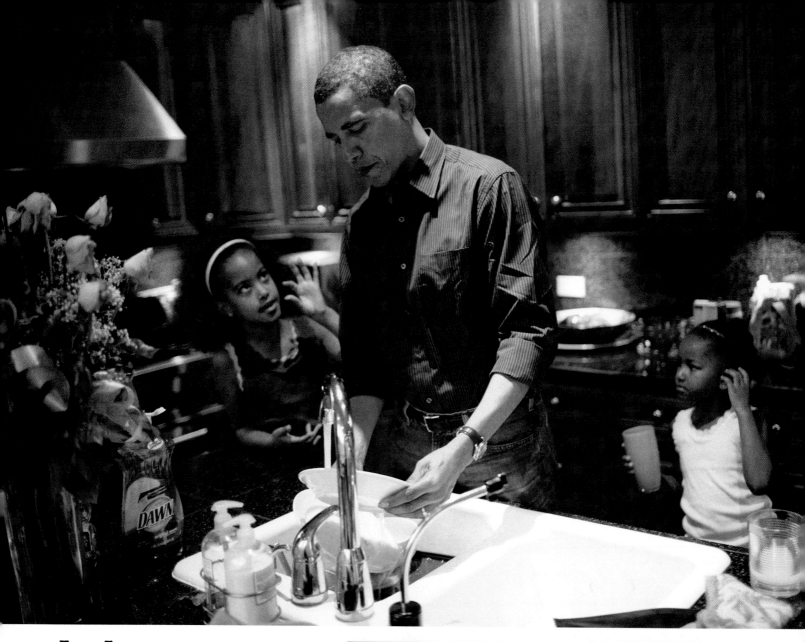

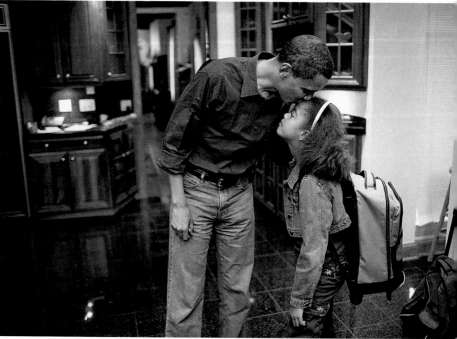

eanwhile, back in Chicago . . . In October 2006, the senator washes the breakfast dishes (above) as Malia, 8, makes her point and Sasha, 5, seems poised for rebuttal. The other photographs show Dad getting the girls off to school. As is evident in these intimate pictures and the ones on subsequent pages, the Obamas were not reluctant to put forward a positive family image by involving their children. They admitted that allowing an interview with a TV tabloid show was a mistake, but they generally followed the lead of Jack Kennedy, who invited LIFE photographers and others to make celebrities of his offspring, rather than that of, for example, the Clintons, who largely shielded their daughter from the glare. On the following pages: The obverse of the domestic morning ritual for a nascent supernova was a schedule of formal events all over the country, including this one in Louisville, Kentucky, also in the autumn of '06.

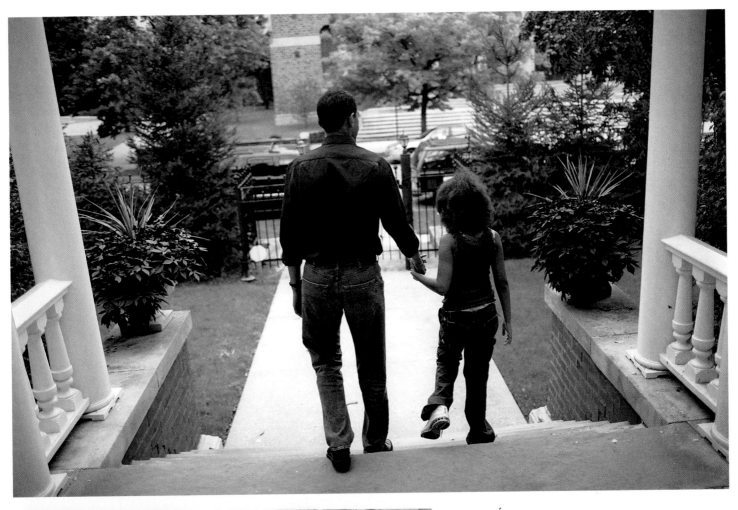

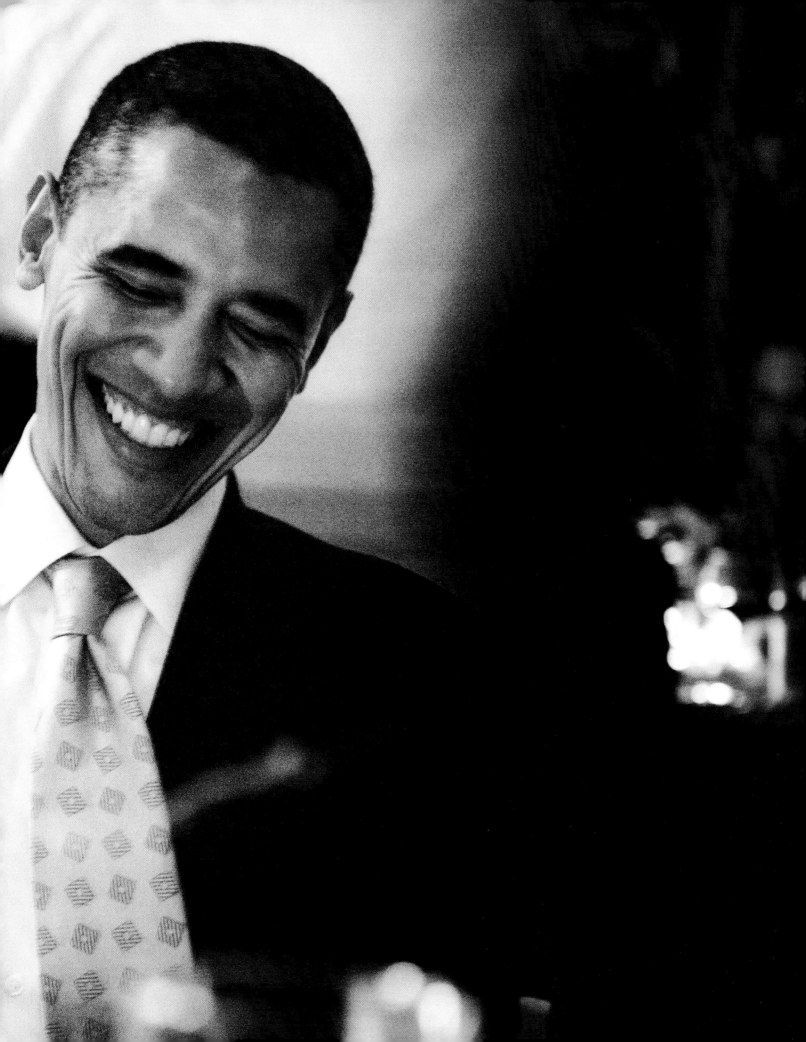

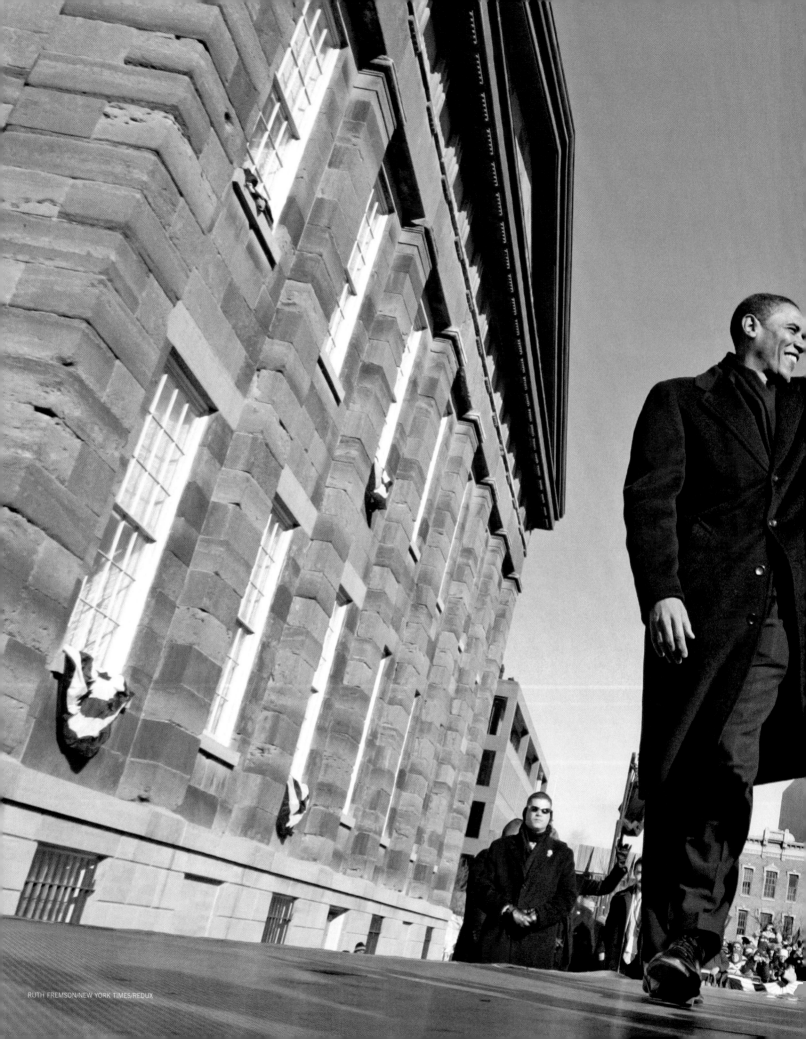

His daughter Malia had asked him, as had others: "Are you going to try to be President?" She wondered in a follow-up question: "Shouldn't you be Vice President first?" Obama didn't necessarily think so, and on a cold, sunny Saturday in February 2007, he stepped onto a podium that had been set up in front of the Old State Capitol building (left) in Springfield, Illinois, and declared, "I stand before you today to announce my candidacy for President of the United States." In 1858, Abraham Lincoln, at the same site, had told his fellow Illinoisans that "a house divided against itself cannot stand." Obama reminded his audience of this, and insisted his would be a campaign to unite a divided country. "As Lincoln organized the forces arrayed against slavery, he was heard to say: 'Of strange, discordant and even hostile elements, we gathered from the four winds, and formed and fought to battle through.' That is our purpose here today. That is why I'm in this race. Not just to hold an office, but to gather with you to transform a nation." Obama asked his listeners to join him in "this improbable quest," and on that day they said they would.

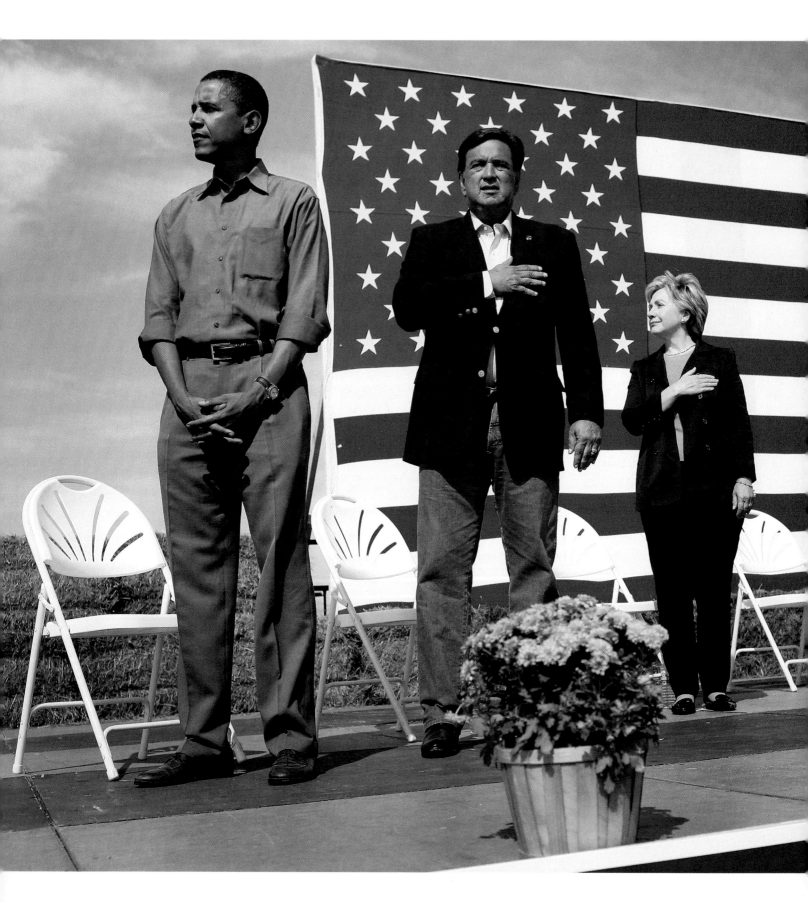

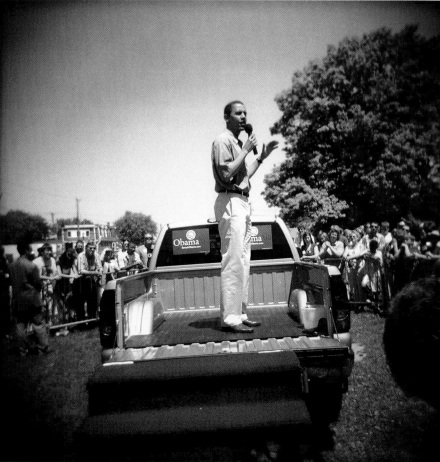

A
lthough the primary-season schedule for the 2008 presiden-
tial campaign was more scrambled than in years past, as states jockeyed
with one another for an early date for their own primaries and thus more
attention, the first stops for any hopeful remained Iowa, where the first
caucuses would be held, and New Hampshire, which would again stage
the first primary. Above: Obama speaks from a flatbed truck in
Dubuque, Iowa, during his campaign's "Walk for Change, National
Canvass Day." Left: He takes part in Senator Tom Harkin's steak fry
in Indianola along with rivals Bill Richardson, governor of New Mexico,
and Hillary Clinton, senator from New York. This is an accidental
photograph, but it illustrates what would become a primary campaign
issue: Obama's patriotism. He had no problem with pledging allegiance
to the flag at any turn or with humming along to the national anthem,
but when he said a candidate shouldn't be judged by his lapel pin, the
conservative TV punditry went ballistic.

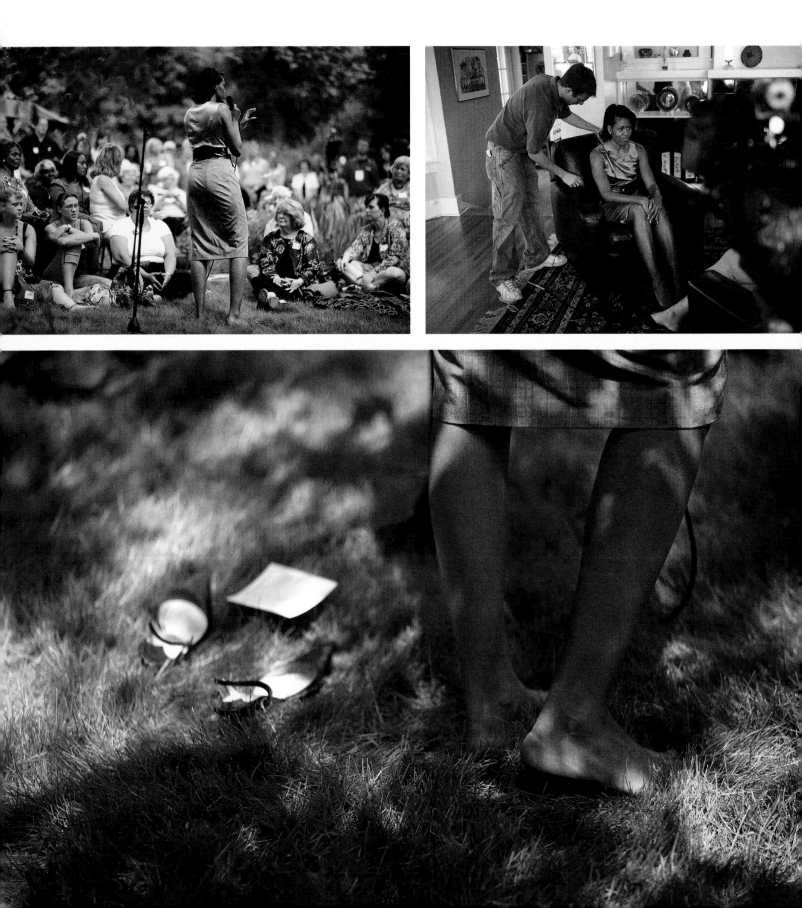

Team Obama fans out across Iowa, and the scenes could have been painted by Norman Rockwell. Opposite: Michelle speaks to a garden party on June 22, 2007, in Sioux City—part of her debut campaign appearance for her husband. On this page, the family works Des Moines: Dad goes door-to-door and Malia addresses a Fourth of July audience on a sunny day—which also happens to be her ninth birthday! Early in the campaign, Michelle spurred controversy when she said, "For the first time in my adult lifetime, I am really proud of my country, and not just because Barack has done well, but because I think people are hungry for change." Some of her fellow Americans ignored the nuances and thought they heard Michelle saying that something was wanting in their country before Obama's arrival. Michelle and the campaign spent months explaining the remark, but it continued to haunt the aspirant First Lady.

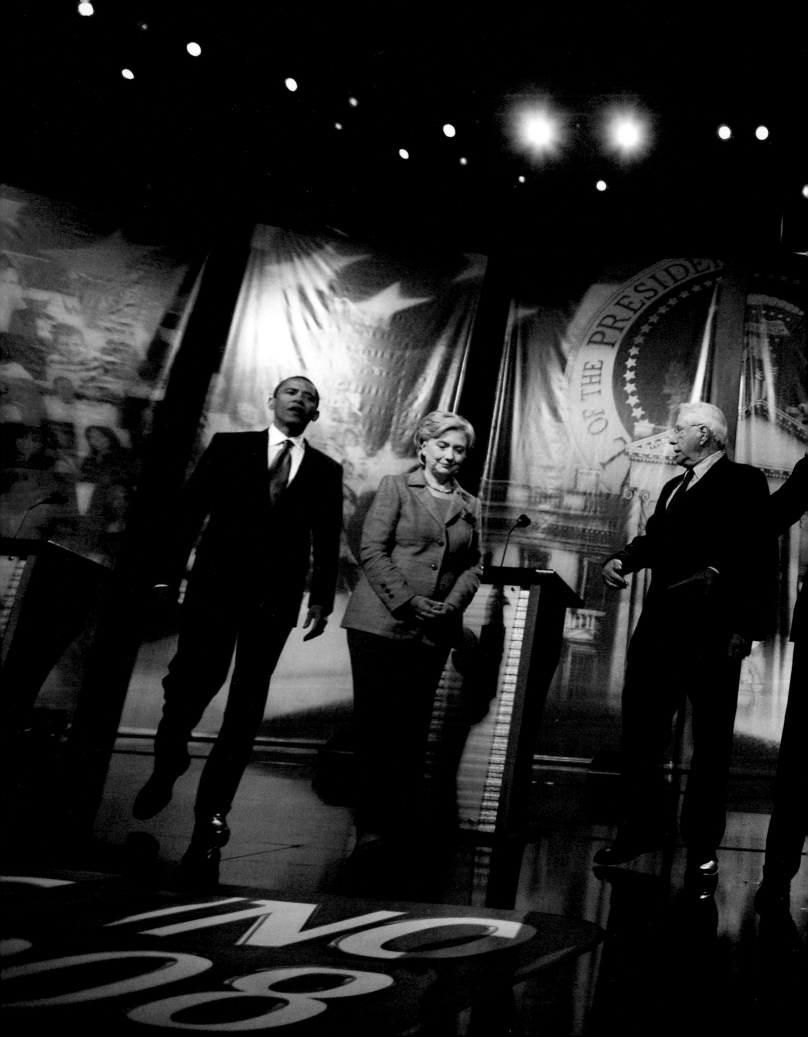

T he debates were a story within the story. They started early; there were lots of them; they were varied in format, nature and tone. At the starting line, there were many candidates (here in the summer of 2007 in Miami, from left: Obama, Senator Hillary Clinton from New York, former Senator Mike Gravel from Alaska, former Senator John Edwards from North Carolina, Representative Dennis Kucinich from Ohio and Senator Christopher Dodd from Connecticut). Then there were several of them, then few. And then two.

Campaigns can be fun—ask the Obama girls, who clearly are reveling in their day at the Iowa State Fair in August 2007. Whether Obama enjoyed his ride on Big Ben as much as it appears, he certainly enjoyed playing the carnival game (right) and then exulting with Sasha after they won. But campaigns are inevitably exhausting, what with all the shuttling from Iowa to New Hampshire to Washington (for the day job) to Illinois (titularly "home"). On the following pages we see Obama on his campaign bus traveling from Derry to Salem in New Hampshire—one more spur on the primary trail. Shhh.

JOSHUA LOTT/CORBIS

SCOTT OLSON/GETTY (2)

131

CHANGE
WE CAN
BELIEVE IN
BarackObama.com

As John McCain sought to exploit, Obama was not just a working politician but also a celebrity. When he schmoozed with Bono, goofed on Saturday Night Live or boogied with Ellen to "Crazy in Love" (opposite page), he was on equal-at-least footing. Left: The fist bump that sparked a controversy. As any parent of a T-ball- or soccer-playing youngster knows, the bump, or fist pound, or dap, is simply a hipper version of the high-five or the handshake. (Children: Home-run hitters used to shake hands with their teammates after crossing home plate. Really.) But E.D. Hill, a FOX News anchor, speculated that what Michelle and Barack were exchanging might perhaps have been "a terrorist fist jab." The dustup was justly ridiculed by Michelle on the morning show The View (below), but the larger point remained: Some conservatives were going to do whatever they could to make Obama look like a radical Islamist.

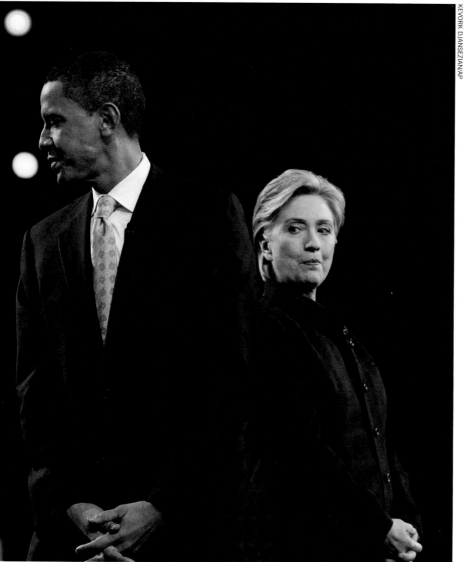

KEVORK DJANSEZIAN/AP

CALLIE SHELL/AURORA

T he showdown. . . . *The primary race between Hillary Clinton and Barack Obama will be remembered long after many general-election contests have faded from memory. Neither gave any quarter, and neither ever believed a comeback win wasn't just around the corner. They were both right: As soon as one scored a big victory, the other came back only days later. Many Democrats said, "Well, if my candidate doesn't win, I could easily vote for . . ." but that wasn't a universal sentiment. Hillary's core supporters loved her, and Barack's staunchest backers felt the same about him. While, as said, many Democrats saw a bounty of riches and said they'd be happy with either candidate, the truest of the true believers in either camp simply couldn't stand the rival politician. Inevitably, the most dedicated Clintonites would feel deprived if Hillary lost, and the most passionate Obamans would feel disenfranchised if Barack got beat.*

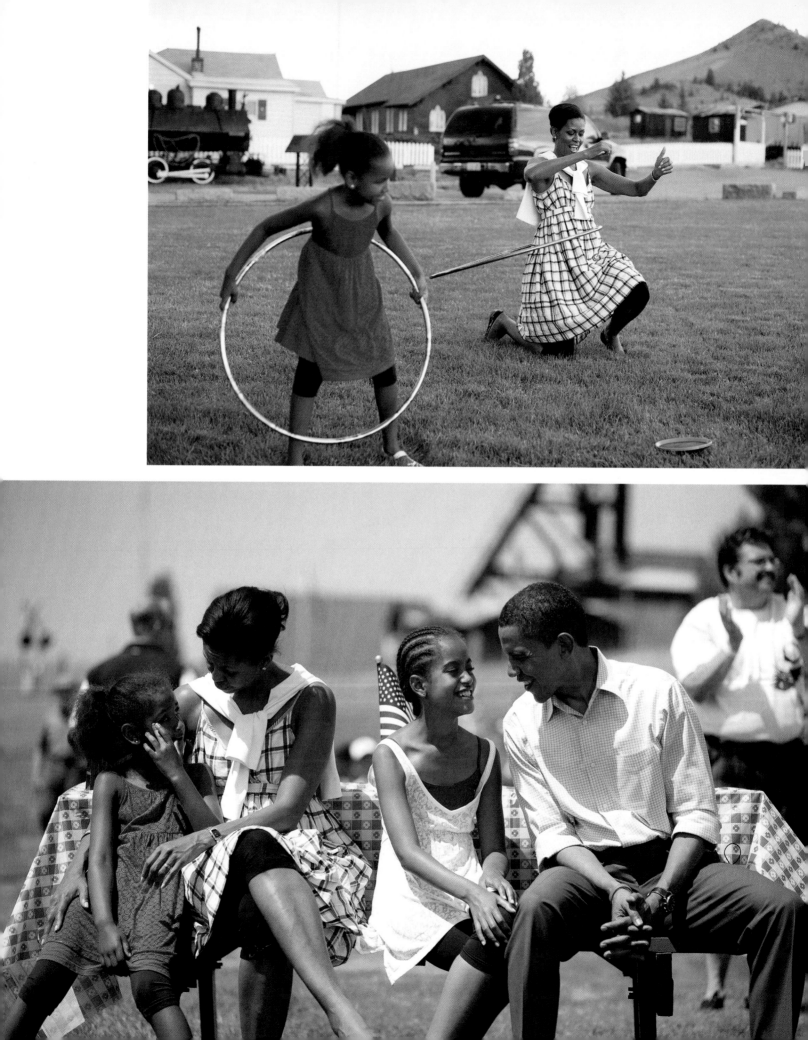

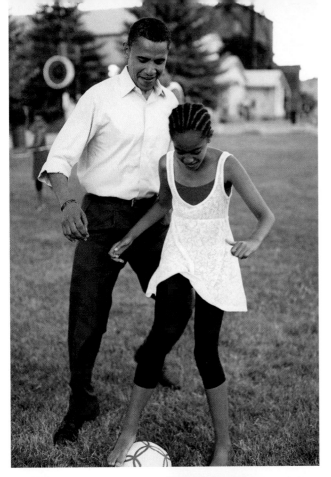

W hat a difference a year makes. Precisely 12 months to the day after the Obama family energized a Fourth of July event in Des Moines, they are doing the same at a 2008 parade and picnic in Butte, Montana. The images—Sasha hula-hooping with Mom, Malia kicking the ball with Dad, the girls concentrating on Uno—seem of a piece with the earlier ones from the Midwest. But something has changed dramatically: Jump-started by his victory in the Iowa caucuses, Obama has gone on to win more than his share of supertight contests, and is now the presumptive Democratic party nominee for President.

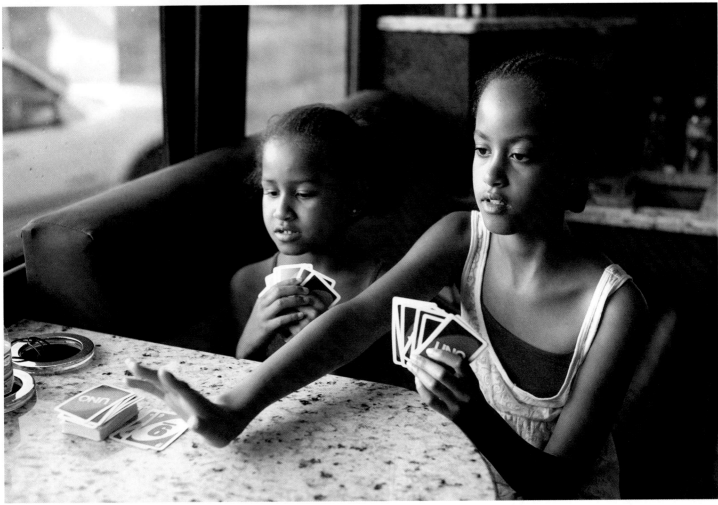

The spouses of candidates are also subjected to excruciating scrutiny: What kind of First Lady will she be? Will she bake cookies? Is she a dutiful mom? Can she steady him? Will she be in the Cabinet? The expectations of what a First Lady might or might not do or be were changed forever by Hillary Clinton's tenure in the White House. There had been strong and effective women before her, to be sure. Eleanor Roosevelt was a public figure of near equal stature to Franklin Roosevelt, and Edith Wilson all but assumed the duties of the presidency when Woodrow Wilson was incapacitated. But Hillary was forthright and forceful and, yes, public. Michelle, smart as a whip and confident, looked like a Hillary. Would she be? She both did and did not work against such expectations during the campaign. Here, she helps her husband with remarks that he will deliver momentarily to supporters in Chicago.

YANA PASKOVA/NEW YORK TIMES/REDUX

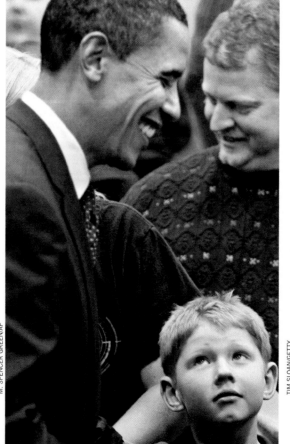

I t's a youth movement. As the weeks and months wore on, Obama's big selling point became, increasingly, his style. He was different and vibrant and . . . young. His campaign's efforts to draw comparisons to JFK proved successful, and armies of the young volunteered to work for him (above, Obama's Chicago presidential campaign headquarters). Those even younger looked up to him (far right, a Virginian; right, a boy from Iowa). The excitement flowing to and around the candidate spread overseas. On the following pages, Obama wades into a sea of adoration in Berlin during his July 2008 tour of Europe and the Mideast.

M. SPENCER GREEN/AP

TIM SLOAN/GETTY

CALLIE SHELL/AURORA

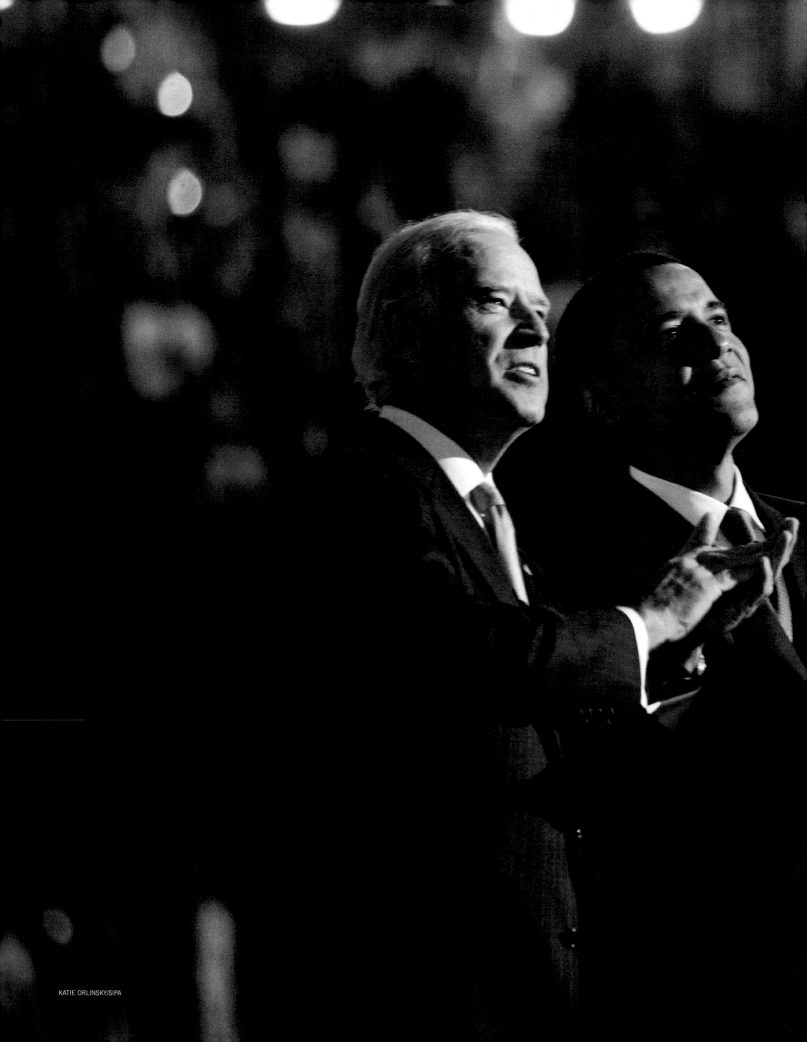

W hen the Democrats encamped in Denver for their national convention during the last week of August 2008, concern was in the air. John McCain had been showing strength in national polls, questions were swirling about whether Hillary and Bill Clinton might be a disruptive force, party operatives were telling their presumptive nominee that he needed to better "define" himself. In the event, the convention was a rousing success. On opening night, the old lion Ted Kennedy, suffering from brain cancer, made a dramatic, emotional appearance and thrilled the crowd with a vigorous speech. Twenty-four hours later, Hillary Clinton was eloquent, inspiring and triumphant in throwing her support behind Obama and calling for unity—a call echoed by her husband on the following night. After Bill Clinton came Obama's vice presidential choice, the veteran senator from Delaware Joe Biden, who boosted the ticket's foreign policy bona fides with a strong speech. Here, Biden shares the stage on that night with a "surprise guest" who had arrived in Denver earlier in the day. The next night would be Obama's alone, and he certainly did define himself—as a fierce advocate for a new direction and as an emphatic foe of John McCain. With a crowd of 80,000 in a football stadium, the setting and performance recalled John F. Kennedy's "New Frontier" acceptance speech 48 years earlier at the Los Angeles Coliseum. Mission accomplished at the convention, it was back to the quest.

ASPECTS
OF
OBAMA

HOW IS THE MAN VIEWED?
DIFFERENTLY BY THE BLACK MAN
AND THE WHITE, THE CULTURAL
ANTHROPOLOGIST AND THE
HISTORIAN, THE NORTHERNER AND
THE SOUTHERNER, THE IMMIGRANT
AND THE FOREIGNER, THE WOMAN
WHO SUFFERED WHEN HILLARY
GOT BEAT. *LIFE* ASKED 12 FINE
THINKERS AND WRITERS TO LOOK
AT THE MANY SIDES OF OBAMA, AND
TELL US WHAT THEY SEE. THEIR
ESSAYS ARE THOUGHT-PROVOKING,
INCISIVE, SOMETIMES FUNNY,
ALWAYS HELPFUL IN UNDERSTANDING
THIS MAN WHO HAS SO RAPIDLY
SEIZED THE AMERICAN SPOTLIGHT.

AP

Like Yesterday, and Not
By Richard Norton Smith

THE VOICE WAS UNFAMILIAR, as befitting one whose sum total of elective office experience was three and a half years as governor of Illinois. Yet for millions hearing Adlai Stevenson for the first time as he welcomed his fellow Democrats to their national convention in Chicago, it was an electrifying debut. Speaking in the shadow of Senator Joseph McCarthy, and in counterpoint to fears stirred by cold war rivalries, Stevenson reminded his audience of the unique perspective afforded by his native Midwest. "Our commerce, our ideas, come and go in all directions," he told them in the third week of July 1952. "Here there are no barriers, no defenses to ideas and aspirations. We want none; we want no shackles on the mind or the spirit, no rigid pattern of thought, no iron conformity."

More than a few professional politicians thought Stevenson spoke over the heads of his listeners. In truth, it was the pols who didn't grasp the unconventional appeal of one who refused to beat his breast

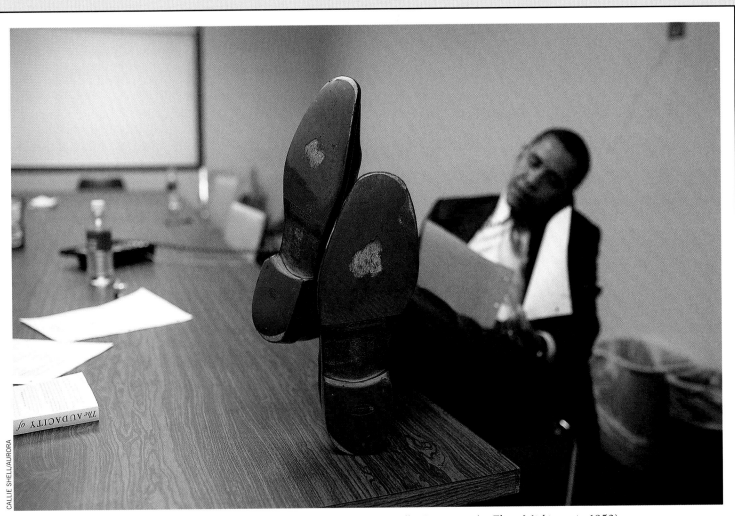

CALLIE SHELL/AURORA

*Sole mates: The presidential campaign trail has worn on Adlai Stevenson (in Flint, Michigan, in 1952)
and Barack Obama (in Providence, Rhode Island, in 2008).*

or claim miracles for his long-entrenched party. After all, said Stevenson, "we dare not just look back to great yesterdays. We must look forward to great tomorrows."

Fast-forward to the 2004 Democratic convention in Boston. Anyone listening to the keynote address as delivered by a gangling, charismatic state senator from Illinois named Barack Obama could easily imagine great tomorrows for this Stevenson with soul. Of course, there were differences; the brainy Obama had famously served as president of the *Harvard Law Review,* while Stevenson in the sociable 1920s had flunked out of the same school.

He might have been heir to FDR and Harry Truman, but Stevenson's Democratic party was still propelled by a solid (and solidly racist) South. To be sure, the engine was running on fumes, its very unreliability demanding the vice presidential selection of Alabama's segregationist senator John Sparkman. Moreover, Stevenson's nomination came at the end of 20 years of Democratic rule, when even he secretly believed the country could do worse than to elect General Dwight Eisenhower, a political moderate and confirmed internationalist.

Half a century later, the shoe is on the other foot. George W. Bush's dismal poll ratings rival those of Harry Truman in the twilight of his presidency. The war in Iraq and the concept of preemptive military action are as alien to twenty-first-century Americans as Truman's "police action" in Korea was to their grandparents.

Some things seem precisely the same. Now, as then, charges of elitism were hurled against the Democratic nominee, fed in Obama's case by his dismissive comments about small-town America, his effortless eloquence and almost eerie equanimity. More entertaining was Stevenson's refusal to take the rituals of campaigning as seriously as the business of governing. Imagine a candidate in YouTube America responding to the admirer who assured him that he enjoyed the support of every thinking voter, as Stevenson did, by declaring this wasn't enough—"I need a majority to win."

Indulging his sense of humor got Stevenson in trouble more than once, but to fans who proclaimed themselves "Madly for Adlai," the candidate's spontaneous wit gave evidence of an authenticity that had yet to be smothered by today's spin doctors. No matter; their devotion could not prevail against the electorate's overwhelming desire for change and Ike's larger-than-life persona. *A desire for change and a larger-than-life persona.* Interesting.

To call Obama a historic figure understates his transformative potential, which only begins with race. In a curious, counterintuitive way, the junior senator from Illinois recalls Stevenson's heroic opponent. Eisenhower's history was our history; a shared story of sacrifice coauthored by 16 million citizen soldiers, their families and the communities they left to combat Nazi tyranny and its genocidal obsession with racial purity. For many GIs, the Second World War became a second American Revolution, exposing the hypocrisy of fighting foreign racism while deferring to Jim Crow at home.

Just as no one belonging to the Greatest Generation could be ignorant of the challenge posed by Europe's strutting dictators, so it is hard to conceive how their children could be oblivious to the unfinished business of American democracy. Born in 1953, I was too young to appreciate Ike's action in sending federal troops to Little Rock—enforcing a court order, he insisted—so that nine black children could attend a school previously reserved for whites only. But I remember, vividly, pictures of police dogs and fire hoses turned on civil rights demonstrators in Birmingham, Alabama. Such images are part of my generation's electronic scrapbook, sharing space with George Wallace standing in the schoolhouse door; Bloody Sunday at the Edmund Pettus Bridge; and Dr. King's dream, unforgettably set forth in the marbled company of the President who, a hundred years earlier, had promised his countrymen a new birth of freedom.

That it was a promise manifestly unkept came home to me a year after Dr. King's speech. A youngster of annoying precocity when my family made its first trip to the nation's capital, in the autumn of 1964, I insisted we detour to visit nearby battlefields in the ancient war that some Americans, at least, were still fighting. In one dining establishment in rural Virginia we sat down to find paper place mats whose large-type greeting gave a whole new twist to Southern hospitality.

WE APOLOGIZE FOR OUR GOVERNMENT

I no longer recall the precise wording that followed, except that it begged the indulgence of customers for errant lawmakers in Washington who, by enacting the so-called Civil Rights Act of 1964, had robbed individual proprietors of their God-given right to deny service to whomever they chose. Resistance so raw made an indelible impression. That it was directed at patrons presumed to share the owner's views was more revealing still. In the years that followed, additional laws would be passed, epithets and stones hurled, fires lit and martyrs made.

I trace much of my generation's history to that dusty little eatery, symbolic of Americans without number who can narrate their own stories of racial confrontation, reconciliation and unease. Perhaps this, in some small way, explains why Democratic primary voters showed themselves less inclined to embrace the feminist narrative of history than they were to address a guilty conscience 400 years in the making. Obama's generational appeal has often been linked to that of John F. Kennedy, coincidentally the last sitting member of the United States Senate to go directly from that talkative guild to the Oval Office.

The same comparison ushers in a paradoxical truth about the Obama phenomenon. Half a century on, Kennedy's breach of the ban on Catholics in the Oval Office seems less significant than it did at the time—certainly of less historical importance than his belated embrace of civil rights and the near-death experience of the Cuban Missile Crisis, to be followed in the summer of 1963 by a limited nuclear-test ban. Beyond his demonstrated growth in office, JFK changed forever how we look at the presidency, and how we define presidential style.

Barack Obama confronts no less a challenge, and just as great an opportunity. Not content to be the Un-Bush, he may yet assist his countrymen to get over their politically unhealthy fixation with the '60s. For a long time now, we have inhabited a country whose alleged 50-50 division is less political than cultural. If you revere the '60s as an era of long-overdue liberation, a killing ground for institutional hypocrisy and stifling conventions, you are likely to vote exactly the opposite from those to whom the tumultuous decade invokes a retreat from individual responsibility and a decline in communal standards.

The debate over the '60s long ago became a dialogue of the deaf. Thirty years later, the Clinton presidency was embroiled in this increasingly sterile shouting match; the even more polarizing Bush years have bred their own desire to turn the page. Enter Barack Obama. His post-ideological appeals to an electorate fed up with the politics of avoidance are radical in their implications. It's as if the change he tirelessly, if not always explicitly, promotes can only begin with the retirement of the boomers and their poll-driven, focus-grouped, 50-percent-plus-one approach to governing.

War rooms belong in the Pentagon, Obama implies, not the White House. The media, and many in his own campaign crowds, understandably dwell on the significance of inaugurating a black man as President on the bicentennial of Abraham Lincoln's birth. Obama's real contribution to history may be to break the logjam of American politics and to restore a measure of civility to the public square, without which there can be no great tomorrows.

THE HISTORIAN AND BIOGRAPHER **RICHARD NORTON SMITH**, A REGULAR COMMENTATOR ON PBS AND ELSEWHERE, IS THE AUTHOR OF *PATRIARCH: GEORGE WASHINGTON AND THE NEW AMERICAN NATION* AND SEVERAL OTHER BOOKS. HE IS CURRENTLY WORKING ON A BIOGRAPHY OF NELSON ROCKEFELLER.

Mother and son in 1968

About Ann

By Gay Talese

BACK IN THE EARLY 1960s when I was a young reporter with *The New York Times* and when front-page stories across the country were increasingly recounting incidents of interracial tension and turmoil, I was assigned to interview former President Harry Truman during one of the morning strolls he customarily took while visiting New York, and among the questions I asked him was: "Wouldn't the occurrence of more interracial marriages in America possibly be a step toward a more integrated and less segregated society?"

"I hope not," Mr. Truman said unhesitatingly, as he kept a lively pace amid a parade of reporters along Park Avenue, explaining that he had always been opposed to mixed marriages and intimate cohabitation between the races. "What's that word about four feet long?" he asked.

"Miscegenation," I responded, hoping he would be impressed that I knew the word. But he only turned toward me with a frown and asked: "Would you want your daughter to marry a Negro?"

"Well," I said after a pause, surprised that this interview had now become personal, "I would hope that a daughter of mine would marry the man she loved."

"You haven't answered my question," Mr. Truman replied sharply.

I said nothing, tagging along next to him while keeping my eyes lowered as I took notes with my ballpoint pen on the folded sheets of copy paper I carried.

In those days miscegenation was defined as illegal in about half the states within the nation, but it was also true that the issue Mr. Truman seemed to raise with his question—"Would you want your daughter to marry a Negro?"—was being publicly addressed in various ways during the 1960s by the disparate likes of fearmongering Southern sheriffs and Harvard-trained historians and such literary polemicists as the black writer James Baldwin. "I don't want to marry the white man's daughter," Baldwin mentioned often in his lectures and appearances on television shows, "I just want to get the white man off my back." But in his book *The Fire Next Time*, published in 1963, Baldwin wrote:

> The only thing white people have that black people need, or should want, is power—and no one holds power forever. White people cannot, in the generality, be taken as models of how to live. Rather, the white man is himself in sore need of new standards . . . [and] the price of the liberation of the white people is the liberation of the blacks—total liberation, in the cities, in the towns, before the law, and in the mind. Why, for example, especially knowing the family as I do, I should want to marry your sister is a great mystery to me. But your sister and I have every right to marry if we wish to, and no one has the right to stop us. If she cannot raise me to her level, perhaps I can raise her to mine.

The editor of *Commentary* magazine, Norman Podhoretz, in his 1963 essay "My Negro Problem—and Ours" wrote that the American Negro's past is a "stigma, his color is a stigma, and his vision of the future is the hope of erasing the stigma by making color irrelevant, by making it disappear as a fact of consciousness. I share this hope," Podhoretz went on, but added:

> I cannot see how it will ever be realized unless color does *in fact* disappear: and that means not integration, it means assimilation, it means—let the brutal word come out—miscegenation. . . .

"Would you like your sister to marry one?" When I was a boy and my sister was still unmarried, I would certainly have said no to that question. But now I am a man, my sister is already married, and I have daughters. If I were to be asked

today whether I would like a daughter of mine "to marry one," I would have to answer: "No, I wouldn't like it at all." I would rail and rave and rant and tear my hair. And then I hope I would have the courage to curse myself for raving and ranting, and to give her my blessing. . . .

AT THE TIME OF THE PUBLISHED WORKS BY JAMES BALDWIN and Norman Podhoretz and other commentators on racial issues, there was a Kansas-born white couple named Stanley and Madelyn Dunham whose 18-year-old daughter had given birth to the son of the 25-year-old black man she had married. The young parents' son, Barack Obama, was named in honor of his African father.

"That my father looked nothing like the people around me—that he was black as pitch, my mother white as milk—barely registered in my mind," Obama wrote in *Dreams from My Father*. Elsewhere in that first memoir, he posed the familiar question: "Would you let your daughter marry one?" and then responded: "The fact that my grandparents had answered yes to this question, no matter how grudgingly, remains an enduring puzzle to me. There was nothing in their background to predict such a response, no New England transcendentalists or wild-eyed socialists in their family tree. True, Kansas had fought on the Union side of the Civil War; Gramps liked to remind me that various strands of the family contained ardent abolitionists . . . but an old, sepia-toned photograph on the bookshelf spoke most eloquently of their roots. . . . Theirs were the faces of American Gothic, the WASP bloodline's poorer cousins."

The decision to bring a black husband into the Dunham household had been made entirely by Obama's mother, a shy and bookish woman. She had suffered from asthma as a child and this, along with the disorientation she experienced as a schoolgirl traveling from town to town due to her restless father's endless pursuit of job opportunities, meant that she developed few lasting relationships with schoolmates and devoted much of her leisure time to reading and taking solitary walks.

She was Stanley and Madelyn's only child. They had eloped and proceeded to live on army bases following Stanley's enlistment in World War II. Ann was born in 1942, and, as we have learned earlier in this book, since her father had wanted a son, he named her after himself—"Stanley." Her full name was Stanley Ann Dunham. She would subsequently receive much unwanted attention from classmates referring to her as "Stanley Steamer" and "Stan the Man."

After the war her parents lived in California while her father attended Berkeley on the GI Bill. But he soon quit to embark upon what would prove to be at best a modestly remunerative career in sales, selling furniture at times, selling insurance at other times. From California he had resettled in Kansas with his wife and child, but

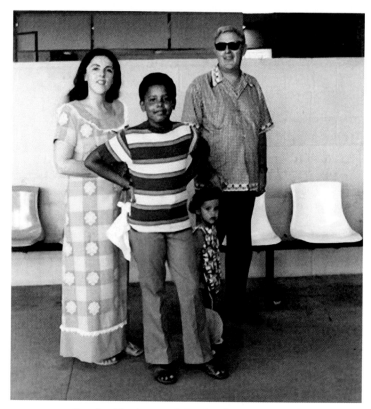

Stanley Dunham with his daughter, Ann, and his grandchildren, Barack and Maya

during his daughter's elementary school years, they were residing in various parts of Texas. They were living in Seattle when she graduated from high school, and in Honolulu when she enrolled at the University of Hawaii. It was on the college campus that Stanley Ann Dunham met and soon fell in love with an African scholarship student named Barack Obama; and in 1961, the year of their marriage, they had the son who would become the famous man who is our subject.

"In many parts of the South, my father could have been strung up from a tree for merely looking at my mother the wrong way," Obama wrote in his memoir, adding that "in the most sophisticated of northern cities, the hostile stares, the whispers, might have driven a woman in my mother's predicament into a back-alley abortion—or at the very least to a distant convent that could arrange for adoption. Their very image together would have been considered lurid and perverse, a handy retort to the handful of softheaded liberals who supported a civil rights agenda."

The young bride's parents, according to this account, had initially been "wary" of their daughter's suitor but gradually were "won over by his charm and intellect"; and as they had miscalculated "my mother's quiet determination," they now had a dark-skinned grandchild to deal with: "eight pounds, two ounces, with 10 toes and 10 fingers and hungry for food. What in the heck were they supposed to do?"

Although the book suggests that his mother had experienced limited social contact with black people prior to the courtship, Obama does write that when Ann had been a grade school student in Texas

and had been playing in the yard outside her parent's home one day with a young black girl, the two of them were confronted by a group of white adolescents shouting "nigger-lover, nigger-lover" in the direction of Stanley Ann Dunham. One of the taunters hurled a rock over the picket fence that fronted her family's property. Suddenly her mother appeared to disperse the crowd, and later her father made phone calls to the parents of the offenders expressing his outrage over the incident. But he was told: "You best talk to your daughter, Mr. Dunham. White girls don't play with coloreds in this town."

WHEN STANLEY ANN DUNHAM WAS 16 and working as an au pair during the summer in Chicago—having never before lived away from her parents—she went to see her first foreign film, *Black Orpheus*. It was a Brazilian adaptation in Technicolor of the mythological Greek love story of Orpheus and Eurydice, reset in Rio during the carnival season and featuring street scenes of flamboyantly attired black actors dancing to samba music and gyrating to drum sounds. A triumph at the Cannes film festival in 1959, and in 1960 receiving the foreign-film prize at the Academy Awards, *Black Orpheus* might have also been regarded as quite risqué by the standards of the somewhat sheltered young woman that Stanley Ann then was; but she nonetheless enjoyed the film immensely and—according to her son's book—she equally enjoyed it a second time decades later when it appeared at a revival theater in New York City.

Her son had begun attending Occidental College near Pasadena in 1979, but two years later he had transferred to Columbia University, and it was during this time that his mother had visited him. After reading in a newspaper that *Black Orpheus* was being shown downtown, she urged that they go together to see it. He agreed but soon regretted that he had, finding the story line simple and the scenery underwhelming as throngs of "black and brown Brazilians sang and danced and strummed guitars like carefree birds."

Midway through the film, as he later recalled in his book, "I decided that I'd seen enough, and turned to my mother to see if she might be ready to go. But her face, lit by the blue glow of the screen, was set in a wistful gaze. At that moment, I felt as if I were being given a window into her heart, the unreflective heart of her youth. I suddenly realized that the depiction of childlike blacks I was now seeing on the screen, the reverse image of [Joseph] Conrad's dark savages, was what my mother had carried with her to Hawaii all those years before, a reflection of the simple fantasies that had been forbidden to a white middle-class girl from Kansas, the promise of another life: warm, sensual, exotic, different."

At this time she had long been divorced from her African husband. Her son had been just a year old when the elder Barack Obama, who had graduated in 1962 as the top student at the University of Hawaii, received a scholarship to pursue graduate studies at Harvard—an opportunity that came, as we learned earlier, without sufficient funds to take his family with him. This separation would influence Stanley Ann's decision to divorce him. She regularly corresponded with him after he received his Harvard degree and returned to Africa (where he remarried); in the early 1970s she welcomed him as a monthlong guest in Hawaii during which time he became reacquainted with their son, who was then in grade school. For young Barack Obama it would be a final meeting, as his father would later be killed in an automobile accident in Africa.

His mother would die of ovarian cancer in 1995 at the age of 52, a year before Obama began his political career in the Illinois legislature. She had lived long enough to read the manuscript pages of *Dreams from My Father*, and as he noted in the book's introduction: "She would read the drafts, correcting stories that I had misunderstood, careful not to comment on my characterizations of her but quick to explain or defend the less flattering aspects of my father's character."

She had spent many of her adult years as an anthropologist in Indonesia, where she spoke the language and where she continued to live for prolonged periods even after her divorce from her Indonesian husband. Whether she was residing in Indonesia or Hawaii or elsewhere, her personal and professional existence was anthropological in nature, founded in her sincere interest in and her acceptance of many different kinds of people. Her son in his speech on racial relationships in America, delivered in Philadelphia in March 2008, expressed pride in the fact that "I have brothers, sisters, nieces, nephews, uncles and cousins of every race and every hue, scattered across three continents," while not failing to mention that his wife, Michelle, a native of Chicago whom he married in 1992, is "a black American who carries within her the blood of slaves and slave owners."

What Senator Obama did not mention in his speech, but what is evident in the nation's latest census figures, is that 7 million people in the United States are now identifying themselves as multiracial, and in this group are such individuals as the baseball player Derek Jeter (black father, white mother); the actress Halle Berry (black father, white mother); the musician Lenny Kravitz (white father, black mother); the singer Mariah Carey (half black, half Venezuelan father, Irish mother); and the golfer Tiger Woods (father half black, quarter Chinese, quarter Native American, and mother half Thai, quarter Chinese and quarter Caucasian). And so wherever Barack Obama's skills and convictions take him in the years ahead, he already represents millions of Americans who are living testimony to a once-derogatory term that is rapidly being phased out in the language: miscegenation.

GAY TALESE, ONE OF THE COUNTRY'S MOST CELEBRATED WRITERS OF NONFICTION, IS AUTHOR OF SEVERAL BOOKS, MOST RECENTLY *A WRITER'S LIFE*.

A Clintonista Comes Over

By Regina Barreca

BEFORE I WAS A BARACK OBAMA SUPPORTER, I was a Hillary Clinton supporter. The reason I was an HRC fan was simple: I wanted to see a woman in the White House as President.

Let me give you some history.

When Geraldine Ferraro accepted the Democratic party's vice presidential nomination in 1984, I was 27 years old, living in New York City and putting myself through graduate school. Time passed; I watched a couple of movies, ordered some pizzas, wrote a few books, taught a handful of classes and suddenly realized I was 50 years old, a Connecticut homeowner and a full professor, and that Nancy Pelosi was Speaker of the House. O.K., so it took a while for another woman to come to the fore—even though it didn't seem terribly long, at least not when the movies were good.

I saw Ferraro and Pelosi as evidence of "our" success in politics. But I wanted the process to accelerate. I wanted Hillary Rodham Clinton to win the Democratic primary and I wanted to see a woman as POTUS rather than FLOTUS.

If we're being honest here, I should also confess that I did think in terms of "we." I thought of Hillary as being "one of us." It was a tribal notion, I'll freely admit, born of the idea that somebody like "us" could become Commander in Chief.

Hillary's strength, passion and "mouth" marked her as one of us. Only certain women have "a mouth" on them, and they've traditionally been treated with respect whether they're at the center of big families in immigrant neighborhoods or at the center of financial empires. They work well with others but refuse to be dominated by them. They're as indestructible as gristle—and only slightly less palatable to those who expect a dainty, sugary treat from persons of female extraction.

I'd hoped that we could show the world you didn't have to imitate Margaret Thatcher (talk about gristle) to be the head of a First World nation and be a woman. I wanted to see Hillary embody, as President, what women of my generation strived to make possible: the idea that you could be smart, opinionated and imperfect (and married to a guy who was smart, opinionated and imperfect—not to mention visible, since a lot of the husbands of previously powerful women have been invisible) as well as have a family and an emotional life when in a position of great responsibility.

Whew. Sounds like a lot for one person, doesn't it?

This leads to one of the reasons that HRC was so admirable during the race: She was willing to sacrifice conventional femininity, which the culture still equates on some level with passivity and nonaggression, on the altar of public service. She knew she would be called every hateful name in the book, be ridiculed, lampooned, mocked and attacked outright, but she didn't shrink from the battle.

She made some concessions to media attention, but these were minor. She learned, for example, to avoid looking like a woman who is being attacked by her own hair and/or strangled by her own jewelry. She stopped wearing those collars that made her look as if her head were being presented on a platter.

But she stood her ground.

It was important to a lot of us that Hillary kept fighting, even after everybody told her to sit down and shut up. A lot of women have been told over the years to sit down and shut up, have been told to relax, have been told that those who know better are taking care of things, and that we should stay out of it because we don't understand the full complexity of the situation.

For too long too many women paid attention.

Hillary paid attention and then did it the way she decided was best. She wasn't participating in the race to show that a woman could do it; she was in it to win.

That's important.

This wasn't some movie where Julia Roberts or Meg Ryan gets to play what in filmspeak is referred to as a "feisty" or "spitfire" character who ends up marrying Hugh Grant or Tom Hanks and going out of business for good once she's proven that girls can play at a boy's game. It's crucial that Hillary could say to her supporters, "I did everything I could," and prove that there wasn't some trick still shoved up her sleeve or tucked into the hem of her skirt. This was politics fought hard, down to the bone, with nobody taking a dive simply in order to get out of the ring. It was exhilarating, as blood sports usually are. And because there was so much at stake, hearts were broken.

It's no surprise, then, that pinned above my desk is a cartoon by Liza Donnelly, which—in one frame—effectively and unashamedly summed up my response to Barack Obama's victory in the primaries: One woman, cup of coffee in hand, says to the other, "I'll vote for Barack, but only because Michelle will make a great President someday."

Hillary Clinton was not only distinguished—she was distinguishable. As with Barack Obama, she would never be mistaken for another politician; they look like people who are famous for other

"I'll vote for Barack, but only because Michelle will make a great President someday."

diversity for photo shoots. Yes, they were that to some people of course, but they were more: They were themselves.

I admired this about both candidates; it linked them inextricably. I knew whichever of them won the Democratic primary, he or she was going to be a candidate who prevailed not because his or her parents banged a boat up against Plymouth Rock and therefore assumed a hereditary knowledge of how the Constitution should work (as if that were built into DNA along with the gene for a patrician nose and a preternatural adroitness at badminton) but because his or her right to lead the country had been earned. This was going to be a person who understood that while talk is politics, politics can't be all talk. Barack and Hillary were, both of them, combinations of the realist and the rhetorician.

Two things became clear during the Democratic primary season. One was that with either Barack Obama or Hillary

things. A scarlet thread running through a gray suit, Hillary was pointed out and pointed to, measured against others from whom she was clearly different; in this respect, too, she is like Barack. Their detractors were quite right to worry that these two would outshine their more anonymous, uniform colleagues.

Interestingly, not everyone who resembled them in the most superficial sense regarded them as champions. Many female voters were wary of Hillary in much the same way that some voters from groups disenfranchised by race were wary of Barack: The successes of these two remarkable Americans refuted the notion that a disappointing life or a batch of unfulfilled dreams were the fault only of irrevocable outside forces. Both Barack and Hillary realized that what we, as a nation, need to confront is the unspoken and yet undisguised envy and contempt that one half of the population of our country has for the other.

Both Barack Obama and Hillary Rodham Clinton made their way into the center of the race for the most powerful office in the country; they were not figures at the edges. They were not there simply as representatives of their groups—as the "woman's face," or the face of an African American man—deftly positioned to offer evidence of

Clinton in the White House, social irresponsibility would become as tacky as unbrushed teeth. It also became clear that an intelligent series of debates could put the "interest" back into "public interest." Citizens who had never before registered to vote signed up and got involved politically; folks who had never watched non-game-show programming for longer than three minutes found themselves listening carefully to arguments and weighing both sides. And we know how involvement works: Once people are actively engaged in the political process, they usually discover a deep-seated sense of security and pride in the fact that politics is now suddenly in very able hands, since those hands belong to their own dear selves.

Finally, the reason why so many of us who were once Clintonistas became enthusiastic supporters of Barack Obama wasn't Michelle (not necessarily) but this: It became clear to us that Barack Obama was not so much Hillary Clinton's rival as he was her successor. And it became crucially evident that all of us were running in this race together.

REGINA BARRECA IS THE AUTHOR OF SEVERAL BOOKS ON FEMINISM, HUMOR AND THE CONFLUENCE OF THE TWO, INCLUDING *THEY USED TO CALL ME SNOW WHITE . . . BUT I DRIFTED* AND *PERFECT HUSBANDS (AND OTHER FAIRY TALES)*.

Before Liftoff

By Bob Greene

IN A BOARDING AREA AT REAGAN NATIONAL AIRPORT outside Washington, D.C., I read the sports section and killed time before my flight.

This was in September 2006. I had brought my son to college, had helped him get settled in for the fall term and had stayed in town a few extra days. Now I was at the airport, waiting to board a flight to Chicago.

In the main hallway of the concourse, passengers from flights that had just landed were walking—some briskly, some distractedly, some wearily—toward baggage claim. They all bore that sort of wrung-out expression that people who have just disembarked from commercial flights tend to have, and I looked out at them from where I was sitting and I saw that among them, by himself and accompanied by no one, was Barack Obama.

Now, Obama was a national figure by September 2006. He had been serving in the United States Senate for well over a year; he had just returned from a trip to Africa that had been thoroughly covered by the media. His keynote address at the 2004 Democratic convention had made him a rising star in politics.

Yet here he was, one traveler in the midst of many. No security detail or assistants were in evidence. The release of his book *The Audacity of Hope*, which would catapult him into a higher stratum of celebrity, was still a month or so away; his announcement of his candidacy for the presidency would not come until early the next year. He walked among the other travelers, speaking to no one, spoken to, at least for the moment, by no one, and on that day it occurred to me: Scenes like this were probably about to become quite rare, if not nonexistent, for him.

There is a long-held American fascination with those whose rise is dizzyingly fast. We claim to honor men and women who achieve things the slow way, step by step, month by month, decade by decade. We say that those people—the tortoises of life, not the hares, building a deep résumé of solid achievement—are the ones worthy of emulation.

But, and this is not restricted to politics, our eyes tend to spark for those whom lightning somehow strikes. It happens once in a very great while: A person in the movies, or sports, or business, ascends from obscurity so rapidly and so powerfully that we cannot look away. Ascensions like that appear to defy not just the laws of proper ambition, but the laws of physics. There is something almost ghostly about the phenomenon.

Much has been written about Obama's career as a Chicago politician, and people around the country could be excused for thinking that, in Chicago and throughout Illinois, he must have been as famous back then as he is nationally today. But it wasn't so. Until his U.S. Senate run in 2004, Obama could have walked into most restaurants or retail stores in Chicago and not have been recognized by the majority of the other customers. He could have waited at a bus stop and not drawn a curious look.

So that moment at Reagan National Airport in 2006 is, for me, an image preserved in time, because it's not coming back. I have heard people tell similar tales about Obama in those days, being seen alone in public. He seemed to know the trick: Move fast but not too fast, draw no attention to yourself, look straight ahead and don't break stride. Years ago a famous athlete—as celebrated in his field then as Obama is in politics now—told me the secret was not to allow people to realize that you had been in their presence until several seconds after you had moved down the road. They're never expecting you to

In November 2005, Senator Obama travels solo through Chicago's O'Hare Airport.

be there, wherever "there" is. The athlete said he had learned to use that knowledge as a tool.

There comes a time, though, when those whose fame grows most incandescent see that fame veer out of their own control. For Obama, that time arrived in 2008. Always surrounded by reporters, his "body man" ever at his elbow, his Secret Service detail as much a part of his wardrobe as the clothing he puts on every morning . . . It must be difficult for a man leading the life that Obama has come to lead to imagine that it can ever be the old way again.

There is a documentary film called *Elvis '56*, about the year when everything changed for another American who was thrust into this most uncommon position. At the heart of the film is a series of black-and-white photographs shot by a freelancer named Alfred Wertheimer while on assignment for RCA Victor. You can see in the photos that Elvis Presley began 1956 as a performer who could still allow himself the luxury of being himself, and being by himself:

window-shopping at a clothing store, walking from a train toward his parents' house in Memphis.

That ability went away during those 12 months. The documentary's narrator is Levon Helm. At the end of the film, he says that after that transformational year, Presley went on to make dozens of motion pictures, to sell hundreds of millions of records, to become wealthy beyond anything he had ever imagined. Over the final images in the documentary—shots of Presley in a car, being chased by fans—Helm's concluding words are:

"But after 1956, we'd never be able to get that close to him again."

On that day in the airport in Washington, putting down the sports page for a second, I watched Obama, alone in a crowd, a man perhaps already seeing the vaguest outlines of where he was heading.

BOB GREENE IS THE AUTHOR OF MANY BOOKS, MOST RECENTLY *WHEN WE GET TO SURF CITY: A JOURNEY THROUGH AMERICA IN PURSUIT OF ROCK AND ROLL, FRIENDSHIP, AND DREAMS.*

A Pilgrim's Progress

By Nancy Gibbs

For a man whose very name means "blessed," Barack Obama presented a historic challenge to his party and our politics. His promise of "Change We Can Believe In" included a change in the very role of belief, in particular, religious belief as it patrols the public square. That he should be a prophetic voice suited his history; that he should move to close the electoral "God Gap" served his strategy. But as generations of candidates before him discovered, placing one's faith at the center of one's candidacy can bring as many risks as rewards, and his experience was just the latest reminder of how hard it is to build a bridge between the Two Kingdoms.

For as long as pollsters have polled, Americans have said they want their President to be a person of faith, as though the acknowledgement of some higher power acts as one more check and balance on the highest office in the land. Even the modern Presidents have been the products of distinctly devout families: Truman's mother taught him to read using the family Bible; Eisenhower's was a Jehovah's Witness; Nixon's was called a "Quaker saint"; Kennedy's mother was a devout Catholic; Johnson's was heartbroken when he left the Baptist Church to join the Disciples of Christ. Ronald Reagan's mother prayed so ardently some parishioners thought she had the power to heal. Bill Clinton's grandmother used to tell him that he would have made a great preacher—"if you weren't such a *baaad* boy."

But Obama traveled a winding road, and he traveled alone. His Kansan mother was a seeker, raised by lapsed Christians, curious about all faiths, who lived for a while in a Buddhist monastery when she worked in India. He called her a deeply spiritual agnostic. His Kenyan father was raised a Muslim and became an eloquent atheist. When Obama attended a Muslim school in Indonesia, a teacher complained that he made faces while they were reading the Koran; at Catholic school he'd pretend to close his eyes during the prayers, then watch everyone else to see what would happen.

It was as an adult that conversion and conviction came. As a college student in New York he would wander into the back of a church in Harlem, savor the music, wonder at the words. He was a reluctant skeptic, he wrote in his memoirs, who could "no longer distinguish between faith and folly," and was "having too many quarrels with God to accept a salvation too easily won."

He worked closely with churches before he attended them, recruiting pastors to help with his community-organizing efforts in Chicago. "You know, you've got great ideas, Obama," he recalled local pastors telling him, "but if you're going to organize churches, it might help if you were going to church."

As we have learned in this book, he began attending Trinity United Church of Christ, a popular home for Chicago's black political and academic leaders. Eventually, he said, he came to "a choice . . . not an epiphany. I didn't fall out in church. The questions I had didn't magically disappear. But kneeling beneath that cross on the South Side, I felt I heard God's spirit beckoning me. I submitted myself to His will, and dedicated myself to discovering His truth." The Reverend Jeremiah Wright would baptize Obama, perform his marriage to Michelle LaVaughn Robinson, baptize their daughters and draw him into the raucous, restless, rooted family of faith that Obama had never had before.

That all constituted a personal journey; but in the years that followed there was a public quest as well. Obama could see as clearly as anyone the role faith played on the American political stage, where all roles and gestures were exaggerated and extreme. The Republicans were cast as the Party of God, Democrats as a bunch of sneering secular coastal elites. Republicans exploited faith voters, Democrats ignored them. Pollsters professed that the best predictor of voting behavior was not what you earned or where you lived but how often you went to church.

In all this, Obama saw an opportunity, and an obligation. The opportunity lay in a generational change, as old evangelical icons passed away and a new band of leaders wanted to talk about the poor and the planet as much as about gays and abortion. It lay in a growing consensus that something had gone wrong, that the phenomenon of politicians nailing campaign posters on the gates of heaven and laying exclusive claims to God's designs was unwise, unfair, even unholy. It lay in the conviction that religious voters are a diverse and divided cohort, and many of them were more concerned with the instructions Jesus gave than the ones James Dobson broadcast.

And so in his debut sermon, at the 2004 Democratic convention, Obama spoke of hope as "God's greatest gift to us, the bedrock of this nation. A belief in things not seen. A belief that there are better days ahead." It was time to put aside childish notions, reject false choices: "The pundits like to slice-and-dice our country into red states and blue states," he declared. "But I've got news for them, too. We worship an 'awesome God' in the blue states, and we don't like federal agents poking around in our libraries in the red states. We coach Little League in the blue states and, yes, we've got some gay friends in the red states. There are patriots who opposed the war in Iraq and

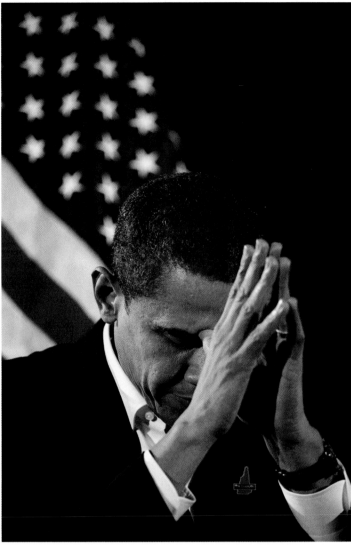

In New Hampshire in December 2006, a prayerful pose

there are patriots who supported the war in Iraq. We are one people, all of us pledging allegiance to the stars and stripes, all of us defending the United States of America."

The speech got an ecstatic reaction, propelling him overnight into the political pantheon. Two years later he went further, delivering what some reformers considered the most important speech on religion and politics since Kennedy's famous Houston testimony in 1960. It was at the annual Call to Renewal meeting that he lay down a challenge not only to those who would impose belief on others but to those who would deny it any space at all. "If we scrub language of all religious content, we forfeit the imagery and terminology through which millions of Americans understand both their personal morality and social justice," he said. "Secularists are wrong when they ask believers to leave their religion at the door before entering into the public square."

As soon as he launched his campaign for the White House, he recruited a full-time faith outreach team and lost no opportunity to discuss the central role his faith played in his life and vision.

Watching Obama soar out of Iowa, you had the feeling something epic had occurred, like the kind of mass revivals that used to sweep across the prairie and set souls on fire. Let others usher the party elders into mainline pews and preach about all their experience in a world that is being forfeited; Obama was busy building a new church, looking for the seekers, those who had lost faith in politics or never had any in the first place, and he invited them home.

He answered questions that his predecessors had never been asked, not just about the role faith would play in his presidency but whether God intervenes in history, how his pastor helped bring him closer to God, what he prayed for when he stood silently, with his head bowed, before the Western Wall in Jerusalem. By that time his faith had come to be a central feature of his candidacy—only not in the way anyone might have imagined at the outset.

His itinerant childhood, not to mention his middle name, were enough to sow Internet weeds that grew into rumors that he had been sworn into office on the Koran, refused to say the Pledge of Allegiance, was a secret Muslim himself. He asserted his identity as a Christian only to find himself called to account for the incendiary preachings of Reverend Wright and the political vamping of Wright's friend Father Michael Pfleger. By the Kentucky primary, he was reduced to having commercials testify that he was "a strong Christian." He didn't go to church on Mother's Day because it would have been a circus: "I am not going to burden the church at the moment with my presence," he sighed, and when the point came that he had to resign his membership at Trinity United altogether, he announced that he would not be joining a new church until after November.

And so even as the general shape of the landscape drew some religious voters to him, questions about his spiritual identity pushed others away. But he persisted in pressing the conversation, refusing to be pushed into a cubbyhole or category. He met in a Chicago law firm conference room with major leaders in the Catholic, evangelical and mainline Protestant churches, including Franklin Graham. While there was no consensus, there was certainly consideration. "There was no way I could leave that room not knowing this was a fellow brother in Christ," said Richard Cizik of the National Association of Evangelicals. Obama went to Zanesville, Ohio—the swing state's evangelical ground zero—to publicly embrace the idea of faith-based groups receiving public funds. He expressed reservations about late-term abortions. And he continued to lace his lessons with Biblical imagery, even as the commentariat began to mock his presumption, calling him "the One," the "Messiah," whose whole identity was just a few notches too transcendent for their taste.

Through it all, he was changing the terms of debate, in ways that

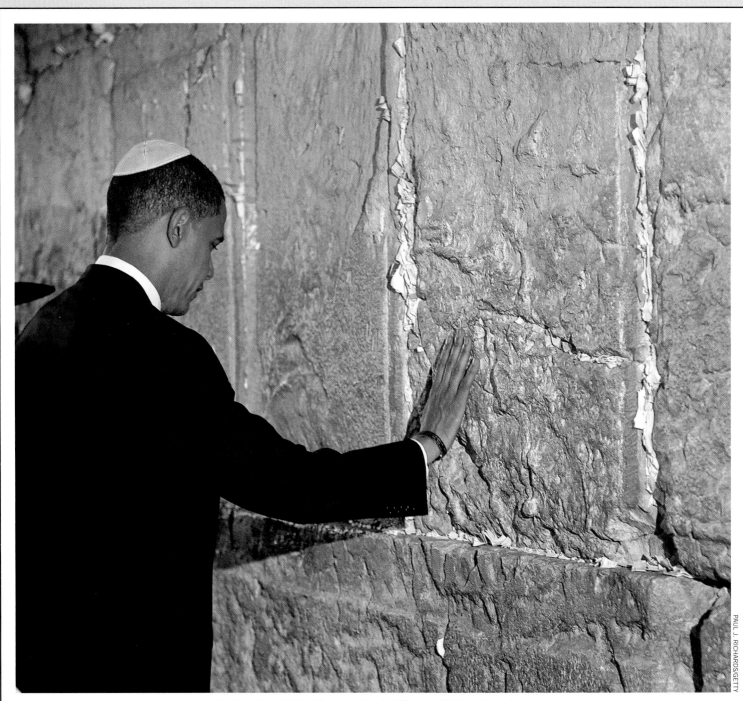

On July 24, 2008, Obama visits the Western Wall in Jerusalem.

may prove as lasting as the precedent of the first black major-party nominee, the first post–baby boom standard-bearer, the first to rally an army of new voters using new technology in pursuit of age-old goals. He was prepared to bear witness to his faith in God's purposes, discuss the influence of theology on his political philosophy, address the questions he raised in his first book: "How do we transform mere power into justice, mere sentiment into love?" On the one hand there was certainty that if faith meant anything, it surely meant a call to action, to help the least among us, to be our brothers' keepers. On the other, he was fully prepared to confess his doubts and talk of mystery, of what he didn't understand.

At a time when America grows ever more diverse, when more than two thirds of people believe that "many religions can lead to eternal life," Obama rejected "certainty theology" in favor of something more inquiring, more inclusive. Exotic though his biography may be, he is a pilgrim in a land founded by pilgrims and is resolved to restore some missing piece to the public square. If he manages to find a way for people of many faiths, or none at all, to address the moral dimensions of public life in a way that feels respectful and restrained, he will indeed have written a new chapter in a long American story.

NANCY GIBBS, A SENIOR WRITER AT *TIME* MAGAZINE, IS COAUTHOR OF THE ACCLAIMED BOOK *THE PREACHER AND THE PRESIDENTS: BILLY GRAHAM IN THE WHITE HOUSE*.

A Happy Warrior in Racism's DMZ

By John L. Jackson Jr.

LISTEN TO BARACK OBAMA TALK ABOUT RACE, and you hear real sanguinity about the future of democracy in an increasingly multiracial and multiethnic American society. Traditional racists' glasses are half empty, not half full, says Obama. Even when gently reminding white audiences not to fall for his opponents' attempts at race-based scare tactics during the campaign, he spoke with a confident smile. He listed the most recent, predictable nods to his name, his race and his peculiar biography as pathetic ploys that barely merited response, except by way of a simple dismissal, a waving of the hand that would banish such thoughts from polite public circles. Obama is an unyielding racial optimist, which is probably one of the best and worst things about him. It is also part of the reason why he cuts such a powerful figure in contemporary American electoral and racial politics.

Most African Americans can't even approach Obama's dogged public optimism on questions of race, at least not all of the time. They see a more measured link between racism and nationhood—a nuanced calculus of inclusion and exclusion, investment and indifference. Literary critic Salamishah Tillet describes this tension as the friction between official forms of national belonging and lingering race-based civic alienation. Similarly, UCLA law professor Devon Carbado distinguishes "American citizenship" from "American identity." The former describes a legal designation open to people from any racial group who satisfy certain standardized criteria. The latter refers to more informal and unwritten assumptions about nationality. In groping with American identity, people continue to internalize stereotypes about African Americans regarding what constitutes a truly American sensibility. Being American requires learning to think like an American, Carbado says, which combines a still-too-easy acceptance of black marginality alongside more laudable celebrations of a color-blind meritocracy and the American Dream.

The contradictions between American citizenship (the legal minimum) and American identity (what we truly feel) cast a long shadow across all of American history. But how the contradictions are manifested has changed quite drastically over the last 40 years or so. For most of our nation's history, racism has been nothing short of conspicuous, unflinchingly explicit. Politicians ran on segregationist platforms; legislatures passed laws lumping blacks and whites into discrete categories of personhood; courts constitutionalized second-class racial citizenship with decisions like the infamous "separate but equal" ruling of 1896. All the while, of course, America's written ideals about social equality were mocked by these commitments to racial discrimination.

Americans of several colors fought to end the profound double standards. And they succeeded—so much so, in fact, that public expressions of racial hatred today (even fairly subtle ones) are met with swift censure and social ostracism. Few people want to be considered racist anymore, and thank goodness for that.

But obviously, this hasn't simply meant the end of racism. Bias has, in many places and cases, just gone underground, cloaked in euphemized public niceties. In the politically corrected public sphere, where people are overly precious about whatever they say vis-à-vis race, racial skepticism thrives.

As an urban anthropologist who has spent many years conducting ethnographic research in New York City's Harlem, I have heard many a Harlemite wax nostalgic about the racial certainties of the Old South. It isn't, of course, that they long for the denigrations that accompanied Jim Crow. But they appreciated that there were assurances that came with life in an explicitly racist world. At least you could trust that racists would be racist to your face. You didn't have to fear that people were playing Jekyll and Hyde with their feelings, masking animus and vitriol in mixed company, while possibly harboring racist beliefs that were expressed only in the homogeneous spaces of our most intimate social worlds.

Racial skepticism comes from not quite knowing what lurks in the hearts of men, not knowing what the conversations sound like when your "kind" aren't in the room. That is why so many whites were surprised about those excerpts from Reverend Jeremiah Wright's sermons and his follow-up comments at the National Press Club, including his intimation that Obama might really agree with him (even if the politician could never admit it publicly).

Wright's comments notwithstanding, Barack Obama seems

genuinely sure about America's capacity to rise above racial skepticism and paranoia. In his books, Obama does a masterly job of explaining how and why African Americans and other minorities might "pull down the shutters psychologically, to protect themselves by assuming the worst." Obama recognizes that many black residents on, say, Chicago's South Side are suspicious of whites, and he can document some of the mistakes that have reinforced such suspicions. He explains how white activists and bureaucrats have at times inadvertently created a space for African Americans to believe the worst, to believe that white officials might be purposefully conspiring against the interests of black neighborhoods. Obama tells the tale of Marty, a white minority-employment activist who attempts to circumvent the inefficiency of city bureaucracies by funneling his resources through the suburbs, a move that some African Americans in Chicago see as yet another racist attempt to enrich middle-class white suburbanites at the expense of the urban black poor.

Obama understands both sides of the issue, even if they don't understand each other. He also firmly believes that both sides ultimately mean well most of the time. His job, he feels, is to get everyone else to see what he sees, to get us to think generously whenever we gaze across America's racial tracks. Obama boosts the robust potential of

Senator Obama and Reverend Wright in happier times: March 10, 2005

participatory democracy for all Americans, especially in an America where race has gone stealth. "I suppose I could spend time," he writes in *The Audacity of Hope*, "brooding over those men in the club, file it as evidence that white people still maintain a simmering hostility toward those who look like me. But I don't want to confer on such bigotry a power it no longer possesses."

Barack Obama knows that there are still racists lurking, and that they don't parade around in white sheets. But he wants to bring people together, to build community and bridge differences. He intends to show Americans that we can believe in one another, to convince us that trusting across racial lines is well worth the risk. Obama embodies both a big-tent blackness and a big-tent nationalism, even in the face of hidden racial animus. Sure, there is still hate and invective out there, but he hunts out the silver lining.

There is definitely something appealing—and perhaps healthy

and productive—about Obama's recalcitrant racial optimism, about the utter audacity of his hope. But it does make some people more skeptical about America's continued contradictory commitments to racial equality. Why did we celebrate the first black presidential nominee from a major party but demand that, on the stump, he be emphatically (and unrealistically) post-racial? This was just the latest version of the hypocritical tension that has haunted race relations since the birth of our republic.

Obama may well believe all that he says, but to some black Americans it sounds as if, to satisfy a white audience, he is "talking out of both sides of his neck," as it is colloquially labeled. This skepticism makes honest racial dialogue impossible.

JOHN L. JACKSON JR. IS THE AUTHOR OF *RACIAL PARANOIA: THE UNINTENDED CONSEQUENCES OF POLITICAL CORRECTNESS* AND *REAL BLACK: ADVENTURES IN RACIAL SINCERITY*.

First Love

By *David M. Shribman*

THERE IS ONLY ONE FIRST LOVE, and I think I watched my own child fall.

You have seen such falling before. For many of an older generation, it came with Kennedy, where it has proved curiously resilient in its hold on our imagination. Jack Kennedy had *style-and-grace*—the three words always come in a single burst when applied to JFK—and he had a sense of humor that hardly anyone now remembers was just short of sardonic. Without the Harvard degree and the Pulitzer he might have been part of the Rat Pack, living on the fringes of Hollywood instead of in a compound in Hyannis Port. And people—responsible adults with secure jobs—fell in love. The feeling lingers with them even now. Mention the phrase "The torch has been passed" (or maybe "Here on earth, God's work must truly be our own") in a crowded room and you'll swiftly identify who is afflicted still. They're the ones whose eyes, though it's been almost 50 years, mist up.

Soon came the brother Bobby—there was something about the Kennedys that prompted people to call them by their first names, or by their initials—and it happened again. Grown men and women swooned, and a measure of Bobby's endurance is how, every 10 years after his 1968 assassination, someone mounts an exhibition of those photographs of RFK's funeral train, the most poignant since Franklin Roosevelt's, maybe since Lincoln's. To this day there are accomplished adults who are willing to be known, in the nation's capital and very far from Washington, not for what they did but for whom they worked. Bobby People.

A dozen years later, as if to prove that this is a bipartisan phenomenon, a whole generation of young conservatives (and many aging ones, too) fell for Ronald Reagan. Today Reagan is an iconic figure, remembered for knowing one thing and for trusting in that one thing: his own instincts. The others may have had great intuition, but the Great Communicator had great instincts. We could use a few like him now. Everyone says so.

Now the trumpet summons us again—at least many of the young among us, and a strong majority of the African American.

This figure, too, is known by his first name—how many of us have ever met another Barack?—and for the way he stands in front of a crowd. Several of his immediate predecessors as Democratic standard-bearers were good, tidy citizens just like he is, and thoughtful too. But, today, does there breathe a soul who can summon a vivid picture of what Walter Mondale, or Michael Dukakis, or John Kerry was like on the stump? By contrast, the Obama style—the cool, patient way he waits for the roar to subside, the effortless manner in which he speaks, the faultless sentences and paragraphs that he crafts and then delivers—is a thing that will be remembered forever.

I saw it first in New Hampshire's North Country, in a village that voted for Barry Goldwater, in a county that went Goldwater's way, too. It was very early in 2007, Obama was only a glint in the Democratic Party's eye—Hillary Clinton and John Edwards were the contenders to watch—yet hundreds, maybe a thousand people, crowded into the high school, the biggest crowd I have ever seen in this New Hampshire town that I have known for more than four decades. Obama was at ease that day. His wife and daughters were with him, and he just stood there, shoulders drooping with innocence, and answered questions, one after the other, smart ones and inane ones, and then he asked one of his own: Was there a decent diner around here?

He won them, this crowd, and I remember thinking, there in the gym, that Obama was striking me the way that Kennedy must have struck my grandparents: So skinny. So young. So gifted, too.

And though I don't fall in love (I don't even vote in primaries, for gosh sakes), I have made it a habit and hobby of mine to watch people falling in love—with political movements, with political ideas, with politicians. And yes, I think I saw my daughter fall.

She's a quiet, introspective sort, the kind who doesn't know the college song (on a campus where everyone knows the college song) but can identify every symphony of Shostakovich (she's partial to the eleventh, and to the third movement of the fifth). Her father spent a lifetime following politicians, taking delight in every aspect of the campaign game. She found it all a great bore, even the time in 2000 when I took her to Portsmouth, New Hampshire, to see

Governor George W. Bush, then over to Exeter to see Senator John McCain. She said the music was horrible.

Here's our divide in a microcosm: The father is obsessed with the 1960 presidential election; one of the two questions the daughter got wrong on the American History SAT II concerned the Kennedy–Nixon debates. You get the picture.

So why, when *Time* magazine ran a huge photograph of the massive Obama rally at Dartmouth College later in the campaign, did Elizabeth Shribman, class of 2010, in the first known example of the girl actually acknowledging the existence of a weekly newsmagazine, point out exactly where she was standing that afternoon? You get that picture, too.

We know why many black Americans support Obama. This is their moment, long overdue, but sweet in its harvest. I think we know as well why young Americans, or at least many of them, are drawn to Obama. It may be for what he is, but it also may be for what he is not: not white, not a baby boomer, not scarred by Vietnam, not imprisoned by Watergate, not carrying a torch for the Kennedys or even Reagan. In short, not typical. An original. And not like their parents. Not at all like their parents.

The great British biographer Robert Blake once examined the phenomenon of "turning points" in history and wrote: "It is true that if all the historians who have used this expression are right, English history would be as full of turnings as the Hampton Court Maze; but there are occasions when it is legitimate."

We may or may not be at a turning point, but a lot of people sure think they see the country, a nation with high gas prices, flickers of inflation and an unpopular war, putting on the turn signal. And

Obama addresses Elizabeth Shribman and other ardent supporters at Dartmouth College in Hanover, New Hampshire, on May 28, 2007.

whether America makes that turn or not, Obama will not be forgotten. The guy who made Elizabeth Shribman fall in love—she and millions of others—will resonate in memory no matter what the future brings. You never forget your first love.

DAVID M. SHRIBMAN WON A PULITZER PRIZE WHEN COVERING WASHINGTON FOR *THE BOSTON GLOBE*. HE IS TODAY THE EXECUTIVE EDITOR OF THE *PITTSBURGH POST-GAZETTE* AND A NATIONALLY SYNDICATED COLUMNIST.

Our Children's Crusade

By Melissa Fay Greene

My husband and I have nine children (four by birth, five by adoption), ages 10 to 26. They are white, Roma (Gypsy) and Ethiopian, which makes Thanksgivings really, really complicated, but does allow easy access to polling data without leaving the house. Regarding the several generations and ethnic groups within our immediate family, I can say that I had not seen everyone so united around a single purpose since the rush to get midnight tickets for the opening day of *Pirates of the Caribbean: Dead Man's Chest*. The children's crusade this time was to see Senator Barack Obama elected President.

The day before Super Tuesday, home in Atlanta, I got a phone call from Molly, our oldest, who works in radio in San Francisco. "There was an Obama supporter yelling on the street right outside my window at work today," she said. "I'm for Obama, but this started to get a little annoying."

"Why, how long was he yelling?" I asked.

And Molly said: "Three hours."

The moment I clicked off, a cell-phone text message came in from Seth, our second-oldest, who is in graduate school in New York City. "Volunteered for Obama today," he texted.

"What did you do?" I wrote back.

"Stood on street corner yelling Obama."

"For how long?" I asked, feeling I already knew.

He texted back: "Three hours."

Only Daniel, 13, did not immediately leap on the Obama bandwagon. He'd recently joined us from Ethiopia and, in his experience, presidential campaigns tended to end in gunfire. "Look, Daniel!" I said, pointing out Senator Obama on television during a candidates' debate. "He could be the first black American President!"

"Where, Mom!" barked Daniel. He is lanky, black-skinned and, typically dressed in a younger brother's small T-shirt, tightly belted ankle-length jeans and huge neon-green Crocs, still clueless about American urban fashion.

"There, Daniel, right there," I said, gesturing again toward Obama.

"Where, Mom?" he repeated, with the Ethiopian roll of the *r*.

"Daniel, right there," I said, having walked to the TV screen and placed my finger on Obama's head.

In Daniel's experience, presidential campaigns tended to involve black candidates. But this didn't look like one of them. "No, Mom," he said sadly. "Not black, Mom. This not black."

But the rest of our kids and their friends caught fire—the words, the call for global justice, the elegance, the books (for the oldest three), the promise to end the war, the overturning of the Bush White House. And also because a fundamental charge against Obama didn't ring true for them: the suggestion by rivals and by pundits that Senator Obama was somehow not quite American enough. Mark Penn, Senator Clinton's chief strategist, wrote memos in early 2007 that surfaced later: "All of these articles about his boyhood in Indonesia and his life in Hawaii are geared toward showing his background is diverse, multicultural, and putting that in a new light. Save it for 2050." And: "I cannot imagine America electing a president during a time of war who is not at his center fundamentally American in his thinking and in his values." Pundits and columnists wondered if the American electorate really understood Obama, and if he understood them. "There is a sense that because of his unique background and temperament, Obama lives apart," wrote David Brooks.

My children and their friends got exactly who Obama was. Obama was far more like them than were Mark Penn or David Brooks. I'm lucky to have a front-row seat to widely tracked societal trends: "Young Americans are far more ethnically and racially diverse than their elders," reported *USA Today*. "The distinctions may be even more blurred for younger generations who are exposed not only to diversity but also to multiracial couples and their children." At the start of the new millennium, white people make up more than 85 percent of Americans 85 years and older, and nearly 80 percent of Americans 40 and older. Under age 40, three of five Americans are white, and that percentage falls the younger you go. Senator Obama's "unique background" didn't make him unusual to my children; it made him knowable. I'm sure my younger ones felt that if Obama happened to drop by for a couple of hours, they'd instantly have him in gym shorts and T-shirt in the driveway shooting hoops, then in the front yard chasing a soccer ball, then getting soaked as the game devolved into a water-gun fight, then perhaps lured to the kitchen table to help with homework, which included, on any given night, assignments in Spanish, French, Hebrew and Latin.

This is not the world I knew as a child. When I was growing up in another Georgia city, Macon, Atlanta was like Macon, but more so: more state flags, with their slashing Confederate emblems like crossed swords, flying everywhere; more segregation, unassailably deep and wide. This was the Heart of Dixie.

Every restaurant served barbecue, and many offered knickknacks—such as salt and pepper shakers resembling a mammy and a sharecropper—in the display cases under the cash registers. Black people were expected to say 'ma'am' and 'sir' to white people. In the 1950s, a large black woman was paid to dress up like Aunt Jemima and sit on a bale of hay at the Atlanta airport, welcoming visitors to the Deep South. The Klan, reborn in Stone Mountain, Georgia, in 1913, was ever-present.

But Atlanta took a sharp turn starting in 1959, when Mayor Bill Hartsfield denounced the domestic terrorism of the white supremacists. He called Atlanta "The City Too Busy to Hate," which was more wishful thinking than fact at that time, but did steer Atlanta in a different direction than its sister cities around the South.

The 1996 Olympics largely fulfilled the late mayor's hopes, and to look around Atlanta today, you might wonder if most of the world's people who came here for the Games simply lingered, driving taxis, opening restaurants, enrolling in graduate schools, starting medical practices. A more diverse city is hard to imagine. In the entire sum of my public school education—in Georgia and later in Ohio—I may have met a total of four black children. Other than Jewish families, including my own, I can't recall being exposed to any ethnic group beyond the Simopoulos family of Dayton. When our daughter Helen arrived in Atlanta from Ethiopia in 2004, speaking both English and Amharic, and started public school kindergarten, her four best friends were an African American girl, a white American girl, a bilingual French American girl and a bilingual Korean American girl. When school let out, the five girls came tearing down the sidewalk to our house, grabbed seats at our kitchen table, and tore with their fingers into the bland Ethiopian bread and dipped it into the spicy Ethiopian stews awaiting them. While adults remarked that the children looked like a UNICEF ad, this was the only world they knew. When they all went to the Korean girl's apartment, they slipped off their shoes at the door and ate kimchi. When they went to the French girl's apartment, they ate Rwandan egg fritters, because her father was born to French parents in Rwanda. Did his "unique background" set him apart? No. Like his daughter's story, like my daughter's story, like Obama's story, this French Rwandan American's was a true American story.

OUR OLDER CHILDREN HAD GROWN UP in this integrated world too. My son Lee began his college application essay two years ago with these words: "When I made the varsity cross-country team, I knew (and the coach knew) I would never finish a countywide meet better than 27th. After all, no *ferange* [white person, in Amharic] ever does. No, those top spots are strictly reserved for my friends, Abdighani, Abdifata, Abbukar and Abdi (Somalian, Eritrean, Ethiopian and Sudanese respectively) and their countrymen. At my urban public high school, where white, American-born students are the minority, the best I can do—other than finish 45th—is, as newspaper editor-in-chief, to cover their phenomenal performances."

Lee continued later in the essay, "My friends, the stars of the school soccer team, come from Japan, Mexico, Afghanistan, South Africa, Somalia, Ghana and Ethiopia; statewide sportswriters nicknamed the team, 'the United Nations.' The rest of our crowd of friends—black and white Americans—rode around the state cheering them on and waving the flags of their respective homelands all the way to the state semifinals."

These children and their friends and their teammates and their classmates and their younger brothers and sisters get who Obama is. He's not an exotic. He looks like one of them.

At one point during the campaign, I canvassed for Obama with Lee, who is now 20, and his brother Seth, 23, in the Kirkwood neighborhood of Atlanta. We were equipped to register unregistered voters. Black, white, straight, gay, working class and affluent families, owners of flea-bitten hound dogs or poodles with their hair-bobs all lived side by side in shotgun houses, in brick duplexes and in multistory villas. From one house to the next, we had no idea what sort of person would open the door.

One man said, "Yeah I'm for Obama, I'm black, ain't I?"

"Well, let's see," I said. "We just met your neighbor, the black Republican."

"Yeah," he said. "You can look at the car he drive and know what he stand for."

Mansion for Obama, Duplex for Obama, Aging White Woman for Obama, Octogenarian Black Male for Obama, White Lesbian Feminist for Hillary, 30-something Young White Mother with Cute Infant for Obama, and a White Libertarian who said, "No Soliciting means No Soliciting," after I asked, "Is it soliciting if I'm not asking you for any money?"

"Who do you like for President?" I asked Swann Lee, a Korean American dancer and my hairstylist.

Mid-cut, she bent down and whispered in my ear, "I like Obama. Don't tell!"

Israeli carpet cleaners arrived at my house. "Who do you like for President?" I asked.

"Well," said a young man, a veteran of the Israeli army, "is it true what they say, Obama is a Muslim?"

Obama reads to children in a Hyde Park day-care center in 1995.

MARC POKEMPNER

"Mom, Obama is win?" asked Daniel.

Daniel's English was coming along nicely, but verb tenses were so difficult! I loved the day he sadly held up his crushed water bottle, which he'd found squashed on a chair seat under his younger brother Yosef. "Mom," he said, regarding it with regret. "Yosef is sit."

So when he asked, "Obama is win?" I didn't know if he was asking, "Is Obama winning?" or "Did Obama win?" or "Will Obama win?" When I pressed him on this, he smiled and grew shy.

Later he asked, "Dad like Obama?"

"Yes."

"Molly vote Obama?"

"Yes."

"Seth like Obama?"

"Yes."

"Lee vote Obama?"

"Yes."

"Lily like Obama?"

"No, not true," I say. "Obama's a Christian."

"I get many e-mails about this."

"They're lies."

"O.K., O.K.," he said, "I like."

Out for brunch with a crowd of old friends, all of us Jewish, including one Israeli woman and one Mexican American Jewish woman, I asked, "Who are we voting for?" I had read in *The New York Times* about Jewish voters' reluctance to vote for Obama. I hadn't personally met any such voter, but I thought maybe there was one among us.

"Melissa, are you crazy?" said one friend. "Do you think we trust McCain on foreign policy?!" Everyone laughed merrily. At the end of our meal, one American Jewish woman offered me a Barack Obama bumper sticker in Hebrew.

Coming home from the airport the other day, I said to the Nigerian taxi driver, "You like Obama?"

"Yes, but do you think they will let him win?"

"Yes, I think they will," I said.

I believed what I said, and said what I believed.

"Lily's 16, too young to vote."

"I know you."

"Yes."

"Molly's friends, Seth's friends, Lee's friends?"

"Yes."

"All?"

I hesitated, thinking about Seth's Bulgarian American friend from high school, who'd become a Young Republican in college and now worked on Wall Street. I texted Seth. The message returned: "Venci for Obama."

"Yes, all."

"Obama is win," Daniel concluded.

Based on this quasi-scientific polling data, and on the changing definitions of words and phrases like "exotic" and "unique background" and "American" in the world—particularly in my children's world—I had reached the same conclusion.

Among **Melissa Fay Greene's** several nonfiction books is the National Book Award finalist *Praying for Sheetrock*.

East German border guards demolish a section of the Berlin Wall in 1989, and many Europeans come closer to America.

Immigrant Song
By Andrei Codrescu

I'M 62 YEARS OLD and maybe I've finally got it right. I'm a first-wave boomer, an immigrant from Eastern Europe, a Jew and a fan of both Thomas Paine and Alexis de Tocqueville. I came to the United States in 1966 during the war in Vietnam and I hated that war as much as I hated the communists who exiled me and my mother from our native land. I hated that war so much that I would have voted for Eldridge Cleaver in 1968, like many of my friends, but I couldn't vote because I wasn't yet a citizen. These young American friends were so angry about the war, they thought that maybe the commies were right. I took some pains to explain Orwell to them, how tyranny always perverts the language of freedom to mean the opposite of what it means, but my commonsense explanations fell on deaf ears. I found myself thought of as a domestic liberal and a foreign policy conservative.

The following decades brought us leadership that didn't deviate much from the left–right positions set in cement after the Second World War, and I became disillusioned with politics. I voted dutifully for Democrats, but cheered when Ronald Reagan got the better of Gorbachev and the Berlin Wall came down. At that point, it looked possible that a third way, neither right nor left, might be found as my generation matured. Millions of us had life experiences that transcended politics and the black-and-white mind-set of the cold war, and we had the subterranean but widespread feeling that a new consciousness was on the rise. We began feeling the living connections in our environment and the possibility of global understanding. The postcommie optimism turned out to be premature: Even as historians like Francis Fukuyama proclaimed "the end of history," history kept making a horrific comeback. The bounty promised by the end of the cold war was not used to rethink the world, to create alternative energy, dissolve borders and eliminate economic injustice. We found ourselves instead in a new war, one more insidious and harder to define than the war in Vietnam, the so-called war on terror.

The Orwellian perversion of language soon increased tenfold. In Iraq "occupation" became "freedom," to give but one example. It seemed to me that the game was rigged in ways I didn't anticipate, and that the worst suspicions and paranoias that we had harbored

in the '60s, were, in fact, real. Phones were tapped. Secret trials were taking place. Oil companies ran the world and, in the words of my old poet friend Joe Cardarelli, "Washington is a play that Texas puts on every four years." It would be an understatement to say that I felt cynical. I was never much of an optimist anyway (being born where and when I was), but when the country elected (sort of) George W. Bush again, I was ready for a solitary cave in the mountains without cable TV. Only I wasn't alone: 50 million of my contemporaries were ready to go into that cave with me, and there just wasn't enough room.

Too many of us had already spent decades working for a sound environment, civil liberties, consumer and workers' rights, and defending individuals against corporate machines. We'd even had a president, William Jefferson Clinton, who was our own age and shared the values of our generation, in a realpolitik sort of way. The trouble was that Bill Clinton shared too many of our generation's not-so-evident flaws as well: a cynicism ready to manifest at any moment and a propensity for a forever-young rock 'n' roll party. His sexual shenanigans were ready-made for the new "values" mafia set in motion by the same Ronald Reagan who helped demolish the Wall. (There are paradoxes and inconsistencies here because my generation, forged in its youth in anger and protest, and in middle age in a frantic work ethic, has clinical complexes as well as simple complexity.)

WHICH BRINGS ME TO OBAMA. I was a Hillary man at the start of the campaign and, once again, I made many of my friends angry. One from Santa Fe wrote me passionate letter after passionate letter, hoping to dissuade me from Hillary to Obama. Her messages boiled down to, "How could you, after all that we know about the Clintons?" She hated Hillary's whole "stand by your man" attitude, and the endless compromises and lies of the couple. A younger friend, who is biracial and actually worked for Hillary during Bill Clinton's second campaign, did not judge me harshly, but pointed out her own gradual evolution, from Hillary (whom she loved still) to the extraordinary presence and force of Obama's thinking.

This is when I started reading and watching the man. I realized, quite against my instinct to hide and to be cynical, that something close to a miracle was taking place: An intelligent, articulate, thoughtful, democratic American was standing on the political stage for the first time in decades. His good looks were deceiving, in a way that, maybe, Kennedy's had been: Within that movie-star physique was an incredible thinker and a determined leader. Hillary had been my first choice because I understood her. She was flawed, yes, but I remembered the college women of her generation fighting for women's rights, for workers' rights, for the end of the Vietnam War. She was the kind of woman whom, in the '60s, I often fell in love with. Sure, she had had many painful experiences, but the young radical was still there. I could feel it in her stubbornness, in her insistence on right and wrong, in her essential faith in human rights. If her husband had decoupled our foreign policy from the human rights policy of the Carter era, she would set the wagon straight again. I had faith in her because I still had faith in the beliefs of my own youth. I felt that, for all the passing time, there was still a young idealist inside me.

Only I now realized that the young idealist inside both Hillary and myself, was not us, so to speak, but Barack Obama.

Let me explain. The idealist within any of us is young. Barack Obama is young. At the same time, our inner idealist is quite deformed by the disappointments of life and politics in the U.S., no matter how well it regards itself: If our inner idealist were to take on a body, he or she would look scary, like an escapee from a gulag. He or she would look nothing like Obama. Our inner idealist has also spent much of its force passing its values on to the children. Our children have gotten a great deal from their parents' idealism: concern for living things, hatred of injustice. But, at the same time, many of us didn't behave all that well. We divorced, we fought, we abused alcohol and drugs, we were hugely selfish. Behaviors like that didn't, I hope, cancel out the idealist teachings, but "Do as I say, not as I do" is as useless a policy as "Don't ask, don't tell."

Barack Obama is not young enough to be the child of an archetypal '60s person, and he's not old enough to be one of us. More important, he's not old enough to be a cold warrior. Barack Obama is just right: He cut his teeth leading fights for justice that had already been given shape by my generation, and his thinking rests on the rock-solid foundations laid by the Bill of Rights, and by those who upheld them, like Martin Luther King Jr. He is charismatic and persuasive, but his rhetoric is rarely vacant. He seems present every time he speaks. He inhabits not only his body but his words as well. He has overcome two of my greatest suspicions: misusing the language and being too pretty to be serious. He means what he says and he is very serious. What's more, he is accessibly human in an understated, delighted way, open and expectant, like a kid about to hear something amazing. I wouldn't be surprised to hear that he likes poetry.

ANDREI CODRESCU EMIGRATED FROM ROMANIA TO THE U.S. AT THE AGE OF 20. HE IS AN AUTHOR AND ESSAYIST, A COMMENTATOR FOR NPR AND PROFESSOR AT LOUISIANA STATE UNIVERSITY. HIS LATEST BOOK OF POETRY IS JEALOUS WITNESS.

Obama, Rhetorically Speaking

By Jay Heinrichs

IN THE UNLIKELY EVENT THAT BARACK OBAMA made me his image adviser, I would tell him to work on his virtue. It's his biggest weakness.

I'm talking about a political variety of virtue that has little to do with good behavior, and which no less a philosopher than Aristotle described some 2,500 years ago. Obama would do well to know his Aristotle. No one understood the political animal more than the old Greek did, and while science and technology have changed since his time, human nature has not.

Virtue, Aristotle said in his masterpiece, *Rhetoric,* makes up one leg of a successful politician's public image—the other two being "practical wisdom" and "disinterest."

Obama scores fairly well on practical wisdom, a characteristic that in politics has more to do with practicality than with wisdom. The practically wise politician is a flexible realist. He considers the needs of each occasion and reacts accordingly. He's perfectly happy to stick to principles so long as they apply to the particular case at hand. Obama demonstrated superior practical wisdom when he opposed the war in Iraq. The Bush administration stood on principle, claiming that the war would bring democracy to the Middle East. Obama wasn't convinced. An invasion in this case would be impractical, he said, and unwise. Nor does the man do badly on disinterest—meaning not lack of interest, but freedom from special interests. If you want to lead people, Aristotle said, it helps to make them believe you have their well-being at heart more than your own. This is no small task for today's politicians, who first must show how they put voters' welfare above that of check-writing lobbyists. Obama jeopardized his reputation for disinterest when he refused federal campaign funding in order to raise an unlimited amount on his own. But his staff properly hyped the multitude of small donors who have contributed so much to his campaign; the bulk of Obama's money came in gifts of less than $90. They argued that The People, not just special interests, showered their candidate with funds. The argument was accepted by many.

Ambition as well as money can sully a politician's reputation for selflessness. It is a fact that it's hard to like and trust someone craven enough to run for high office. A hypocrisy underlying this fact is ours, not the politician's: We require of him an ambition bordering on mania, and then we dislike him for it. But be that as it may, the politician is in a pickle—how to appear modest in a profession that doesn't reward modesty. Obama's nifty rhetorical ploy in this regard is a time-honored one: fatherhood. On several carefully stage-managed occasions, he has his little girls stay up way past their bedtime so that a national audience can see him love them. He may, in truth, be the world's very best dad, but that doesn't really matter: Observers of these scenes smile at this man who obviously has higher priorities than running for office. Small children are always a great asset for an office seeker.

While Obama comes out on the plus side in both practical wisdom and disinterest, he needs to take a hard look at Aristotle's third component of the public image. Political virtue has nothing to do with being pure of heart; in fact, it has little to do with being good at all, for the simple reason that people disagree about which things are "good" and which aren't. Different types of people value things differently.

Aristotle's "virtue" deals with values. The value you put on various things in life colors how people feel about you. If you value God and family, that may gain you respect, but small things matter too. If you value beer more than wine, then a beer drinker is more likely to find you likable. You and your bar mate share at least one value. Beer.

Indeed, there's an old political saw that Americans prefer politicians they would want to have a beer with. This is where Obama, who can look to a beer drinker like a closet wine sipper, gets in trouble. When he tried to look like a regular guy by bowling, he bowled a 47. Anyone who bowls a 47 cannot be classified as a regular guy.

What, you are asking, do beer drinking and bowling have to do with running the country? Why can't we simply elect practical and wise leaders without wanting to date them? Why did Obama even put on those bowling shoes?

Aristotle told us why Obama felt that he had to, even though he didn't really have to—and should not in the future. The philosopher who invented logic as we know it said that reason alone does not determine whom we pick as our leaders. Because of our "sorry human nature," he wrote, we relate more to personalities than to logic. Voters use their guts more than their brains. If we like and trust a politician, we feel less inclined to check his facts.

But Aristotle allowed special public figures such as Obama an escape from the need to pander. Obama does not have to pass the barroom test in order to succeed as a statesman; the rare politician who can outshine the regular guy, and thus does not have to pretend to be something he's not, is one who is larger than life.

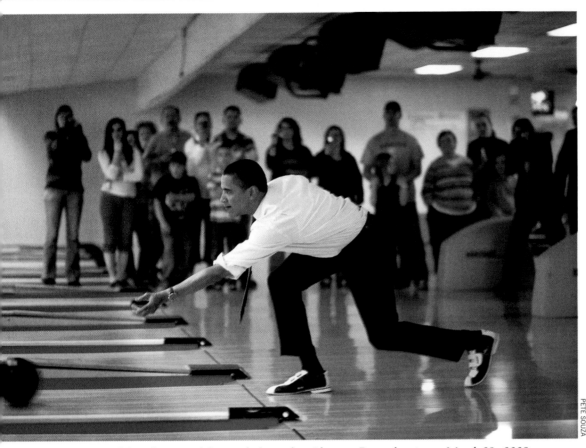

The candidate shows good form to little avail in Altoona, Pennsylvania, on March 29, 2008.

needed programs, keeping the middle class from bearing too much of the burden. Aristotle would advise Obama that, in order to get Americans behind him, he should tap "values." Obama should address the rich with some of the same values he uses to lecture African American fathers: It's their responsibility; their selfishness is hurting their own people and, ultimately, themselves.

What Aristotle is doing here is bringing in values to support a practically wise decision. He is getting Americans to buy in emotionally—to identify Obama's choice with virtue and to rejoice in this best sense of themselves.

Aristotle would urge Obama to sound more virtuous about global warming and healthcare. He should dwell less on the consequences of climate change and more on how America is slipping as a technological and creative leader. America leads, dammit, and that's what we should do with the earth's biggest challenge. Healthcare: We're falling behind the competition, becoming one of the least healthy industrialized nations. Us! *America!*

Issues like these, and the virtuosity of his approach to them, will determine whether Obama ever achieves his image's glorious potential. Unless he brings his virtue up to the level of his disinterest and practical wisdom, he will continue to come across as a merely eloquent, not-so-regular guy.

He reminds me, at present, of one of the two greatest orators in ancient times, Cicero and Demosthenes. Cicero spoke with eloquent, persuasive logic, and everyone said his speeches were fascinating. Demosthenes told his audience what they as a people stood for, and how what they valued was under threat of extinction. When he finished, the people shouted, "Let's march!"

Obama is a pretty fair Cicero. What he needs to be, what our country needs right now, is a leader to inspire some serious marching.

Instead of playing the common man, Obama, who is plenty uncommon enough by birthright and precocious achievement, should become even more so. Aristotle would tell Obama to go large—to transcend his inner Coolidge and channel his inner Kennedy and Reagan.

How? For one thing, he should make more speeches like the one he gave in response to his loose cannon minister. Obama sounded more like a preacher in that speech than the Reverend Wright himself. You could see Obama reach out in one rhetorical direction and then another when he said the black church "contains in full the kindness and cruelty, the fierce intelligence and the shocking ignorance, the struggles and successes, the love and, yes, the bitterness and bias that make up the black experience in America." Rhetoric like that does not just embrace African Americans, it embraces all America. Aristotle said that by describing the values that an audience has in common, sermonic orations tend to bring people together and make them feel part of something bigger than themselves. Obama has the talent and personality to do what Aristotle urged.

We're not merely talking about speeches here, but also policy decisions and even press releases. All of them should seem large-minded. For instance, Obama wants the rich to resume paying taxes at the level they did prior to the tax cuts of the last eight years. There are good practical reasons for increasing taxes on the rich, and Obama has given them all: reducing the deficit, paying for badly

JAY HEINRICHS IS AUTHOR OF THE ACCLAIMED BOOK ON RHETORIC, *THANK YOU FOR ARGUING: WHAT ARISTOTLE, LINCOLN, AND HOMER SIMPSON CAN TEACH US ABOUT THE ART OF PERSUASION*.

The View from London

By Fay Weldon

Currently, Britain loves Barack Obama. We like his citizen-of-the-world stance, his energy, his goodwill and his youth. If the world can be saved by sheer good nature, he's the one to do it.

Mind you, we're cautious. We fell for Tony Blair for much the same reasons, and he turned out to be a control freak at heart. He arrived at Downing Street all smiles and with a guitar, and before long you couldn't play a duet on a pub piano without paying a license fee. Then we remember Neil Kinnock, a prime ministerial candidate, who bounced onto a stage shaking his hands above his head in premature triumph and thus lost his party an election. We'd warn Obama to be careful: Popularity is more difficult to handle than the grudging marginal acceptance winners tend to get. Let his watchword from now on be humility. Elections are the only time voters get a taste of power, and they get really angry if, later, they feel they've been taken for granted.

If I don't mention the race issue it's because it's so explosive over here we have got out of the habit of mentioning it. It's just too difficult. To call someone black if you're white can be taken as an insult: Only if you're black is it O.K. to say black. The law obliges us to be very polite to each other. But good for you, Obama, you of "mixed ethnicity"—that phrase is allowed—good for you for not proposing yourself as any kind of victim, rather the opposite.

It is true that British opinion has been out of love with the United States lately, what with Iraq and not stopping your President from taking happy pills and crying, "Let's go get 'em!" so that the whole Middle East blows up and with it the price of gas. And then there are other alleged shortcomings of yours, such as rendering us obese with your Krispy Kreme Doughnuts, making films that leave Britain out when you're winning World War II, giving us too much choice at Starbucks and having an empire when ours is over. But mostly for not quite understanding that, thanks to technology, nothing is as it used to be. If you want to bring about a world where men and women are equal and democracy rules (who doesn't?), you would do better to spend the trillions on getting Google into Taliban homes rather than you would by bombing them.

We had our own experience with terrorism with the Irish Republican Army (whom you would keep supporting), and what brought that to an end wasn't a negotiated peace accord, but the rise of designer labels. The IRA suddenly looked uncool—a collection of overweight men in bad suits who dropped cigarette ash into their trouser cuffs. So they dressed in Armani and joined the Northern Ireland government. Same reason the Berlin Wall came down: The protesters looked so young and with-it and the old men of the Stasi so gray and boring. They didn't stand a chance. So then, you'd do better to get your best admen onto the current war game than your generals. Project messages onto the Afghan clouds: Beards are unsexy. No use objecting there are no clouds to speak of in Afghanistan. If you can get robots to Mars you can do something about the weather, and incidentally get rid of the poppy crops, too. It's just a question of ingenuity, geoengineering, imaginative funding. That's what we think. We watch your brilliant special-effects films and how can we think otherwise? This is the computer age: YouTube, Facebook, MySpace. You don't need bombs to conquer, you need celebrity.

Also: The new way is all carrot, no stick. They've managed that in Europe: turned us into the Soviet Union Lite, with no KGB, just lots of money spent where it's needed, convincing us we want to belong to the whole. If you're the Federation of American States, we're the Federation of European States, though we don't like to call it that. We're currently busy accruing extra territory all the time just as the Soviet Union once did. Extending boundaries. Not "give me your tired, your poor, your huddled masses yearning to be free," but "give me anyone out there who wants broadband." No worry for you: We don't have an army to speak of, we live on our wits and by spinning truths.

We reckon this is the way Obama wants to go. It's a youth thing. Barack Obama reaches out his young and virile, multiethnic, mouse-friendly arms to us and we want to fall into them. We so badly want a leader. We want a politician we can like.

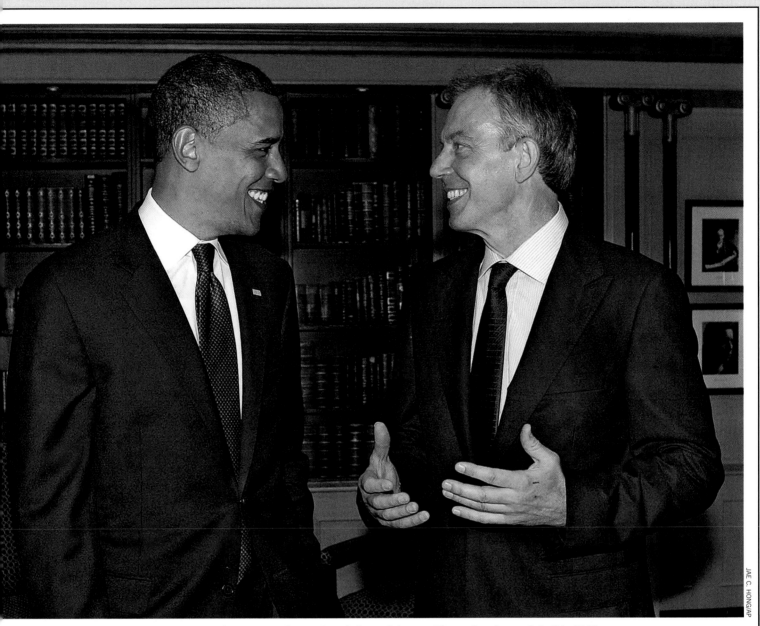

Senator Obama meets former British Prime Minister Blair in London on July 26, 2008.

Perhaps, with him, we could become the fifty-first state? Forget all grievances? We want to be friends. Britain and the U.S.: We were made for each other. True, we quarreled when you left home—a little matter of our troops taking the White House in 1814, and your Baltimore schooners shelling up our seaside resorts, and so on. But that was a long time ago, and we did concede victory to you at last. The recent unpleasantness: It's been a lover's tiff, a blip in the special relationship. It's all over now.

We like you again, and we like the Obamas. We like Michelle's wry smile, and the feeling that she knows what it is to be on the sharp end of life. We don't think she's likely to turn into Cherie Blair with her penchant for mystic crystals and personal soothsayers. Michelle has her feet on the ground. If she has Obama's ear, so much the better. We couldn't see what there was to object to in that *New Yorker* cover that showed the couple in Islamic dress. We

have been so trained over here to think of Islam as the religion of cuddly, nice people except for a few misguided nutters, it seemed a rather friendly joke.

Just one thing. We're not completely sure about Obama's habit of applauding himself and his audience in mutual self-congratulation. Chairman Mao used to do it. It doesn't feel quite right. And it's odd, this clapping business. It can misfire. Legend has it that when U2's Bono was doing his thing at a concert in Glasgow the other year, the music stopped and he quieted the audience, clapping his hands and saying, "Every time I clap my hands, a child in Africa dies." And a gravelly Scottish voice from the back called out, "Why don't you stop X#@%!* clapping, then?"

The celebrated English author and social commentator **Fay Weldon** has written more than two dozen novels, including the modern classic *The Life and Loves of a She-Devil*.

The Cultural Challenge of Barack Obama

By Charles Johnson

LIKE THE NARRATOR of Charles Dickens' *A Tale of Two Cities*, many black Americans at the dawn of the twenty-first century may feel, "It was the best of times, it was the worst of times." The reason is that, as Eugene Robinson explained in an April 4, 2008, article in *The Washington Post*, there are actually two very culturally different black Americas as this new millennium begins.

In one grim and depressing portrait, 25 percent of black Americans live in poverty. Seventy percent of black babies are born out of wedlock and more than half of black children are fatherless. In America's prisons, where on average the 2.25 million persons incarcerated in 2006 had fewer than 11 years of schooling, about half are black. One in nine black men between the ages of 20 and 34 is in prison. While black people represented 13 percent of the United States population in 2005, they were the victims of 49 percent of all murders, 15 percent of rapes, assaults and other nonfatal violent crimes nationwide, and most of the black murder victims—93 percent—were killed by other black people. In 2008, the black male high school graduation rate in Baltimore dropped to 25 percent, was 50 percent in Chicago, and in California 19,440 black students (42 percent) quit school. And to these dire figures we must add the fact that nearly 600,000 blacks have HIV, with their rate of death two-and-a-half times that of whites who have been infected.

Yet, remarkably, against the background of this highly publicized, pathological portrait of black America (or perhaps in part because of it), Senator Barack Obama is, according to a controversial political ad prepared during the campaign by his opponent, John McCain, "the biggest celebrity in the world." I would argue this is so because in the brief time since he was introduced at the Democratic Party's convention in 2004, Obama has become in this country an avatar of the other black America, and on the international stage he is the emblem for something even grander. Eloquent and elegant, charismatic and holding a degree from Harvard Law (where, as we know, he served as the *Law Review*'s president), relatively young compared to Establishment politicians, always comfortable in his skin, tall and lean in a Lincoln-esque way, he and his wife, Michelle, represent in the post–civil rights period nearly two generations of high-achieving,

disciplined black professionals—historically, transitional generations—whose achievements are everywhere evident in fields as diverse as business, the sciences, education, law and entertainment. Add to this the unique accidents of his biography—a white mother from that most iconic of states in pop culture (Kansas, for heaven's sake, Toto), a Muslim father from Kenya (which makes him genuinely African American), and his formative years spent in Indonesia (a country that is 90 percent Muslim) and Hawaii (a state of considerable multicultural diversity)—and we have a figure whom it is no exaggeration to call a "once in a generation" millennial candidate. Indeed, his biracial background, like that of Tiger Woods, Halle Berry and so many others, is an indication of a demographic that will only increase in the twenty-first century.

Understandably, then, after Obama's win of the Iowa primary and his string of victories against the presumed front-runner Hillary Clinton, which suggested that for the first time in American history a black person truly had a chance to become President, the public response to Obama became nothing short of primal, and he and Michelle the stuff that dreams are made of, symbols for a new century and its desire to transcend tribalism and the barriers between people. Crowds cheered when Obama blew his nose. Suddenly, after Iowa, we came to understand that something more than just yet another presidential election was taking place in the United States.

With little political history or baggage in his brief résumé to weigh him down (which his opponents saw as his greatest liability), Obama was, as he himself said, a kind of blank slate onto which Americans could project their deepest and most visceral social and cultural longings. For black people, the promise of his becoming President was the "impossible dream" their ancestors had nurtured since the era of slavery, then segregation when a black person in the Deep South risked his life if he dared to register to vote. For whites, a President of color—especially one who in his expansive, post-racial speeches transcended several decades of Balkanization along the lines of race, class and gender—meant that the ideals of equality and opportunity enshrined in the nation's most sacred documents, the Declaration of Independence and the Constitution, were not just fine-sounding words but instead a tangible possibility that might take place in our lifetime.

And across the planet, from Africa (one newspaper headline in Kenya called him OUR SUPER POWER SON) to the Middle East (in a Muslim nation, a proverbial man on the street told reporters that the freshman senator looked like people he saw every day), Obama's globe-spanning background is inspirational because, as he said to an audience of 200,000 in Germany during his weeklong midsummer world tour, he is an American who views himself as "a fellow citizen of the world."

Senator Obama in his office on Capitol Hill on November 17, 2005

Perhaps it would be best to describe the Obama phenomenon as being not so much revolutionary as it is evolutionary. But if that is so, then a candidate as cosmopolitan as Obama has to face the problem of the people who do not want to evolve either because they fear the new and unknown, or are heavily invested in a pre-twenty-first-century vision of black American life. The senator from Illinois predictably finds himself walking a cultural tightrope, performing with balance, remarkable grace and civility when attacked by those with a tribal mentality who feel he is "not black enough," and are threatened—politically, culturally and even existentially—by the sea change and reordering of priorities that his presence represents.

It began with videos on the Internet featuring his former pastor, Reverend Jeremiah Wright of Trinity United Church of Christ in Chicago, damning America in the old style of Black Power militants and Afrocentrists from the 1960s, accusing the U.S. government of creating the AIDS virus to destroy blacks, proclaiming that Jesus was "a black man" and that the brains of whites and blacks operated differently. His divisive oratory forced Obama to deliver in Philadelphia, on March 18, 2008, his "A More Perfect Union" speech in which he tried to heal the wounds created by Wright and refused to cast his former minister aside. But Wright persisted in public with his rhetoric. Finally, Obama had to dismiss such paranoid and irresponsible declarations as "a bunch of rants that aren't grounded in truth." (And later he was obliged to also distance himself from the negative political preaching of Father Michael Pfleger.)

And that was just the beginning.

Just as comedian Bill Cosby understands the importance of addressing the dysteleological elements in black behavior that lead to broken homes, fatherless children and young men unable to compete in today's knowledge-based, global economy, so too, Obama championed better parenting and black responsibility in his Father's Day message at the Apostolic Church of God on Chicago's South Side. This, as the world saw, caused the incredible meltdown of Reverend Jesse Jackson, who was caught on camera saying Obama was "talking down to niggers. I want to cut his nuts off." However, Jackson only muttered out loud what many alienated, black, 1960s-era "oppositional" leaders feel when Obama says he is against reparations for slavery; or that he would amend affirmative action in, say, school admissions to include poor whites; and feels in regard to the Hurricane Katrina disaster that, "I do not subscribe to the notion that the painfully slow response of FEMA and the Department of Homeland Security was racially based. The ineptitude was color-blind." The hecklers he encountered at a town-hall meeting in St. Petersburg, Florida, holding a sign that read WHAT ABOUT THE BLACK COMMUNITY, OBAMA? were a reminder of that anger many feel at his nuanced and careful approach to a "black agenda."

But a black presidential hopeful could only become the leader of the most powerful nation in human history if he rose above the racially provincial and parochial. That is one enduring lesson of Obama's dramatic, historically unprecedented campaign. The truth that real excellence is color-blind, and that broad service to others has no tribal affiliation, will live on in our memories long after the general election of 2008 is over.

THE CRITIC, ESSAYIST AND LECTURER **CHARLES JOHNSON** IS THE AUTHOR OF SEVERAL NOVELS, INCLUDING THE 1990 NATIONAL BOOK AWARD–WINNING *MIDDLE PASSAGE*. HIS MOST RECENT COLLECTION OF SHORT STORIES IS *DR. KING'S REFRIGERATOR AND OTHER BEDTIME STORIES*.

THE JOURNEY CONTINUES . . .

In August 2008, Barack Obama takes time off during his quest for the White House to return home to Hawaii, where he visits with his grandmother Madelyn and with his half sister Maya and her family. During the sojourn, he also visits his grandfather's grave in Punchbowl National Cemetery and, here, offers a lei to the Pacific Ocean at the spot where, in 1995, his mother's ashes were scattered. This is where his American journey began. It has already been an extraordinary one and, Obama now realizes, will continue to be—whatever tomorrow brings.